Simple Photogrammetry

Simple Photogrammetry

Plan-making from small-camera photographs
taken in the air, on the ground, or underwater

J C C Williams

1969

Academic Press
London and New York

Academic Press Inc. (London) Ltd
Berkeley Square House
Berkeley Square
London W1X 6BA

U.S. Edition published by
Academic Press Inc.
111 Fifth Avenue
New York, New York 10003

Library of Congress Catalog Card Number: 70-92400
SBN: 12-754650-2

Printed in Great Britain by
Spottiswoode, Ballantyne & Co Ltd, London and Colchester

Preface

In 1933, in the days of plane-table mapping in the oil field region of northwest Peru, an interested geologist and I suspended a small camera from a homemade box kite, which we then launched from a cliff top into the almost eternal south wind blowing across a canyon about a thousand feet deep. The camera shutter was held against the pull of a piece of elastic by a thin wide lamp wick attached to a small lever (giving an advantage against the elastic). The wick, ignited at one edge just before take off, burned through by the time the kite reached its ceiling altitude; the elastic then worked the shutter. Thus in several photo-flights we got some near-vertical aerial photographs of almost inaccessible places around the foot of a very deep chasm. The total cost of this air-cover was under three pounds sterling, including the price of the camera. The kite was subsequently converted into a survey beacon, or majon, and possibly some of it remains as such to this day. Regrettably, we did not extract any actual measurements from the photographs; had we done so I believe we could have claimed to have carried out the first piece of overall simple photogrammetry in Latin America.

In 1965, as a considerable advance on the Peruvian job, I did some simple graphical work for a cadastral plan of the ancient ruins on the island of Arvad, or Rouad, in the eastern Mediterannean Sea, from a collection of 35 mm low-level Oblique and Low Oblique photographs taken by Miss Honor Frost from the window of a Piper aircraft, and nominal Horizontals she had taken on the ground. The Arvad plan, covering a flat coastal belt about one and one-half kilometres long by some 60 metres wide, crowded with detail (mostly massive walls fallen to the ground and into the sea), which I drafted as a working drawing but which was re-plotted and fair-drawn by Miss Frost, aroused a good deal of interest among archaeologists—at least partly because it had been made from small-camera photographs by one person using nothing more than ordinary drawing equipment.

Miss Frost suggested that I should write some notes about the kinds of working methods I had used, and I did so. I showed these to Dr. Maling at the University College of Swansea, who considered them of sufficient interest to be reproduced for first-year geography students. Geography courses ordinarily include practical work on land surveying, to which photogrammetry is mainly applied. Photogrammetric work undertaken by students normally consists of exercises with orthodox Vertical air photographs. I have no idea to what extent simple graphical photogrammetry, with one's own photographs taken from the ground, a small aircraft or a boat, the surface of the sea when swimming or near the sea bed when diving, could be a useful adjunct to ordinary academic exercises; but I can say that such work can be illuminating as well as of considerable practical use in beginning the study of photogrammetry; and it can be interesting to the point of being entertaining.

Since then I have discussed other possible applications with people of many different callings concerned with some aspect of land surveying. It seems that even those with access to the considerable resources of photogrammetric

organizations can find occasions for the use of simple methods and their own hands. Even when complete air-cover exists and maps have been made, local problems arise, particularly in reconnaissance work where the available maps are only planimetric. Such problems can often be solved adequately by the use of small-camera photographs, if these are relatively close up, Obliques or high Obliques, whereas the air-cover is vertical and taken from a great height. What in this context might be called auxiliary snapshot-photogrammetry can be useful to civil engineers, geologists and hydrographic surveyors as well as to land surveyors. In the case of a small survey not requiring great precision but considerable field time, there are obvious advantages in making a camera the principal tool. Perhaps the best example is a suitable archaeological site during excavation, on shore or under the sea, where repeated surveys are required. Given light and a good working scheme, the camera can be used to make quick records which are far more explicit and comprehensive than notes or plotting sheets and which if necessary can be worked on repeatedly at leisure. The camera makes no blunders. It records everything in its view, not only those things considered important at a given time. As an observer it cannot compare with the eyes, which have curved retinas that move together in association with some kind of living intelligence; it is a fixed-monocular, plane-projection, self-recording measuring machine of a most ingenious sort, but for what it does observe it has an excellent memory.

Simple photogrammetric methods can be used to extract architectural information from old photographs and sometimes old paintings or drawings. It is certain that some artists have used an artificial aid such as a camera lucida to draw outlines in perspective, that is, to produce a one-eyed view as a "camera obscura" does. Even holding a pencil at arm's length to compare the tangents of angles measured at one eye tends to produce views that will respond to photogrammetric methods.

The kind of work considered here does not require any previous knowledge of the subject or any mathematical skill, or any special knowledge of photography (beyond that of knowing how to take good pictures, if necessary from an aircraft or under the sea). The best all-purpose camera is an underwater one with a plane-glass window, since it can be used as it stands in the air. Ordinary photographic printing paper is usually stable enough, but matt or semi-matt prints are preferable. Colour pictures are sometimes helpful in showing up distinctions which in monochrome may not be apparent. Colour slides projected onto a screen are useful to refer to when working on monochrome prints made from the transparencies.

During the last 30 years or so, photogrammetry of many kinds has become big business. It is also an important aspect of science applied to the study of what exists on Earth, and on and *in* other bodies, including human ones. This comprehensiveness, with its numerous divisions and specializations, has, I believe, led many people to assume that the whole subject is matter for only the skilled and learned. But as with the great developments in the means of travel (for example; nobody provided with his own canoe need baulk at a small creek because he does not understand the works of a hovercraft or lacks the means to

charter one), it appeared to me that a discussion of the simple means available for the solution of surveying problems by small-camera photogrammetry would be useful to many people, some of whom may not have considered the possibilities. I have therefore greatly expanded my original notes, and this book is the result.

Brecon, Wales. J. C. C. Williams

Acknowledgements

I am most grateful to Miss Honor Frost for permission to reproduce several of her photographs, and for her collaboration in carrying out experimental work at sea surface and undersea in working conditions. I am grateful to Dr. Maling for his interest and encouragement; and to Unesco for permission to reproduce (Chapter 17) the substance of my chapter (b) in the Manual on Underwater Archaeology (Part II), in the series "Monuments and Museums". I have to thank Mr. J. L. B. Bell for drawing—after some persuasion—Figures 28A, D, G, H and 33A; and Dr. Owen Forester for computing the values in Table I, Chapter 9.

Contents

Chapter 1

Trapezoids

If the four corners of a large square are marked on level ground and photographed from a high point nearby, the result is a controlled Oblique air photograph, from which a plan of anything standing on the ground in the vicinity of the square can be made easily. Figure 1A is an example. This snapshot was taken on 35 mm film with an ordinary hand-held camera with a nominal focal length of 50 mm, from a height of 14.5 feet.

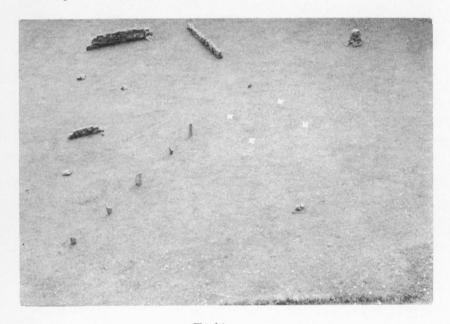

Fig. 1A.

The four white spots, corners of a two-foot square, form a trapezoid on the photograph. Figure 1B shows lines drawn through the sides of the trapezoid, making two lanes which are two feet wide on the ground, and stand mutually at right angles. From this, it already may be deduced that the gap between the miniature walls in the background is a little less than two feet, and there is a general indication of relative plan-positions overall.

Figure 1C shows a set of sixteen trapezoids, each the virtual image of a

1

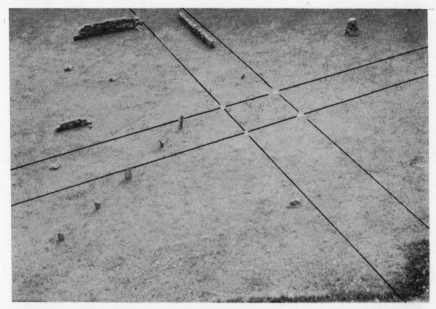

Fig. 1B.

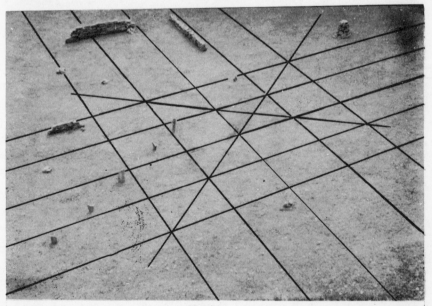

Fig. 1C.

two-foot square, generated from the original single trapezoid and making on the ground four two-foot wide lanes in each direction. A good deal of plan-position information is now available. In Fig. 1D the trapezoids cover the photograph. Figure 2 is the resulting plan, which was made in a total of one hour's work. On the plan the rectangular outline of the photograph forms a trapezoid. This is a corollary of the fact that squares on the ground form trapezoids on the photograph.

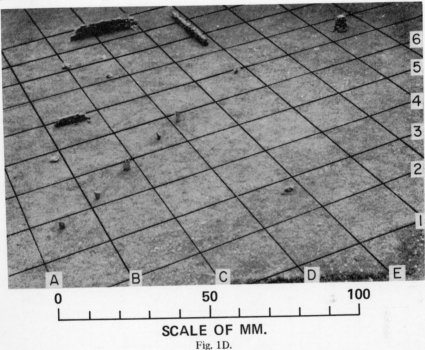

Fig. 1D.

The errors of the distances as obtained from the plan in this instance were found to be all under 2%, most of them under 1½%. This is a simple experiment that can be repeated. The square shown in Fig. 1A is too small to give good results, but the small size is an advantage for this demonstration. (The scale-bar of millimetres shown in Fig. 1D has no immediate significance.)

On the plan, Fig. 2, the two-foot distance is given by the scale-bar as 100 feet, so that later discussion of the photograph can be in the context of the kind of dimensions that might be found in fact with a very low-level Oblique photograph taken from a small aircraft or from a high ground point.

A large square can be set out on the ground readily by the use of the well-known triad of integers 3, 4 and 5, the sides and hypotenuse of a right-angled triangle. The corners can be marked by white- painted boards or the like. A board a foot square will ordinarily make a good spot on a photograph taken with a camera of 35 mm or 50 mm focal length at a distance of 500 feet.

Simple Photogrammetry

The way in which an array of trapezoids can be generated from an original single one is partially shown in Fig. 1C. In Fig. 3A the trapezoid 1, 2, 3, 4, represents a square as photographed. This one is of a practicable size and it is placed centrally in the foreground.

Fig. 2.

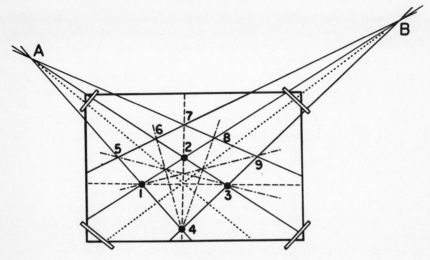

Fig. 3A.

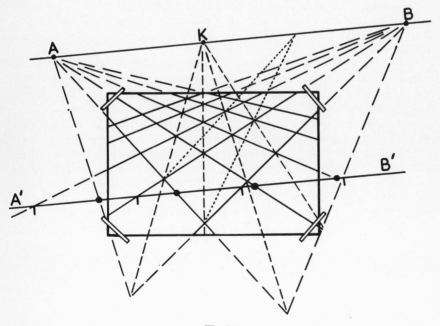

Fig. 3B.

Solid lines are drawn through 4, 1, and 3, 2, to find A, and through 1, 2, and 4, 3, to find B. Through the intersection of dashed lines through 4, 2, and 1, 3, dotted lines go to A and B. Dash-and-dot lines 3 to 5, 4 to 6, 4 to 8, 1 to 9, can then be drawn. Solid lines through 5, 6, 7, go to B, and through 9, 8, 7, to A. The trapezoids 1, 2, 5, 6; 2, 6, 7, 8; 2, 8, 9, 3, are each the virtual image of a square that is a replica of the square 1, 2, 3, 4, on the ground. Further extension can be carried out *ad lib.*

Figure 3B shows the array of trapezoids completed. The line joining A and B is the Horizon Line, which is very nearly the virtual image of the sea-horizon. This, if the obliquity of the photograph had been greater—that is, if the camera had been tipped downward less—would have appeared on the photograph, provided, obviously, that no solid objects intervened. (A photograph of zero obliquity is a Vertical, that is, the camera points vertically downwards; a photograph of obliquity of 90° is a Horizontal, that is, the camera points at the horizon. A Low Oblique is nearly a Vertical; a High Oblique nearly a Horizontal.)

Diagonals of trapezoids, as shown by the lines to K on Fig. 3B, meet at the Horizon Line, as do any other lines of like kinds, such as the dotted lines indicated; all such lines that meet on the Horizon Line are the virtual images of lines which are parallel on the ground and are equally spaced.

Along any line parallel to the Horizon Line, such as A'–B' on Fig. 3B, spaces between lines of like kinds in the trapezoids are equal. It follows that the scale of an Oblique photograph of level ground is uniform along any line drawn parallel with the Horizon Line.

A vanishing-point, B, in Fig. 4, for example, may be too distant to be found accurately on the drawing board. From the point D at the intersection of the diagonals of the trapezoid 1, 2, 3, 4, a line can be drawn to A, from which it follows that the lines 3–5, 4–6, 5–6–7, 4–D–2–7, A–7–8–9, 3–8–K, etc., can be drawn. But it is better to introduce some measurements of proportions at an early stage. Measured perpendicularly from the line 4–3, the spaces C'–D', C'–E', C'–F', must be proportional to the spaces C–D, C–E, C–F, measured perpendicularly from the line 4–3. If these latter spaces are measured, and C'–E' also, then C'–D' and C'–F' can be found. These measurements are of course in no way associated with the scale of the photograph which, in the case of an Oblique, obviously changes rapidly from foreground to background, as the changing size and shape of the trapezoids shows. But all the lines of the same family as that of a chosen base-line meet it at the Horizon Line, and the spaces between the lines, measured perpendicularly, diminish in proportion with distance as the Horizon Line is approached.

Similarly, if both vanishing-points are distant, as in the case of a Low Oblique on which the trapezoid 1, 2, 3, 4, is itself almost a square, proportional parts of perpendicular measurements from a chosen base-line can be used.

In some circumstances it may be necessary to find a line parallel to the

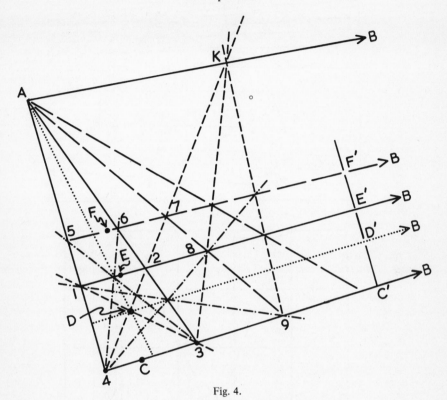

Fig. 4.

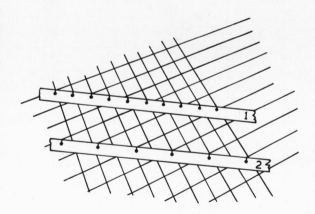

Fig. 5.

8

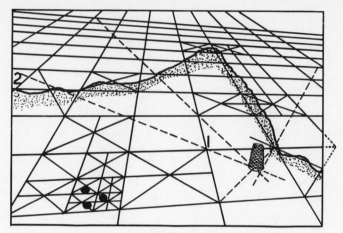

Fig. 6A.

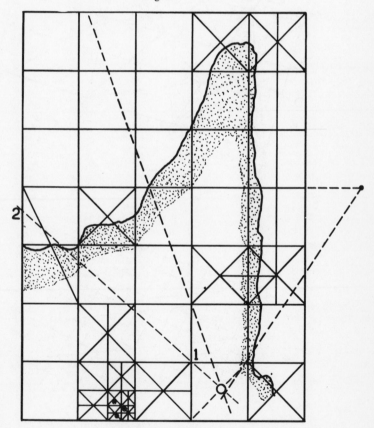

Fig. 6B.

Horizon Line, although the Horizon Line itself is too distant to be found directly. One can make use of the fact that the scale is uniform along any line parallel to the Horizon Line. Figure 5 shows two strips of paper, 1 and 2, marked with arbitrary equal spaces, laid on an array of trapezoids that are not very far from being squares.

The equal spaces of strip 1 have been fitted into one family of lines and, as a check, those on strip 2 have been fitted into the other family. Both strips (if they are parallel, as they should be) are then parallel to the distant Horizon Line.

An alternative method for finding a Horizon Line parallel is as follows: Figure 3A shows that if from any convenient point z on the line 4—2, a line parallel with the line 3—A is drawn, it will cut the line 4—A at a point A′; if from the point z a line parallel with the line 1—B is drawn, it will cut the line 4—B at a point B′; A′ and B′ are points on a line parallel to the Horizon Line.

Obviously with a Vertical, on which the nominal trapezoids are in fact squares, the Horizon Line has no particular direction, but is circumambient.

The plan (Fig. 6B) made from an Oblique of about 65° (Fig. 6A) shows how, by identical straight-line sub-division of trapezoids and squares of the plan-grid, and by the use of alignments such as 1—2, details may be transferred from photograph to plan. The position of the distant point of an alignment, e.g. the point 2, can be estimated.

It is generally better to work on a perfectly clear transparency fastened to the photograph rather than on the photograph itself. The very thin variety (without imbedded wires) of the ironmongers' material called "Claritex" is good enough for this purpose and it is cheap. A fine-pointed scriber can be used as a drawing tool and a completed array of trapezoids can be pricked through to the photograph and marked in ink. If this is done it is better not to draw ink lines where the lines on the ground that they represent could not be marked; for instance, a line should end at the foot of a wall standing across its path, and then continue beyond. If the lines are drawn straight through solid objects some of the useful impression of actuality is lost.

If the photograph shows shadows, it is helpful to position the working light so that it illuminates the photograph in much the same way as the sun illuminated the ground.

Figures 6C and 6D illustrate arrays of trapezoids constructed on low-level Obliques of practically level ground, taken from a small aircraft flying at about 100 knots. The camera had a focal-plane shutter, moving in the direction of flight during an exposure of 1/200 sec.

The word Trapezoid in use here—not in error for Trapezium as may be argued (authorities differ and can be found to contradict themselves as well as each other)—for the plane projection of a grid of squares. Such a projection is also commonly known as a grid or, by scholars, as a Möbius Grid. But to many people the word grid suggests rectangles, and usually squares. It seems sensible to use different names for things that are different. Hence, here, we shall use the term *Grid* for squares or other rectangles on a plan, and *Trapezoid* for their representation on a (usually oblique) photograph.

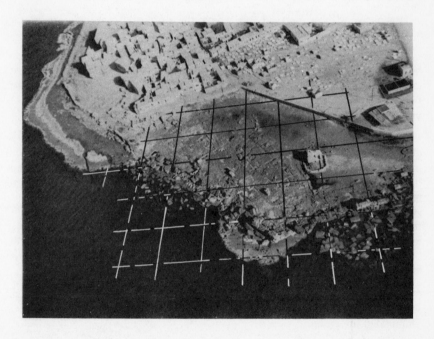

Fig. 6C. Part of a print from 35 mm film. Obliquity of the photograph 42½ degrees (a low Oblique). Taken from a height of 170 metres. The constructed array of trapezoids is the virtual image of a grid of 20-metre squares on the ground. Part of the island of Arvad. (Photograph by Honor Frost.)

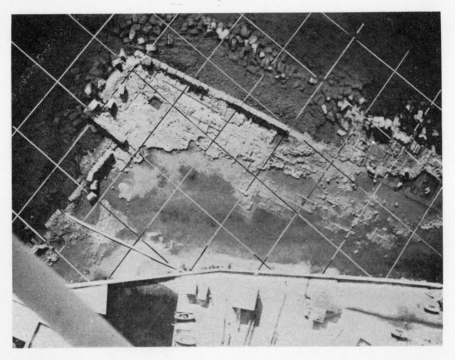

Fig. 6D. Part of a print from 35 mm film. Obliquity of the photograph 11½ degrees (a near-Vertical). Taken from a height of 160 metres. The constructed array of trapezoids is the virtual image of a grid of 20 metre squares on the ground. Part of the island of Arvad. The grid is part of the same system as that shown on Fig. 6C. (Photograph by Honor Frost.)

Chapter 2

Creating the Image of a Square, Set Out on Level Ground

If four well-spaced identified points with known relative plan-positions are marked on a photograph of level ground taken from a height, these four points may be used to find, on the surface of the photograph, the positions of the four corners of a square, such as might have been set out on the ground and then photographed.

The method (introduced into photogrammetry by S. Finsterwalder, according to Dr. Schwidefsky (1)) is sometimes referred to as that of using anharmonic ratios, but the term "paper-strip method" is more appropriate.

Figure 7A is a piece of a blank plan-grid, on which four fixed points, K, L, M and N have been plotted. The four corners of a grid-square are marked 1, 2, 3 and 4.

Take Fig. 7B as an oblique photograph on which the four known points K, L, M, N, have been identified and marked.

To transfer the grid-square from the plan to the photograph, draw solid lines on the plan, running from K, through L, N, and M; and dash-and-dot lines through 2, 3, 1, 4. Lay a strip of paper (paper strip one) on this family of lines, as shown; on the edge of this paper strip mark L, 2, 3, N, 1, 4 and M. On the photograph, draw solid lines running from K, through L, N, M. Transfer the paper strip from Plan to Photograph, and lay it across the lines running from K. Position it precisely where each point on its edge meets the line on the photograph that bears the same letter; only one such position exists. Then pin it to the drawing-board. Draw dash-and-dot lines from K, to the points 2, 3, 1, 4, on the paper strip. Unpin the strip and remove it.

On the plan, now called Fig. 7C, draw solid lines from N, through M, K and L, and dotted lines through 4, 3, 1, 2. Extend the line running to point 3 (which in this particular case lies on the side of N remote from the paper strip) in reverse, as shown. Lay a new paper strip (paper strip two) on this family of lines. On its edge mark 4, M, 3, 1, K, 2 and L.

On the photograph, (now Fig. 7D), draw solid lines from N, to cut M, K and L. Transfer the paper strip from Plan to Photograph, and lay it across the lines from N; as with paper strip one, position this where each mark on its edge meets the line with the same letter; only one such position exists. When the paper strip is in this position, pin it down. Draw dotted lines from N, to the points 4, 3 (this line must be extended to the far side of N), 1 and 2 on the paper strip. Unpin the strip and remove it.

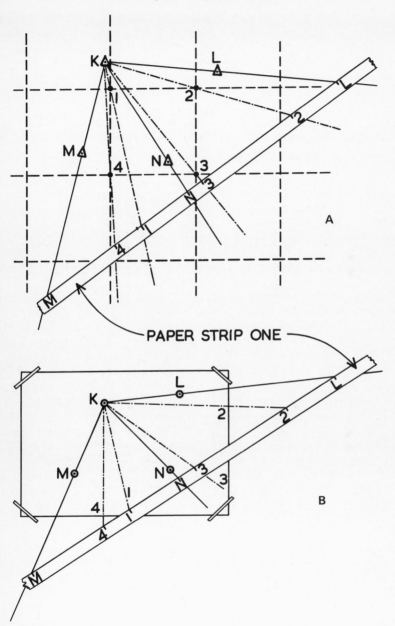

PAPER STRIP ONE

Figs. 7A and 7B.

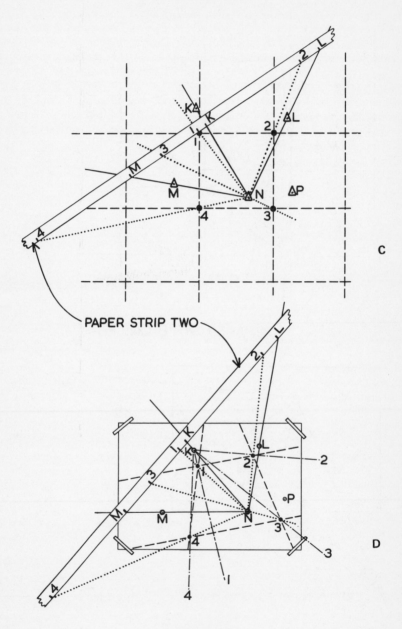

PAPER STRIP TWO

Figs. 7C and 7D.

On Fig. 7D, the intersection of a dash-and-dot line with a dotted line determines the position of a numbered point. To avoid any possible ambiguity, it is as well to number the dash-and-dot lines, as has been done on Fig. 7D; mark the four points whose positions have now been determined and number them 1, 2, 3 and 4. These four points are the virtual images, on the photograph, of the four corners of the grid-square numbered 1, 2, 3 and 4, on the plan. If that grid-square had been marked out on the ground and then photographed, the images of its four corners would have appeared on the photograph at the points now marked and numbered. Through these points draw dashed lines, as shown in Fig. 7D; the photograph is now at the stage of Fig. 1B in Chapter 1.

For a check on the work repeat the procedure working from, say, L. The result should be a perfect three-line intersection at each numbered point. A failure to produce a perfect three-line intersection would be due solely to imperfect work in plotting. A perfect three-line intersection only proves that the plotting has been well done. It is no proof that the control points are correctly plotted on the plan; or that they are correctly marked on the photograph.

This may be shown by carrying out an experiment. Plot four points at random in the form of a trapezoid on a piece of paper and label it "Plan". Name the points A, B, C and D clockwise. Plot a fifth point, at random, in the vicinity of the four; name this E. On another piece of paper, labelled "Photograph", plot four points at random, but in the form of a trapezoid, and name these a, b, c and d clockwise. By the method described, transfer the point E from Plan to Photograph, intersecting it with rays from all four points.

If the work is carefully done, the result will be a perfect four-line intersection on the Photograph, representing the position of E transferred.

To obtain an absolute check on the accuracy of the plan-positions (and on the identifications,) it is necessary to introduce a fifth control point, such as the point P, shown on Figs. 7C and 7D, and to work with, say, the four points P, M, K and L, using exactly the same procedure as before.

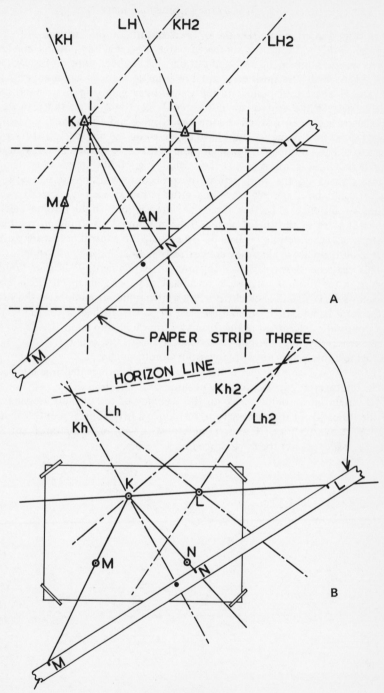

KH LH KH2 LH2

K L L

M N N

A

PAPER STRIP THREE

HORIZON LINE

Kh2

Lh

Kh Lh2

K L L

M N N

M

B

Figs. 8A and 8B.

1. Finding the Horizon Line, by Paper-Strip Method

If the image of a square is transferred from the plan-grid to an oblique photograph, that image may be used to find the position of the Horizon Line, as has been shown in Chapter 1. But in some cases it may not be necessary to transfer the plan-grid to the photograph, but only to find the Horizon Line.

On Fig. 8B, a photograph, draw a line Kh, through the point K, to somewhere around the upper left-hand side. By the use of a paper strip (paper strip three) as shown, transfer this line to the plan, Fig 8A. It appears there as the line KH; parallel to KH draw a line LH. Transfer LH to the photograph; it appears there as Lh. The intersection of Kh and Lh will be a point on the Horizon Line because Kh and Lh are the images of lines which are parallel on the ground. Repeat the procedure, working at the upper right-hand side of the photograph; draw a line Kh2, through the point K; transfer this line to the plan, where it appears as KH2; draw a line LH2 through L, parallel to KH2; transfer this line to the photograph,

Fig. 9A.

Simple Photogrammetry

Fig. 9B.

Fig. 9C.

where it appears as Lh2. The intersection of Kh2 and Lh2 will be a second point on the Horizon Line. The work should be checked by using some points other than K and L to find another point on the Horizon Line. As with the transfer of a square from plan to photograph, agreement of the results of work from four points proves nothing except that the plotting has been well done.

2. Plan-Figures Other than Squares

Square grids on plans have the advantage of being simple to draw and easy to plot on, and it is for this reason that it is usually best to use trapezoids that are the virtual images of squares. However, figures other than squares can be used to save time.

Figure 9A is part of a square-gridded plan, with control points A, B, C and D (It may be supposed for the moment that the plan is otherwise blank.) Figure 9B is an oblique photograph on which the four control points have been identified and marked a, b, c and d. The details are to be transferred to the plan. In the circumstances of four well-placed control points being available, only a small area to deal with, and, it is assumed, no necessity to transfer the plan-grid to the photograph, a portion of the grid on the plan can be erased, as it were, and a temporary net of irregular quadrilaterals substituted for it. The points A, B, C and D, on the plan, can be treated exactly as if they were the four corners of a trapezoid on a photograph. If a, b, c, d, on the photograph are treated in exactly the same way, each resulting trapezoid on the photograph will be in harmony with the corresponding trapezoid (irregular quadrilateral) on the plan. The resulting network of lines can be used to transfer detail in the ordinary way.

If one of the control points had been wrongly placed for use in the manner described, one point in a better position could have been marked on the plan and transferred to the photograph by the paper-strip method. It must be realised, of course, that the lines drawn on the photograph are not in this case the images of parallel lines, and that the line joining the vanishing points is certainly not the Horizon Line.

When the work of transferring detail to the plan is complete, the temporary net of irregular quadrilaterals can be erased, and the regular plan-grid drawn over the work.

Another method which may be useful calls for five control points. Figure 10 represents both; a pentagon of five control points on a plan and the five points as they appear on the photograph. On Photograph and on Plan, any points of the figures resulting from drawing straight lines from point to point across the pentagon may be joined by further straight lines, and so the area of the pentagon and a small surrounding area may be cut up to any desired extent into irregular figures; each of which will be in harmony on the photograph with its correspondent on the plan.

3. Strip or Block of Photography

If a fairly large area of level ground has been photographed from many different altitudes, at different obliquities and from many different view points, and the

photographs everywhere overlap their neighbours; and if there is also an available outline plan of the ground showing the plan-positions of a large number of ground points that can be identified on the photographs, then a grid of squares can be drawn on the plan, and the paper-strip method can be used to transfer this grid to the photographs. On each of the photographs a part will then appear as an array of trapezoids. The lines of the grid can be numbered and lettered in one single comprehensive system, and the corresponding trapezoidal lines can be marked identically. With such a set of prepared photographs, the compilation of a complete plan can be carried out rapidly. Each grid-square will probably be seen from at least two view-points, and some from several.

Although in the ordinary course of events, four well-placed control points are required for each photograph, on some there may be fewer than four, or none at all. However, trapezoidal lines can be copied from controlled photographs onto others that are short of control points. This can be done by using the small detail evident in the overlaps. A trapezoidal line is the virtual image of a grid-line supposed to be painted on the ground, and it must appear in the same place from any view-point. In such a group of photographs, those that are nearest to being Verticals, and have good control, will naturally become the master-photographs.

With four control-points A, B, C and D, it will not invariably be the case that the internal angles of the figure will be like right angles. One may be greater than 180°, say that at D. In this case, ordinarily, rays out of A, B, and C can be used in the usual way in the paper-strip method, but if a ray out of D is required it will be necessary to take not the line running from D through, say, C, but its reverse extension running from C through D. A little practice with the paper-strip method will make this point clear.

On ground that is level overall, and so is suitable for treatment by the method described, one or two of the control points may stand out of the general plane of the ground, on a local eminence or in a hollow. The images of such points will of course be displaced from where they would have been if the points were in the plane. The way to overcome this difficulty is discussed in Chapter 16, Section 2.

4. Uniformly-Sloping Ground

If all of the ground shown on a photograph is at one uniform slope it can be treated as being level ground for plan-position purposes. The actual ground-positions of the control points will lie on one plane to which the horizontal plane on which the plan-grid lies can be considered to have been projected vertically. The horizontal distances between the control points are the distances required for the making of a plan, and naturally remain the same for any slope of the ground. The photo-positions of the control points are the result of point-projection of the sloping ground-plane to the negative and so to the print; the effect of the slope of the ground is essentially the same as the effect of a change in obliquity of the photograph. However, a Horizon Line of the sloping

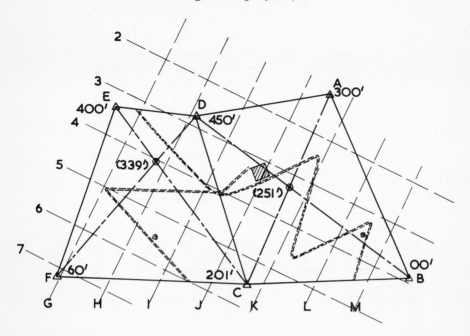

Fig. 10A.

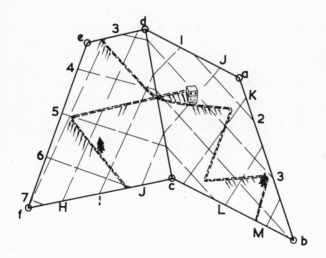

Fig. 10B.

place will not necessarily be anywhere near the true Horizon Line, that of level ground. With this consideration in mind, the paper-strip method can be used to transfer the plan-grid to the photograph, where it will appear as an array of trapezoids which can, in its turn, be used to transfer detail from photograph to plan in the ordinary way. If only a part of the ground shown is at one uniform slope, the part of the photograph that covers it can be dealt with separately from the rest and treated as a separate photograph. In this case, the methods discussed in Section 3 of this chapter may be more convenient than the paper-strip method.

To discover whether four control points of known height above some datum do lie on one plane, it is only necessary to find, by interpolation on the plan, the height of a fifth hypothetical point derived from the four real points. If this height is the same however found, the four real points lie on one plane. For example, if the four real points form a roughly rectangular figure, the height of the cut-point of the diagonals can be found by interpolation on each diagonal; if the two values for the height agree, the four real points lie on one plane. In the case of a four-sided figure A, B, C, D, having relatively small internal angles at A, B, C, but an internal angle at D greater than 180°, so that the cut-point of the diagonal BD with the diagonal AC is outside the figure formed by the four points, the height of the cut-point is found by extrapolation along the BD diagonal and by interpolation along the AC diagonal. In the case of a pentagon of points being used, A, B, C, D, E, if the diagonals of the figure A, B, C, D, show that it lies on one plane, and similarly with the diagonals of the figure A, B, C, E, all five points lie on one plane. In all cases, whether or not it may be assumed that the plane through the control points is in contact everywhere with the ground it is proposed to deal with, can be decided only by inspecting the photograph. A neighbouring photograph may possibly be used for getting a stereoscopic view of a sort, which could be of assistance in this.

Given a sufficient number of well-placed control points of known height, from among which a selection can be made, a hill-slope more or less facing towards the camera can be cut up into two or more facets, each of which can be dealt with separately. If in this work, trapezoids that are virtual images of grid-squares of a single system are used, the trapezoidal lines of one facet will join, usually at an angle, those of one adjoining facet at points along the junction-line. The plan-position of a point on the junction-line can then be found from either array. This is illustrated in Fig. 10A, a plan gridded with 100-foot squares, and showing heights in feet of the control points A, B, C, D, E and F, and Fig. 10B, an Oblique with the control points identified, a, b, c, d, e and f. On the plan, the height of the cut-point of the diagonals of the quadrilateral E, D, C, F, is found to be 339 feet by interpolation between C, at 201 feet, and E, at 400, and the same value, 339, is obtained by interpolation between F, at 60 feet, and D at 450; therefore E, D, C, F, lie on one plane. Similarly with the quadrilateral D, A, B, C, the diagonals of which cut at 251 feet. In this example the facets stand at extremely steep slopes, about 1 in 1.1 on E, D, C, F, and about 1 in 1.25 on D, A, B, C. All of the paths shown zigzagging up the slopes are rising at 1 in 3, except the short branch going to the hut, which is falling at about 1 in 10.

Chapter 3

Principal Distance

If the Principal Distance of a camera is known, the camera is not solely an instrument for making records of aspects, but is also an instrument for making measurements of angles and recording them automatically. Ignoring the negative entirely, it is clear that a photographic print is an aspect projected to a plane as viewed from a point. The plane containing the print can be considered to stand between the view-point and the view. When the plane stands in such an attitude and at such a distance from the view-point, that the projected images, as seen from the view-point, are superimposed on the real objects from which they came, the plane is then at the correct Principal Distance from the view-point. Angles measured at the view-point between the images on the plane have the same values as angles measured at the view-point between the real objects themselves. This Principal Distance can be called the Principal Distance of the print. It is what can be called the Principal Distance of the camera, multiplied by the degree to which the print is enlarged from the size of a contact print.

The Principal Distance of the camera can be described as the length of the perpendicular from the image-node of the lens-system to the focal plane, in which the negative stands. The image-node can be regarded as coincident with the object-node, so that the lens-system, however complicated in fact, is effectively a point or pin-hole through which rays of light entering the camera pass in straight lines to the negative. Then the Principal Distance of the camera is the length of the perpendicular from this hypothetical pin-hole to the plane in which the negative stands.

The Principal Distance of a survey-camera is a fixed quantity, since such a camera is used only to photograph things that are far off. The camera is permanently set at "infinity". The prints from such a camera are normally at contact size, and are large, such as 6 inches, or 9 inches, square. In the kind of work discussed here, the use of ordinary small hand-held cameras is presupposed and the "infinity" setting will not be used invariably. Contact prints would be far too small to work on. The term Principal Distance (of the camera) as used here, means the Principal Distance appropriate to a given distance-setting. For the Principal Distance of the print, the term Equivalent Principal Distance is used here; this is the Principal Distance (of the camera at a given distance-setting) multiplied by the degree of enlargement of the print from contact size.

It can be assumed that a ray of light that passes through the hypothetical pin-hole (here named p) perpendicularly to the negative, travels in the optical axis of the lens-system and impinges on the negative at the Principal Point,

which is here named P. It can be assumed also that P lies at the geometric centre of the negative, and so is reproduced at the geometric centre of a print made from the whole of the negative. Since the Principal Distance measures the space between p, and P on the negative, this distance can be called pP. The Equivalent Principal Distance of an enlarged print can be called epP.

The epP for a given print at a known degree of enlargement taken at infinity, can be found experimentally and so pP at the infinity setting is immediately discoverable. Values of pP for other distance-settings can be derived easily.

1. Example of Experimental Measurement of Principal Distance at Infinity

Figure 11A shows a Horizontal taken with camera resting on a level support. It is from a print of the whole negative, and the point P has been found by drawing diagonals. It shows Rod 3 and Rod 4, surveyor's poles, standing vertically on a piece of level ground. To get these rods into position to left and right of the view, a Rod 1 was placed to the left, (as seen in the view-finder) at a distance of 200 feet or so, and similarly a Rod 2 was placed at the right of the view. A measurement of exactly 300 feet from the front of the camera lens, along the line through Rod 1, established Rod 3; and similarly Rod 4 was established at a distance of exactly 300 feet along the line through Rod 2. Rods 1 and 2 were then removed. The distance between Rod 3 and Rod 4 was then measured and found to be 191.2 feet. The 300-foot measurements were made, nominally of course, from p, whose precise position in the camera was unknown; however uncertainty of an inch or so in 300 feet is negligible.

Figure 11B represents a plot of the relative positions of p and the rods at a large scale. On the photograph, Fig. 11A, the distance P to Rod 3 measured 88.3 mm; P to Rod 4, 93.3 mm. These distances were plotted on a line 3—P—4 on a transparency, and a line P—p of unknown length was set off from P at right angles. The transparency was fitted to the drawing, Fig. 11B, with 3 on the line p—Rod 3, 4 on the line p—Rod 4, and the line P—p cutting p. P was then pricked through to the drawing, and it was found that the distance P—p measured 270.0 mm. This is the epP of the print. (What has been done here is to insert the photograph into the position appropriate to it between the lines p—Rod 3 and p—Rod 4. The line 3—P—4 on Fig. 11 B may be called the Trace of the Positive Plane; in this line, the photograph can be considered to be standing vertically, the drawing being laid horizontally. The photograph itself then stands in the Positive Plane; the negative plane stands of course on the other side of p where the line Rod 4—p prolonged will cut the negative image of Rod 4, and where similarly the line Rod 3—p prolonged will cut the negative image of Rod 3.)

The width of the negative was 36 mm and the width of the print 200 mm. The degree of enlargement was therefore 200/36 = 5.55 (which was verified by the rod-space on the negative and on the print, 181.6/32.7 = 5.55. A difference would have suggested a masked print.) Since epP = 270.0 mm, pP = 270.0/5.55 = 48.65 mm. The lens, incidentally, was of nominal 50 mm focal length as marked

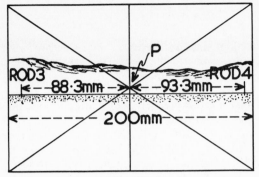

Fig. 11A.

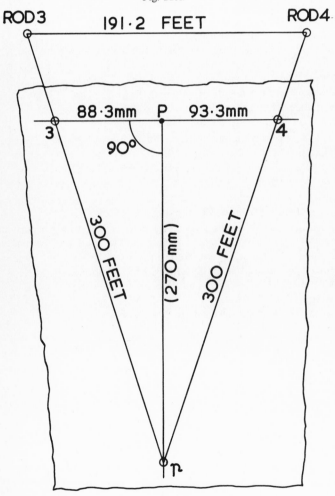

Fig. 11B.

on the housing: makers of small inexpensive cameras do not ordinarily expect them to be used for photogrammetric purposes. They set the focal-plane correctly for the lenses supplied. The pP for settings of other than infinity can be found well enough from the physical forward movement of the lens-housing. It may not be easy to measure this precisely, but it is not vitally important since objects photographed at these settings would be at close proximity. If the overall movement can be measured fairly well, the intervening movements can be interpolated by a consideration of the angle through which the lens is rotated to different settings, and this angle can be found with a small protractor.

In the case illustrated the results were: infinity, 48.65 mm; 6 metres, 49.2 mm; 3 metres, 49.8 mm.

In practice, it is usually found that the results are practically independent of aperture-setting. This is not precision-work.

In another case, with a lens of nominal 35 mm focal length, the results were: infinity, 36.50 mm; 10 metres, 36.64 mm; 5 metres, 36.76 mm; 3 metres, 36.95 mm. The second place of decimals is not really an indication of the precision of the results. With pP and the degree of enlargement known, epP, for a given print, can be found at once. Then the print can be used to measure angles at p, since the distance from P on the print to an image-point, divided by epP, is the tangent of an angle measured at p. p is the radiant-point of an infinite number of lines which make immediately-ascertainable angles with the line p—P. Such angles are, of course, very useful. As a simple illustration, the vertical angle, measured at the camera, to the sky-line on Fig. 11A (assuming that the camera was perfectly level) is found from the measurement to the sky-line from P; 16.0 mm; tan vertical angle = 16/270 = 0.059 by slide-rule; the angle is $3°-24'$.

The required epP can be found graphically as described, to the accuracy with which the measurements on the negative and on the print can be made. It is necessary to plot at a large scale, and sometimes this may be inconvenient. The epP can be found by calculation easily enough. For example, the angle 3—p—4 (Fig. 11B) is found: 191.2/2 = 95.6, and 95.6/300 = sin ½3—p—4 = 0.3187 = sin $18°-35'$; 3—p—4 = $37°-10'$.

By protractor on a small plot, 3—p—P = $18°$ -10': then P—p—4 = $9°$ -00', approximately.

1st approximation

log 88.3 = 1.9460	log 93.3 = 1.9699
log cot 18°-10' = 0.4839	log cot 19°-00' = 0.4630
log epP = 2.4299	log epP = 2.4329

rate of change in cotangents per minute = 4, with both angles. Sum of rates of change = 8

$$
\begin{array}{r}
2.4329 \\
2.4299 \\
\hline
8)\quad 30 \\
\hline
4\ (\text{minutes})
\end{array}
$$

2nd approximation

log 88.3 = 1.9460	log 93.3 = 1.9699
log cot 18°-06′ = 0.4856	log cot 19°-04′ = 0.4614
log epP = 2.4316	log epP = 2.4313

3rd approximation not required: epP = 270.0 mm.

This method of successive approximation by dividing the difference of the two log distances by the sum of the rates of change in log cotangents for 1 minute, is derived from one case of the Evans Method (after S. E. Evans) for the rapid solution or problems in resection (see Chapter 14). In the Evans method, sines of the angles at points such as 3 and 4 (Fig. 11B) are used; the angle 4–P–3 (180° in the present case) being known, and the angles at p having been measured, the sum of the angles at 3 and 4 can be easily calculated, since the sum of the known and unknown angles is 360°; the distance p–P is then calculated from the known distances P–3 and P–4 by successive approximation, the calculation of course producing also the values of the angles at 3 and 4.

Prints made commercially are very often masked to an extent of about 3 mm at sides and 1½ mm at top and bottom. Then it is often difficult to find the degree of enlargement and impossible to find P definitely. This trouble can be overcome by marking negatives with a sharp scriber or other similar fine pointed

Fig. 12.

instrument. Figure 12 shows a suitable method of marking. The diagonal lines find P and the vertical lines can be used to find the degree of enlargement. To mark a negative in this way is to provide the print with fiducial marks, such as appear automatically on survey-photographs. These, because they have such marks and are taken with cameras of precisely known Principal Distance, are called Photograms to distinguish them from photographs: photographs are records of aspects only, photograms records of angles as well. Photogrammetry is primarily the work involved in making use of the angles between points of the aspects.

Chapter 4

Heights from a Single Oblique

The Principal Distance, pP, found in Figs 11A and 11B was that of the camera used to take the photograph Fig. 1D. The epP of the print is 288.2 mm (If the scale of mm attached to Fig. 1D is used, it will be found that the width of the print is about 140 mm. Then since it was taken on 35 mm film, (the negative of

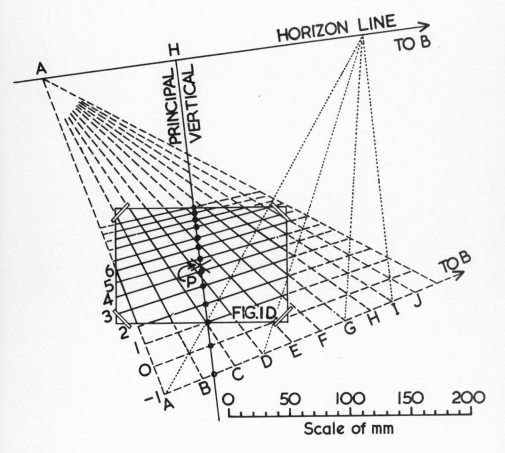

Fig. 13.

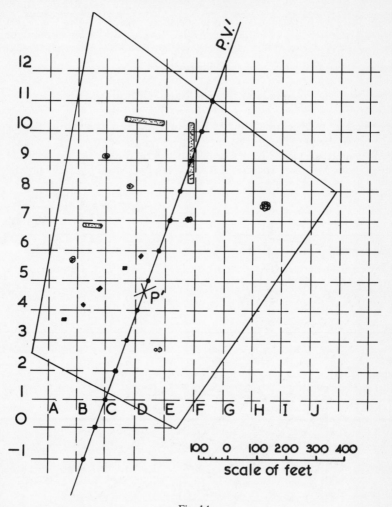

Fig. 14.

which is usually 36 mm wide) it would appear that the degree of enlargement was 140/36 = 3.88, so the epP should be about 49.0 x 3.88 = 190.1 mm. But the print had been trimmed considerably to give it a more realistic appearance. The epP and the place of P were found before the trimming was done. If it be supposed that the trapezoids on it represent 100-foot squares, the heights of the walls, tower, etc. shown on it, can be found in those terms.

Figure 1D, with its array of trapezoids,, Horizon Line, and point P, is reproduced in Fig. 13; the photograph is on the drawing-board which itself is

then in the Positive Plane. At right angles to the Horizon Line, the "Principal Vertical" is drawn through P. The Principal Vertical is the trace of the Principal Plane, which is a vertical plane that cuts the Positive Plane perpendicularly in P, and so contains p; that is to say, it contains the camera.

The plan, Fig. 2, is reproduced as Fig. 14. To this, the line of the Principal Vertical has been transferred by the use of the trapezoids and the corresponding grid-squares; the line is marked P.V.'; it is the trace of the Principal Plane on the plan. The spaces along P.V.', between the grid-lines, scale 105 feet.

A Principal Plane section, that is, an elevation of the Principal Plane, can now be drawn; (Fig. 15). The epP, 288.2 mm, is set off from p to P. Through P, the Trace of the Positive Plane is drawn at right angles to p–P. (The Trace of the Positive Plane can be considered to be the Principal Vertical seen from the side.) To this, the various cut-points of the trapezoidal lines on the Principal Vertical on the Positive Plane are transferred by the use of the distances from P, and a ray out of p is drawn through each transferred cut-point. Spaces of 105 feet to the plan-scale are set off along the edge of a paper strip, which is then fitted into the lines radiating out of p. Thus the P.V.' line is transferred from the plan to the Principal Plane section. If now, the distance P–H on the Principal Vertical is transferred to the Trace of the Positive Plane, it should be found that a line p–H is parallel to P.V.'

The line p–H is the trace of the horizontal plane through p; the line P.V.' is the trace of the horizontal plane in which the plan stands. (But there is no

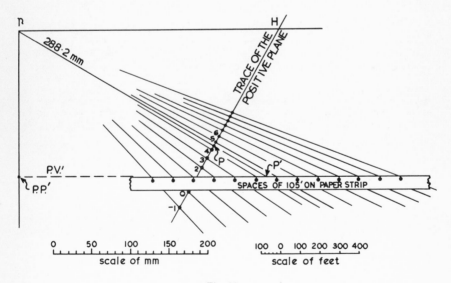

Fig. 15.

objection to regarding it as the trace of the horizontal plane in which the level ground itself stands.)

A perpendicular from p to P.V.′ is the Plumb Line; it finds P.P.′ the Plan Plumb Point, that is to say the plan-position of the point vertically beneath p–effectively, beneath the camera. The prolongation of the line p–P finds P′ on P.V.′ P′ is the plan-position of P. The angle made by the Trace of the Positive Plane with the line p–H–or, what is the same thing, with P.V.′–is the obliquity of the photograph; O. O in this case is 60°. The distance p–P.P′ is the height of p above ground to the scale of the paper strip. In this case the height is 725 feet.

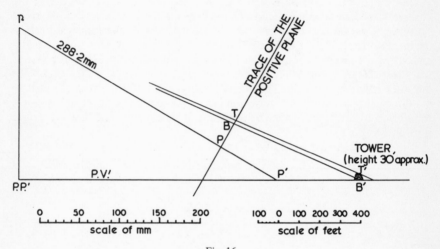

Fig. 16.

Figure 16 is Fig. 15 cleared of lines no longer required. The height of the tower-like building in Fig. 1 is assumed to be necessary. Figure 17 is another print of the same epP as Fig. 1D. To the Principal Vertical, as taken from Fig. 13, perpendiculars are let fall from the top and from the foot of the tower, finding the points T and B. From P to B scales 33.8 mm, from P to T 38.5 mm. These distances are set off from P on the Trace of the Positive Plane on Fig. 16, so finding the points T and B. Rays drawn from p through T and B to P.V.′ contain the vertical space T′–B′, which is the height of the tower: about 30 feet by the scale of the paper strip, although in fact the drawing is too small to give an adequate measure. The height of a standing-stone in the foreground of the photograph could have been measured in exactly the same way.

In practice the Principal Plane section would be drawn at full scale, so that distances (e.g. P to B, P to T) on Fig. 17, could be taken with dividers and transferred directly to Fig. 16.

There is some advantage in doubling the epP and doubling the distances transferred by dividers. The Trace of the Positive Plane will then usually be so placed that P is close to P'. This tends to keep the work under better control.

To measure, one at a time, the heights of a large number of objects all of approximately the same height would be tedious. In suitable cases it would be simpler to construct what can be called a set of Heighting Parallels.*

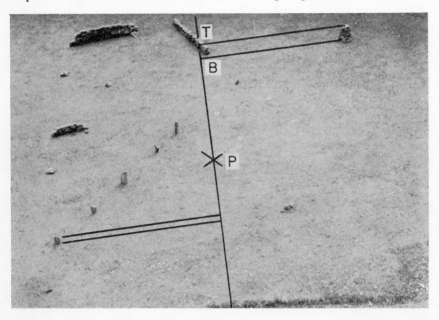

SCALE OF MM

Fig. 17.

Figure 18 is a Principal Plane section prepared for a more enlarged print of Fig. 1A. The epP is now 440.4 mm, otherwise there is no change. Assuming that it had been decided to use a height interval of 40 feet (for the reason that many of the heights to be measured were between 35 and 45 feet) a 40-foot line is drawn at this height above P.V.' (The interval is too great for the objects actually

*Credit for the idea of what is here called "a set of Heighting Parallels" is due to C. H. Seely of the Dominion (of Canada) Forest Service, according to Dr. Trorey (2) who refers to it as a "Heighting Grid".

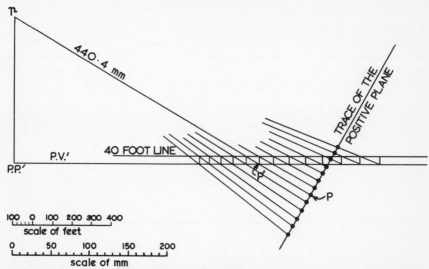

Fig. 18.

SCALE OF MM.
Fig. 19.

shown on the photograph but it will make a good demonstration of the method.)

At P' on P.V.', a vertical is drawn to the 40-foot line; through the point found in this way, a line is then drawn from p to P.V'; from the point found here, a vertical is drawn to the 40-foot line; and so on; and how to proceed in the opposite direction is plain. All of the resulting lines from p, extended, cut the Trace of the Positive Plane at points which can be transferred to the Principal Vertical on the print, Fig. 19. Through these points, lines perpendicular to the Principal Vertical are drawn. The result is a set of Heighting Parallels at 40-foot intervals. If the foot of a vertical object appeared to stand on a line, and the head of it on the next, the object would be 40 feet high. Small interpolations and extrapolations can be made, but not considerable ones. For the objects actually shown, a 20-foot interval would have been suitable, and then only the tower would have been somewhat too high an object to be measured by the use of the parallels.

Figure 20 is intended to illustrate the point. It represents an Oblique of about 45°, taken with a very wide-angle camera. It shows two blocks of buildings standing parallel to the Horizon Line. Each block contains eight buildings of equal width and five storeys of equal height, except that one has seven storeys and one only two-and-a-half. The lines A, B, C, D and E are a set of Heighting Parallels with a 50-foot interval. The background building is exactly contained between lines A and B, and so it is 50 feet high. The gradient of a line running down from the camera to the building would be relatively slight, and it would be found that a simple sub-division of the A—B space measures the true height (or very nearly so) of individual storeys. The foreground block is exactly contained by the lines C and D, and so it also is 50 feet high; but this 50-foot interval cannot be simply sub-divided to find the height of an individual storey; obviously not, for as the block rises, it approaches the camera very appreciably, the images become progressively greater, and the view is very much more oblique than is that of the background block. A line through the summit of the two-and-a-half storey building cuts the C—D space at (H) whereas the mid-point of C and D is at (M). It might be supposed from the positions of (H) and (M), that the height of the building was about 21 feet, whereas it is in fact 25 feet. The summit-line of the tower is at (J), between lines C and B. By extrapolation from the D—C space, it might be supposed that the overall height was 82 feet. By using the lines C and B to measure the excess over the 50 feet between D and C, it might be supposed that the height was 85 feet. The right answer is of course 70 feet. It must be borne in mind that a line such as C stands for two lines, one vertically above line D, the other on the ground vertically beneath line B. An object such as the low building can be measured approximately, but one such as the tower cannot be measured at all by the Heighting Parallels. Its height must be found by means of an individual measurement, as demonstrated with Fig. 16.

In making a small interpolation or extrapolation on photographs taken

with a wide-angle lens, measurements must be taken perpendicularly to the lines of the Heighting Parallels and not along the apparently tilted lines of objects near to the edge of the photograph.

In practice, of course, Heighting Parallels would not be used on a photograph such as Fig. 20. Figure 20 has three other uses: First, to emphasize the fact that along a line parallel to the Horizon Line the scale is uniform, it can be seen that the identically-wide buildings have identically-wide images along the lines A, B,

Fig. 20.

C and D. Secondly, the figure represents a photograph taken with a camera of 90° field-angle, and so the perspective appears much exaggerated. If the figure is laid horizontally, looked at with one eye only from a point vertically above the middle and at a distance equal to half the width, the effect of exaggerated perspective will disappear. (It may help to put a low-power lens in front of the eye, in which case one may find something like a pseudo-stereoscopic effect.) The eye will see what the camera "saw" because the eye will be at p: which is the point at which the eye should be placed to examine any photograph. Thirdly, it will be found that all the lines that are the images of truly vertical lines go to a vanishing point. This point is the Plumb Point, P.P., sometimes called the Nadir point. On a Principal Plane section, such as Fig. 15 (see also Fig. 26) the line through p and P.P.′ is the Plumb Line. This will cut the prolongation of the Trace of the Positive Plane at P.P. (the Photo Plumb Point, called simply the Plumb Point.) Then P.P.′ is the plan-position of P.P., as well as being, as already said, the plan-position of the point vertically beneath p, i.e. the plan-position of p.

From Fig. 18, the spacing of the vertical bars on P.V.' can be calculated from

$$\text{Base N} = \text{Base O}\left(\frac{H}{H-h}\right)^N$$

Where Base N = the distance from P.P.' to the foot of the vertical at N spaces from P'; Base O = the distance from P.P.' to the foot of the vertical at P'; H = height of p above P.V.'; h = height of the height line above P.V.'. Since a power is involved, it is easier to use Logarithms.

$$\log \text{Base N} = \log \text{Base O} \pm N\left(\log \frac{H}{H-h}\right)$$

Taking an example with Fig. 18, Base O = 1250 feet, H = 725 feet, h = 40 feet. Taking N = 7; this is on the side of P' remote from P.P.'; the sign is +.

$$\log H = 2.8603$$
$$\log H-h = 2.8357$$
$$\overline{\log H/H-h = 0.0246 \text{ (constant)}}$$
$$7$$
$$\overline{}$$
$$0.1722$$
$$\log \text{base O} = 3.0969$$
$$\log \text{base N} = 3.2691$$
$$\text{Base N} = 1858 \text{ feet.}$$

The foot of the vertical bar seventh to the right of P' is then 1858 feet from P.P.'. This would control the otherwise purely graphical work.

Chapter 5

Having One Item of Ground Control, or None

On any photograph the extensions of the images of vertical lines either converge to a vanishing-point, or they lie parallel to one another. If they are parallel, the obliquity of the photograph would be 90°; it would be a Horizontal. If they converge to a foreground point, that point would be P.P., the Plumb Point, and the photograph would be an ordinary Oblique. If they converge to a background point, that point could be called the zenith-point and the photograph could then be called an inverted Oblique; the camera would have had to be pointing uphill. If they converge to meet at P, the photograph would be a Vertical (obliquity = zero). In the case of an ordinary Oblique the line through P and P.P. would be the Principal Vertical; in the case of an inverted Oblique, the Principal Vertical would

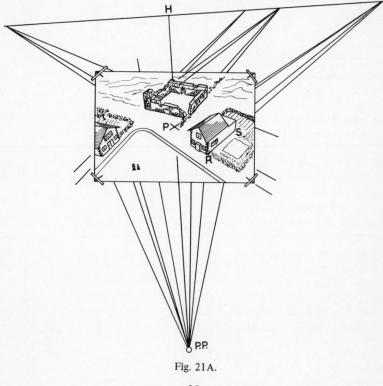

Fig. 21A.

38

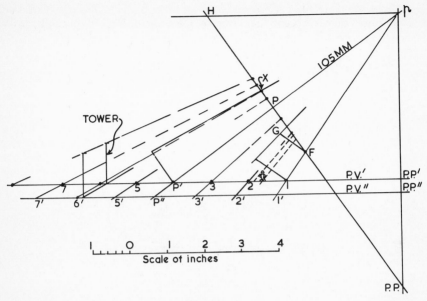

Fig. 21B.

pass through P and the zenith-point. The Principal Vertical on a Horizontal is parallel to the images of all vertical lines.

On any photograph the images of vertical lines are the traces of vertical planes that contain the Plumb Line.

On any photograph other than a Vertical the images of horizontal and parallel lines converge to vanishing-points on the Horizon Line, or, if they are themselves parallel, they are parallel to the Horizon Line. On an ordinary Oblique the Horizon Line is in the background, on an inverted Oblique it is in the foreground, and on a Horizontal it passes through P.

Figure 21A, indicating a low-level Oblique snapshot, was taken for the purpose of making a plan with heights, of a ruin standing on level ground. The epP is 105 mm. The distance between the points R and S, the side of the house, is 47.5 feet. That is the sole item of ground control. The P.P. has been found by the use of vertical lines, and the Horizon Line has been found by using horizontal and parallel lines. The Principal Vertical has been drawn perpendicularly to the Horizon Line through P and P.P. The fact that the Horizon Line cuts the line P–P.P. at right angles is a check on the work.

A Principal Plane section, Fig. 21B, is constructed with p–P 105 mm, and the distance p–H and/or the distance P–P.P. taken from the Positive Plane. A temporary P.V.$'$ line is drawn, parallel to p–H, in any convenient position, and P$'$ is marked on it by the extension of p–P. From P$'$, equal spaces, of, say, 1

inch, are set off along P.V.' These are marked 1, 2, 3, etc., for reference. From each point, lines to p cut the Trace of the Positive Plane at distances from P which can be transferred to the Principal Vertical; through each transferred point, lines parallel to the Horizon Line can be drawn, as on Fig. 21C, which would be a transparency prepared for laying on 21A.

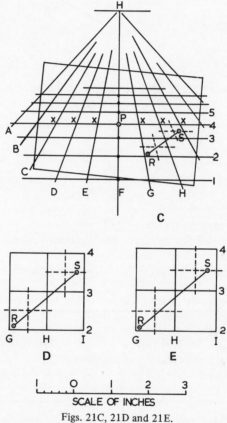

Figs. 21C, 21D and 21E.

On the Principal Plane section 21B, a line of length equal to one of the P.V.' spaces, 1 inch, can be set off from P' perpendicularly to p–P'. From the end of this line, a line to p will cut the Trace of the Positive Plane at the point X. The distance P–X can be taken with dividers and set off repeatedly, as shown on Fig. 21C, along the Principal Parallel, which is the line through P parallel to the Horizon Line. Lines through the several points X, and H, complete the construction of an array of trapezoids. The same result for the latter work would

be obtained by setting off a P.V.′ space perpendicularly from p–1 (Fig. 21B) and drawing a line to cut the Trace of the Positive Plane as shown. The space F–G can be used on the trapezoidal line 1 exactly as the space P–X was used on the Principal Parallel.

A blank plan-grid of squares can be prepared, and given reference numbers and letters appropriately. But since there is a ground-dimension available, it would be more convenient to make a grid consisting of only a few squares first, to cover this. (See Fig. 21D.)

The side-lengths of these squares are of course the same as the P.V.′ spaces, in the present case 1 inch. To this piece of plan, the points R and S can be transferred from the trapezoids. It is found that R to S, 47.5 feet, scales 2.20 inches. Then 1 inch = 21.6 feet. The trapezoids then, are the virtual images of squares with sides of 21.6 feet. If a final complete plan-grid is drawn with squares of 1.08 inch sides, the scale of it will be 1 inch = 20 feet. A piece of the final grid is shown on Fig. 21E. On this, R to S scales 2.37 inches; 2.37 x 20 = 47.4 feet. The fact that the grid squares are at an "odd" size, 21.6 feet, is of no importance for making the plan.

On Fig. 21B, a new P.V.′ line, P.V.″, can now be drawn. On this the spaces, 1′ to 2′, etc., are 1.08 inch = 21.6 feet. The vertical scale for heights, from P.V.″, is of course the plan scale, 1 inch = 20 feet. If the height of the tower in the background is now measured by projection to the Principal Vertical (as with the tower in Chapter 4) and thence to the section, it will be found to be 1.15 inch = 23 feet. If, as a matter of interest, the P.V.′ line is used, as shown, and not the P.V.″ line, the height will be found to be 1.05 inches, and 1.05 x 21.6 = 22.7 feet, in other words the answer, as obtained graphically, is the same. If, in the absence of the R–S distance, the height of this tower had been known, it could have been used to give scale to the section and so to the plan.

In the illustration the important object, the ruin, has been taken too far in the background for the purpose of making a good plan, but the position is fairly good for the heights. A greater camera-height, and a view, just taking in the useful house, would have made a better photograph to work on.

It has been assumed that the place of P, and the epP were known. If they had not been known, they could both have been found.

The house R–S itself produces two Horizon Line points and a P.P. point. The three points form a triangle, in which perpendiculars from the sides to the apices will intersect at P. This is illustrated in Fig. 22*, in which the Horizon Line A–B and the Plumb Point P.P. have been found by the use of the horizontal and parallel lines, and the vertical lines, of a single rectangular building.

It may be seen that if the distances P–H and P–P.P. are known, they can be plotted on the Trace of the Positive Plane in a Principal Plane section, e.g. Fig.

* Gomer T. McNeil (3) is responsible for the idea illustrated by Fig. 22. McNeil says that the method for finding what is here called epP, the Principal Distance of the print, was suggested by E. L. Merritt.

21B, and from P, a line towards p can be set off at right angles. If this plotting is done on a transparency and fitted into the right angle formed by the lines p–H and p–P.P., the points H and P.P. can have only one position if the line P–p is to cut p. Then the epP is found; it is the distance p–P. Also, if the position of P is unknown, but the overall distance H–P.P. is known, and the epP is known, the latter can be set off as an arc of circle with centre p. The H–P.P. distance, marked on the edge of a paper strip, can be fitted to the p–H and p–P.P. lines in

Fig. 22.

a position where it is tangential to the arc. If the obliquity is other than 45°, it will fit in two possible places, one of which can usually be rejected. Then the obliquity is found, and P is found by a perpendicular to H–P.P. from p.

If there is no known ground-dimension at all, it is still possible to make a plan and measure heights but there will be no scale-bar on plan or section. A useful approximation of the scale can sometimes be acquired by measuring in terms of inches or other arbitrary units whatever familiar artifacts or creatures appear in the view. According to the P.V.' line and so to the original 1-inch spacing, the height of one of the people standing in the foreground of Fig. 21A is 0.27 inch. Assuming say, 5.7 feet = 0.27 inch, 1 inch = 21 feet. This would be one version of the side-length of a square of which a trapezoid was the virtual image.

If there are several overlapping pictures of the same general view, each can be dealt with in exactly the same way, but the grid appropriate to each photograph will be quite independent of the others, initially. It would be convenient if at least the scale of these grids were made the same. If according to the grid made for a selected photograph, the distance between two objects is found in inches, it may be adopted as a known dimension for use in the final plotting of the grids for the overlapping photographs. The P.V.' lines on the Principal Plane sections will be amended accordingly, so that heights in parts of an inch as measured on one will agree with the same heights as measured on another, or as nearly as may be with graphical work.

Incidentally, all able-bodied people stand remarkably vertically as a rule. If, from among the images of a group, a selection of slender figures is made, the average central line of them will point at P.P. quite well, and if there are several people in different parts of the view the lines may even find P.P. Young women with pots on their heads are especially valuable in this respect, even when the camera height is a hundred metres or more.

It is not invariably important to know the true relative positions and true relative sizes of objects well-separated from one another. Relative position locally and relative size locally, with a very good idea of the overall situation, may be adequate.

To make a plan is sometimes similar to drawing a portrait in which characteristics are made evident. Of many possible view-points, a plan is full-face. There seems to be no instance of a good full-face portrait being regarded as worthless on the grounds that the artist did not state its scale.

Chapter 6

Use of the Apparent Horizon Line

A high Oblique may show the horizon of the sea or that of an expanse of level land. This would be the Apparent Horizon Line, and on a photograph taken from a considerable height with a wide-angle camera, it may appear as a slight curve*. The true Horizon Line, such as would be found by the images of horizontal and parallel lines, would be slightly above the Apparent Horizon Line, since the former is the trace of a horizontal plane through the camera. If the Apparent Horizon Line is to be used to find the true Horizon Line, this can be done by the use of the vertical angle called the Dip of the horizon.

Assuming a case where the Apparent Horizon Line is a curve, the longest possible chord to the curve is drawn (Fig. 23A), and at right angles to the chord, the Principal Vertical is drawn through P. On the Principal Vertical, the distance P–Apparent Horizon Line is measured, and set off on the Trace of the Positive Plane in a Principal Plane section (Fig. 23C). The angle AH–p–H can easily be determined, using the convenient fact that the angle in minutes of arc = the square root of the camera-height in feet. (The height above ground-level in the case of the horizon of an expanse of level land, or above sea-level in the case of the horizon of the sea.) Thus, H is found on the trace of the Positive Plane, from whence it can be transferred to the Principal Vertical; the true Horizon Line can then be drawn through H at right angles to the Principal Vertical or, what is the same thing, parallel with the chord.

The expression, Dip in minutes = $\sqrt{\text{height in feet}}$, takes into account the effect of refraction of light in the atmosphere between the camera and the Apparent Horizon Line. Figure 23B shows the camera p, the trace of the horizontal plane p–H, the Trace of the Positive Plane P.O., the trace of a plane dipping to the Apparent Horizon AH, and a curved line AH′ to p. C is the centre of the earth and an arc of radius C–AH′ is the earth's surface. The angle D measures the arc from the Plumb-Line p–C, and this arc is equal to the true Dip. But a ray of light radiating from AH′ to p will appear to have come from AH, since it is refracted downward in transit, and it is at AH that the photograph will record it. The coefficient of refraction can generally be taken as approximately 0.94, so that in effect the angle AH–p–H = 0.94 D, in radians. But the angle is small and if the radius of the earth is taken to be 20,900,000 feet and, for

* M. Hotine (4) says "the curvature of the line of the apparent horizon is the trace of a hyperbolic section, made by the cutting of a cone by a plane; the apex of the cone is the camera, and the plane is the photograph".

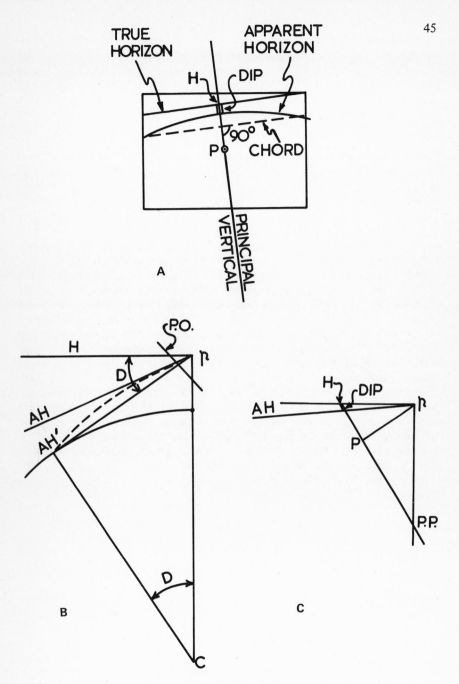

Figs. 23A, 23B and 23C.

example, the height of the camera as 1000 feet, then

$$20,900,000/20,901,000 = \cos$$
$$D = 0.999952 = \cos 0° \text{-}33'; \text{ and}$$
$$33 \times 0.94 = 31 = \sqrt{1000} \text{ approximately,}$$

If a co-efficient of 0.86, or one of 0.92 (both of which are in use in different parts of the world) is used in place of 0.94, the result for graphical work is effectively the same, and in fact much more elaborate calculation will not necessarily give a better answer. It may be seen that the height need not be known very exactly, e.g. $\sqrt{500} = 22$ approximately, $\sqrt{1500} = 39$ approximately, and an error of 8 or 9 minutes will produce a plotting error of only some half-millimetre on a print of about 200 mm epP.

At very low heights above desert land or on the ground, the most ordinary form of mirage may be seen; parts of the bright sky appear to lie below the horizon, and look like extensive lakes of water. The same thing might be found in miniature in temperate lands, on the surface of a black asphalt road for instance. This phenomenon appears to be caused by a local and temporary inversion of the normal air-density decrease with height, the lower air being warmer than the upper. This would cause the curve of the line AH'—p (Fig. 23B) to be inverted. In such conditions, it may be impossible to determine where the Apparent Horizon Line actually is, since it may appear at different heights in different parts of the view.

Strictly, the vanishing-points of an array of trapezoids should be on the Apparent Horizon Line, and the drawn lines (except the principal vertical lines) should be curves, since they purport to be images of squares or other rectangles set out on the ground and then photographed. This can of course be ignored for practical purposes, as can be the fact that it is impossible to set out a square or other rectangle on the surface of a spheroidal body.

Chapter 7

Graphical Conversion of Photograph-Angles to Plan-Angles

If, as with Fig. 21A and 21B, an Oblique of level land itself provides the data for making a Principal Plane section, a P.V.′ line can be drawn on that Principal Plane section, parallel to p–H or at right angles to p–P.P. Any points marked on the Principal Vertical can be transferred to the Trace of the Positive Plane and projected to P.V.′. From there they can be transferred to a P.V.′ line drawn on a plan. Chosen points on the photograph can then be transferred to the plan by the use of angles measured on the photograph, provided that such angles are converted appropriately before being plotted.

In what follows, an angle measured on the photograph, from the Principal Vertical, at a point, e.g. P.P., is called a Pha angle. Its correspondent, for plotting on a plan from P.V.′ at the corresponding point, e.g. P.P.′, is called a PLA angle.

Figure 24A is an Oblique of level land, and Fig. 24B is the corresponding plan. The obliquity of the photograph is 40°. It is assumed that it is required to convert the Pha angle P.–P.P.–M, 15°–40′, to the corresponding PLA angle P.′–P.P.′–M′.

Figure 25A illustrates a construction for the conversion of angles at P.P.

From a base line, perpendiculars P.P.–H and (H)–M are set up at a convenient separation. At (H) the obliquity, O, (40°) is set off and the line (H)–(P.P.) is then drawn.

At P.P., the Pha angle (15°-40′) is set off from P.P.–H, so finding the point M. With centre (H) and radius (H)–M, an arc of a circle is described to cut the line (H)–(P.P.) at (P.P.). From (P.P.) a perpendicular is let fall to find (p) on (H)–M. The angle H–P.P.–(p) is the required PLA angle (20°-10′). With this construction, as with that to follow, the way to make a reverse conversion is self-evident. Also as with that to follow, it is evident that the construction can be made from many different starting-points. If there are several Pha angles at P.P. to be converted, a line (H)–M can be plotted first, then the arc drawn, so finding (P.P.) and hence (p), after which the Pha angle can be set off at M, so finding P.P. Thus there will be a new place of P.P. for each conversion, but the rest remains the same.

With angles at P.P., Pha is smaller than PLA.

Given Pha and PLA at P.P., O can be found, since the difference between the angles determines the ratio of the distance M–(p) to the distance (H)–M. Thus (P.P.) is found and hence the angle O.

To make an angle-conversion at P.P. by calculation, the following expression can be used.

tan PLA = tan Pha sec O

from which it follows that

sec O = tan PLA cot Pha.

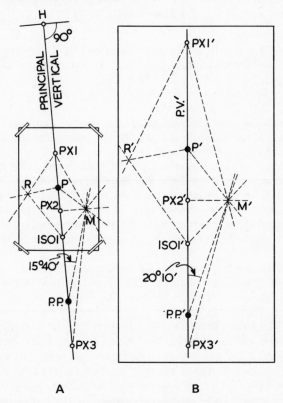

Figs. 24A and 24B.

Thus, as with the graphical method, O can be found from Pha and PLA. (This is usually best done at P and P′, rather than at P.P. and P.P.′.)

In an unusual case the plan-position of P.P.′ may be known. It may be a point on a high cliff shown on an existing fairly detailed plan. If P′ can be identified on the plan by the use of P, the P.V.′ line can be drawn on the plan. If points on this line can be identified on the photograph, the Principal Vertical can be drawn, and the obliquity found by the use of a Pha angle at P and its correspondent at P′.

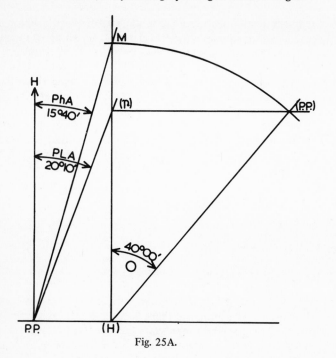

Fig. 25A.

Fig. 25B.

Figure 25B illustrates a construction for the conversion of angles at P. As before, perpendiculars, in this case P–H and (H)–(p), are set up from a base line at any convenient separation, and the obliquity, O, is set off from (H)–(p) at (H). Pha (48°-00′) finds M. An arc of radius (H)–M and centre (H) finds (P) from which a perpendicular to (H)–(P) finds (p). The angle H–P–(p) is the required PLA angle (40°-20′). This angle, with the PLA angle at P.P.′, 20°-10′, fixes M′, the plan-position of the point M of the photograph.

With angles at P, Pha is greater than PLA.

With Fig. 25B, O can be found, given the angles Pha and PLA at P. The difference between the angles determines the ratio of the distance (p)–M to the distance (H)–(p). Since the line (p)–(P) is tangential to the arc of a circle, the angle (P)–(p)–(H) = 90° − O.

To make the conversion by calculation,

$$\tan PLA = \tan Pha \cos O$$

from which it follows that

$$\cos O = \tan PLA \cot Pha.$$

On Figs 25A and 25B the points in brackets, e.g. (P.P.), are so marked because they are points of a Principal Plane section drawn, as a rule, diagrammatically only. The line (p)–(P.P.) represents the Plumb-Line, and the distance (p)–(P) (Fig. 25B) represents the equivalent Principal Distance of the print, epP; (p)–(H) represents the trace of the horizontal plane through p.

Given the data, such figures can of course be drawn to scale, as they are in the illustrations; the distance (P.P.)–(H) on Fig. 25A is the same as the distance P.P.–H on Fig. 24A and similarly with the distance (P)–(H) on Fig. 25B.

If they are drawn to scale and combined, the result is an ordinary Principal Plane section to which can be added a P.V.′ line. This has been done with Fig. 25C. With this construction, Pha angles measured at any point on the Principal Vertical can be converted to PLA angles.

Assuming that it is required to convert the Pha angle M–Px1–P on Fig. 24A, and assuming also that the plan-position of Px1, i.e. Px1′, is unknown; Pha = 25°.

P.V.′ can be inserted into the section because the distance P.P.′–P′ is available on the plan (Fig. 24B) and because P.V.′ must be drawn at right angles to the Plumb-Line, (p)–(P.P.). The distance P–Px1 can be taken from the photograph and plotted from (P), so finding Px1 on the Trace of the Positive Plane, which is the line through (P.P.), (P), and (H). Through Px1 a line from (p) finds Px1′ on P.V.′; so Px1 can be transferred to the plan. An arc with centre (H) and radius (H)–Pxl finds M; at M the Pha angle (25°) is set off, so finding the point 1; the angle (H)–(p)–1 is the required PLA angle, (15°). Similarly a Pha angle measured at Px3 (11°) on the Positive Plane can be converted, and the

plan-position of the point, Px3′, at which the resulting PLA angle (16°-30′) is to be set off can be found.

A Pha angle = 90° obviously "converts" to a PLA angle = 90°. Thus with a point on the photograph, Px2, through which a perpendicular to the Principal Vertical

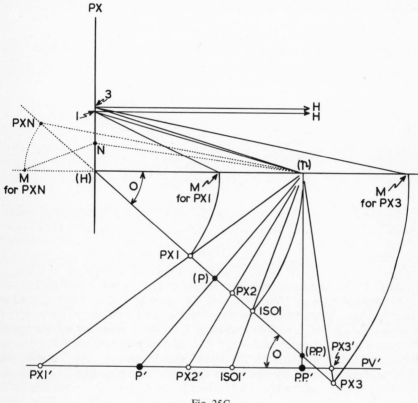

Fig. 25C.

cuts M, it is necessary only to find the place of Px2′ on P.V.′, in order to draw a plan-line Px2′–M′.

Pha is smaller than PLA for points near to P.P., greater for points near to P and for a considerable distance beyond, and smaller again beyond any distance at which angle conversion on Obliques can have any practical use. But from this it follows that there are two points at which Pha and PLA are equal. These points are the Isocentres, and may be named Iso 1 and Iso 2; ordinarily it is only Iso 1 that is of any use. On Fig. 25C, the place of Iso 1 on the Trace of the Positive Plane is found when the triangle (H)–(p)–Iso 1 isosceles; that is to

say, Iso 1 can be found by describing an arc with centre (H) and radius (H)–(p). Then the place of Iso 1' is found on P.V.', and so it can be transferred to the plan. Having Iso 1 on the Trace of the Positive Plane, it can be transferred to the Principal Vertical; (the position may be off the photograph). Any angle measured at Iso 1 can be plotted on the plan at Iso 1', directly, and without reference to Principal Vertical or to P.V.'

On Fig. 25C, the angle (P.P.)–(p)–Iso 1 is equal to half the angle (P.P.)–(p)–(P), and this is true for any Principal Plane section; the bisector of the angle P.P.–p–P finds Iso 1.

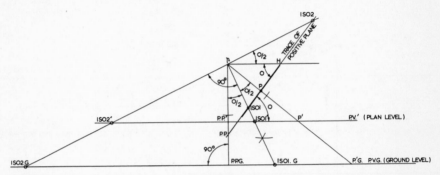

Fig. 26.

The second Isocentre, Iso 2, is seldom of use except on inverted Obliques (Chapter 18) but it is interesting academically and so it is worth mentioning.

A complete Principal Plane section is illustrated by Fig. 26. The plan level in space is shown diagrammatically above the ground level, since the plan is a reproduction of the ground in miniature. It is rarely necessary to distinguish between a point on the ground, e.g. P.P.G., and its plan-position, P.P.', but for these occasions the names on the figure may be used. On the Trace of the Positive Plane a double line represents the extent of a photograph. A point on the ground, P.'G., on the line P.V.G., has a plan-position at P', on the line P.V.', and a photographic image at P on the Principal Vertical. A line on the ground, P.V.G., has a plan-position at P.V.', and the virtual image of the line, on the photograph itself, or continued off it on the Positive Plane, is the Principal Vertical.

Iso 1 on the Trace of the Positive Plane is found by bisecting the angle P.P.–p–P., which is equal to the obliquity, O. A line at right angles to the bisector finds Iso 2, and in a reverse direction, Iso 2'. Angles measured at Iso 2 on the Positive Plane have the same values as angles measured on the plan at Iso 2', but in mirror-image. This effect is best illustrated with a Horizontal photograph, Fig. 27B, its Principal Plane section 27A, and its plan, 27C. The foreground of the photograph has been provided with an array of trapezoids in

order to demonstrate clearly the manner in which the mirror-image effect occurs.

Reverting to Fig. 25C, it is also of some academic interest to observe that if the point Px1 is moved to coincide with (H), no angle-conversion is possible since the point will then be on the Horizon Line point cut by the Principal

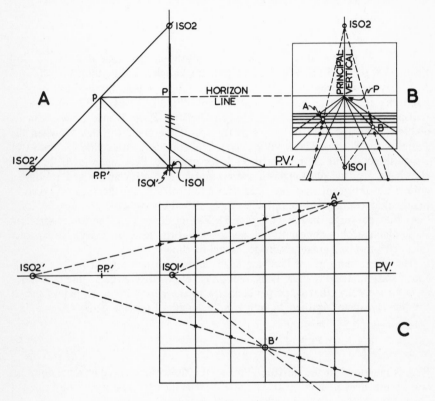

Figs. 27A, 27B and 27C.

Vertical; from this point any drawn lines are the virtual images of parallel lines. But if Px1 were moved to a point Pxn beyond the horizon line and so towards Iso 2, angle-conversion would become possible again. If a Pha angle were set off at M (for Pxn), so finding the point N, then the angle (H)–(p)–N would be the corresponding PLA angle; but, as with the case of Iso 2 in Fig. 27, the result is in mirror image.

With Fig. 25C, to make an angle-conversion by calculation in the case of a Px point, let the distance (p)–(P) = the epP of the print = f. Let the distance

(P)–Px as measured on the Positive Plane = *d*. Then if *d/f* = tan *a*, the angle (H)–Px–(p) = 90° ± *a*. Let this angle be C; if Px lies towards (H) from (P), C = 90 + *a*; if towards (P.P.), then C = 90° − *a*.

The angle Px–(p)–(H) = 180° − (0 + C). Let this angle be D.

$$\text{tan PLA} = \text{tan Pha sin D cosec C}$$
$$\text{tan Pha} = \text{tan PLA cosec D sin C}$$

From which

$$\sin D = \text{tan PLA cot Pha sin C.}$$

With epP known and the distance *d* measured, the angle *a* is known and therefore C is known: then if Pha and PLA are known, O, the obliquity, is found.

It may be seen that the obliquity can be found graphically on Fig. 25C once given Pha and PLA at, e.g. Px1 and epP (p)–(P). The line (p)–Px1 drawn on a transparency on which the Trace of the Positive Plane is also drawn, can be pivoted about (p) until Px1 rests on the arc of the circle through M, when the Trace of the Positive Plane will cut (H). The conditions for doing this with Px1 are quite good, but are poor with Px3, for example. PLA angles at P′, Iso 1′ or elsewhere, are true plan-angles if the ground is level. PLA angles at P.P.′ have a unique advantage in that the lines drawn out of P.P. are the traces of vertical planes that contain the plumb-line, as is also the case with images of vertical lines that converge on P.P. (Chapter 5). For an observer at the camera-station, these planes would appear to cut any ground-form, level or uneven, in straight lines. This can be a great advantage, as will be shown.

The expressions given here for angle-conversion are derived from a simple consideration: If a Principal Plane section is held vertically then a line drawn out of H horizontally, that is, perpendicularly to the paper, is the Horizon Line. If this line is made of unit length, and L is the length of the line p–H,

$$\frac{1}{L} = \text{tan PLA.}$$

PLA is measured in the horizontal plane; it is always measured at some point on one of the lines p–P.P.′, p–P′, or p–Px′. It is measured between the Principal Plane and another vertical plane that intersects it at the point considered, on the line considered. All these lines pass through p. The corresponding angle at P.P., measured in the Positive Plane, is found from

$$\frac{1}{L \sec O} = \text{tan Pha}$$

$$\frac{1}{L} = \text{tan Pha sec O}$$

$$= \text{tan PLA (at P.P.′).}$$

The corresponding angle at P is found from

$$\frac{1}{L \cos \overline{O}} = \tan \text{Pha}$$

$$\frac{1}{L} = \tan \text{Pha} \cos O$$

$$= \tan \text{PLA (at P}').$$

For the corresponding angle at Px, the distance H–Px = cot Pha. The angle H–Px–p is called C. The angle Px–p–H is called D. The angle p–H–Px is O.

$$\cot \text{Pha} = L \sin D \, \text{cosec} \, C$$

$$\frac{1}{L \sin D \, \text{cosec} \, C} = \tan \text{Pha}$$

$$\frac{1}{L} = \tan \text{Pha} \sin D \, \text{cosec} \, C$$

$$= \tan \text{PLA (at Px}').$$

Chapter 8

Alignments

If a photograph shows one thing standing exactly behind another one may presume that the camera was in line with the two. On a plan such alignments can be used to find the point from which the photograph was taken. Rays drawn from this point to objects shown on the plan and on the photograph form a family of angles into which the photograph can be fitted. Thereafter it can be used to measure further angles, which in their turn can be used to find positions or to measure heights.

Fig. 28A.

This is best illustrated at first by a Horizontal taken on the ground. Imagine a practical problem: take Fig. 28A, a snapshot of unknown epP (possibly trimmed) that shows part of a local plan (Fig. 28B); and take Fig. 28C, a piece of a general plan or compilation; add the local plan to the compilation; then add to both the trench shown only on the photograph, and finally measure the heights of the old wall and the local hill, individually.

Working copies of the documents are Figs 28D, E, F. On the photograph all likely vertical lines are parallel, so the obliquity is at least close to 90°, and the photograph can be treated as a Horizontal. The photograph shows no side-ways tilt, but it would not have mattered if tilt had been present. On a Horizontal,

56

Fig. 28 B.

P.P. is at infinity. The vertical lines remain the traces of vertical planes that contain the plumb-line and therefore contain the camera; these planes cut any ground-form in straight lines. The line through the tree (right) and the wall-end can be put on to the plan (Fig. 28E) at once. A line running through the gap between the houses (left) and the centre of the hut can also be added because the horizontal lines of the hut, being nearly perpendicular to the vertical lines, must be almost parallel to the Horizon Line, and so are shown at a practically uniform scale; the centre of the image is at the centre of the hut. These two

100 0 100 300 500
SCALE OF FEET

Fig. 28C.

alignments fix the camera-station on the plan. It comes out on a massive wall, which is a satisfactory result, since the camera was obviously well above the ground.

Above the house BC appears an object A, which it is assumed can be recognized as A on Fig. 28F. The apparent place of A between B and C can be measured on the photograph, for the reason referred to with the hut. This alignment of A with B–C and the camera can then be put on to Figs 28E and

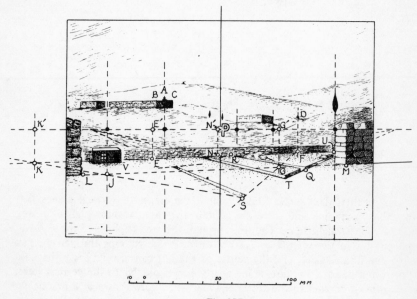

10 0 50 100 MM

Fig. 28D.

28F. On Fig. 28E, the distance along the alignment from the camera-station to BC, scales 487 feet. This can be plotted on Fig. 28F; then a reduced copy of Fig. 28E can be added to Fig. 28F, which disposes of the problem of adding the local plan to the compilation.

On Fig. 28E lines are drawn to corners of the house as shown. This makes a total of five lines radiating out of the camera-station. Perpendicularly to the five

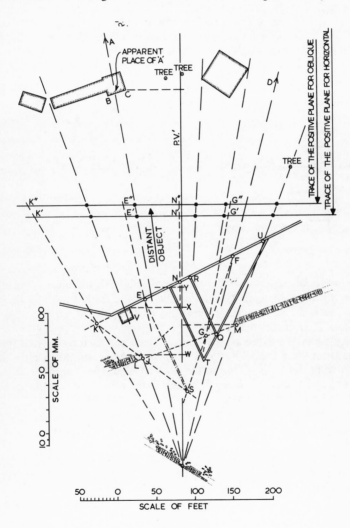

Fig. 28E.

corresponding vertical lines on the photograph, the four spaces formed are
marked on the edge of a paper-strip which can be fitted into the radiating lines
on Fig. 28E, so finding the position of the Trace of the Positive Plane (for
Horizontal). A perpendicular to this, from the camera-station, is P.V.', which can
be transferred to the photograph as the Principal Vertical. The length of the
perpendicular is the epP of the photograph, 208 mm.

Assuming that the ground is almost flat on the camera side of the new wall,
the Horizon Line can be found fairly easily. It will be of course at right angles to
the vertical lines and will pass through P, or very near it. P, however, has not yet
been found. The photograph may have been trimmed.

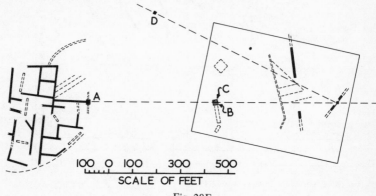

Fig. 28F.

The images of the two parallel trenches on Fig. 28E will meet at the Horizon
Line, as will those of the horizontal parallel lines of the hut roof. But if, on Fig.
28E, a line is drawn from L (at the foot of the old wall, left) parallel to the
trench-line T–Q, it cuts the new wall at N still apparently on level ground. N can
be projected to the Trace of the Positive Plane and then transferred (using its
distance from the Principal Vertical) to the photograph, on which a line through
L and N will meet the T–Q line at the Horizon Line. Then the Horizon Line can
be drawn, and P marked. Since P comes in the centre-point of the print, it is
unlikely to have been trimmed.

On Fig. 28D the trench-end, S, is aligned with T–Q; this alignment can be put
on to the plan (Fig. 28E) and the line L–M can be drawn on both Fig. 28D and
Fig. 28E.

On Fig. 28D, a line S–J cuts the prolongation of the line of the foot of the
new wall at K; a vertical through K finds K', which can be transferred to Fig.
28E, on which a line from the camera-station to K' finds K; J is at the cut of
L–M and the line from the camera-station through the hut; S is on the alignment
of K and J.

Since S is also on the T–Q alignment, S is fixed. A check could be made by

the use of the points F and G, which could be transferred from photograph to plan in the manner used to transfer K. It will be noticed that the fact that the point D (on the vertical through F) is not on the plan is of no significance as it is on the photograph.

On Fig. 28D again, the line of the trench cuts the foot of the new wall at E; a vertical through E finds E', which can be transferred to Fig. 28E, so finding E, through which passes the line of the trench. The end of the trench can be cut off by a line from L to U (the point U being on the vertical through the tree) at the foot of the new wall. The trench is seen to be parallel with the others, and so all three find the same Horizon Line point on the photograph; this is a partial check on the work.

The procedure involved in finding the height of the old wall at M would be as follows: On Fig. 28D take the measurement from the Horizon Line to the foot of the wall (23.4 mm) and from the Horizon Line to the top of the wall (4.5 mm); on Fig. 28E take the distance from camera-station to M (190 feet) and from camera-station through M to the Trace of the Positive Plane (224 mm); then:

If $h + h'$ is the height of the wall,

$$h/190 = 23.4/224$$

$$h = 19.8 \text{ feet}$$

$$h'/190 = 4.5/224$$

$$h' = 3.8$$

So the wall is 23.6 feet high.

Alternatively, on Fig. 28E, a perpendicular can be let fall from M to P.V.'. The camera-station to the foot of the perpendicular scales 177 feet. Since with a Horizontal there is no point in projecting the image in the same way to the Principal Vertical, the measurements below and above the Horizon Line are the same as before. The epP is 208 mm therefore

$$h/177 = 23.4/208$$

$$h = 19.9 \text{ feet}$$

$$h'/177 = 4.5/208$$

$$h' = 3.8$$

It may be noticed that this result for $h + h'$ would be hardly affected if the Horizon Line were drawn out of place by several mm, provided it were still parallel to the true position. The camera-height, above the (apparently) level ground is seen to be 19.8 or 19.9 feet; let us call it 20 feet.

The height of the ground (relative to that below the camera) at the house B–C (31 + 20 = 51 feet) can be found in exactly the same way by either

method, but in such a case there is no up-and-down compensation for a misplaced Horizon Line.

The photograph shows an object D which is on the compilation, Fig. 28F, but not within the limit of the local plan, Fig. 28E. However, on the latter, the angle A—camera-station—D has been measured. If the house B—C were not shown on the local plan, but only on the compilation, this angle could have been used to put first the camera-station, and hence using the alignment to A, the entire local plan, onto it; the angle could be plotted on a transparency and so fitted-in. Having the distance to D, a fair measure of its height could be obtained in terms of the height of the level ground at the trenches. Similarly the height of the top of A could be found.

The photograph also shows a distant skyline object to which a ray has been drawn on 28E; this ray could be put on to the compilation. From some other camera-station position found on the compilation, another such ray, similarly obtained, making a good cut with the first, would fix the position reasonably well. Then, the distances being known, the height could be measured in terms of the height of the level ground at the trenches, and used to find the height of the second camera-station. This might be some miles away from the first. The result would not be more than a fair approximation, but that would not necessarily diminish its value at all. It could prove, for instance, that the second station stood well above the first.

If the height of the ground on which the distant object stood were known in terms of, say, mean level of a virtually tideless sea, and the height of the ground in Fig. 28D were known in the same terms, an approximation of the distance to the object could be obtained by using the height-finding technique in reverse. For example, height of ground at object, 300 feet; height of ground at trenches on Fig. 28D, 2 feet; camera height 20 feet. Height of object above horizontal plane = 278 feet. Image-height of ground at object, above Horizon Line, 30.0 mm. Camera-station to Trace of the Positive Plane, 209.5 mm. If D is the distance, then

$$278/D = 30.0/209.5$$

$$D = 278 \times 209.5/30.0$$

$$= 1940 \text{ feet}$$

It is clear that an error of 2 mm in the position of the Horizon Line will produce an error of about 130 feet in the distance, but the result may still be valuable.

Figure 28G is a very low-level high Oblique taken from a view-point vertically above the camera-station of Fig. 28A. (Some trifling changes in the topography, etc. may have occurred in the interval between the taking of the two views.) Everything done with the Horizontal can be done with the Oblique, except that the distant object is now out of view (See Fig. 28H.)

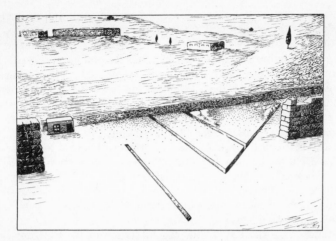

Fig. 28G.

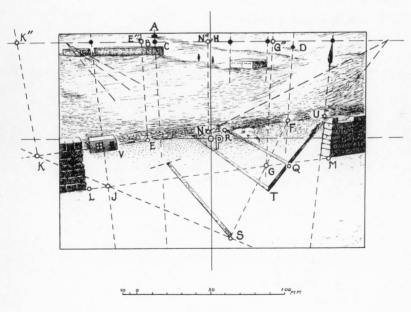

Fig. 28H.

The traces of the vertical planes now converge to a distant P.P., the Horizon Line retreats into the background. (It appears that this photograph also has no sideways tilt.) It is not quite so easy to find the alignment of the hut and the gap between the houses, but if the hut's vertical lines are prolonged upwards and the houses' downwards, the resulting lines make a good guide. The alignment of A and B–C is found easily, as is that of the tree and the wall-end. The place of P.P. can be found well enough by the extension of the gap-hut and tree-wall lines, and this position can be used for drawing all other traces of vertical planes cutting the camera, e.g. those to the sides of the house, to A, K–K″, etc.

The spaces between the cuts of the five principal lines on the Horizon Line can be transferred to the plan, Fig. 28E, by the use of a paper strip as before, so finding the Trace of the Positive Plane (for Oblique). The P.V.′ line can then be drawn and the cut-point on the Trace of the Positive Plane can be transferred to the Horizon Line; through this point the Principal Vertical can be drawn perpendicularly; it should cut P.P.

The distance from the P.P.′ (= the camera-station of the Horizontal) to the Trace of the Positive Plane, along P.V.′, measures 218 mm; this is the distance p–H in a Principal Plane section. From the point H, to P.P., the distance will be found to measure about 735 mm on Fig. 28H. Then 218/735 = cos obliquity, O, = 0.297, from which O = 72°-45′, approximately. In a right-angled triangle P–H–p of a Principal Plane section,

$$P–H = 218 \cos 72°\text{-}45′$$

$$= 64.7 \text{ mm}$$

This can be plotted on the Principal Vertical of Fig. 28H, so finding P. The epP

$$= 218 \sin 72°\text{-}45′$$
$$= 218 \times 0.9551$$
$$= 208.2 \text{ mm}.$$

A considerable change in the H–P.P. distance will not have a serious effect on these figures. The figures could of course, have been obtained graphically almost as well by plotting the Principal Plane section, the useful part of which is shown by Fig. 28J.

On Fig. 28H, for convenience, a line is drawn through P, parallel with the Horizon Line. This line is the Principal Parallel. The distance from the Principal Parallel to the top of the old wall, above M, can be taken with dividers and set off on the Trace of the Positive Plane on Fig. 28J, so finding T, for top. The same can be done with M, the foot of the wall; rays from p to T and M contain the height of the wall. The distance from P.P.′ (= camera-station) to the foot of the perpendicular from M to P.V.′, 28E, is 177 feet; this can be plotted (or transferred with dividers) along p–H of 28J, and a perpendicular let fall to

cut the lines p–T and p–M. The cut on the p–M line finds the level of P.V.'. So it is found that p is 67 feet above ground, and that the wall is 24 feet high. Similarly it is found that the height of the ground at B–C is 50 feet above P.V.', that is to say, above the level-ground height.

On the oblique, 28H, there is a useful vertical alignment. A line parallel to the Principal Parallel and close to it will cut (a) the more distant right-hand corner of the hut roof, (b) the more distant top-corner of the old wall in the left of the view, and (c) the trench-end near N. Then all three points lie in one plane that passes through the camera and is perpendicular to the Principal Plane. On the plan, Fig. 28E, perpendiculars W, X and Y, are drawn to P.V.' These lines on the plan, are the result of perpendicular projection to the plan, of horizontal

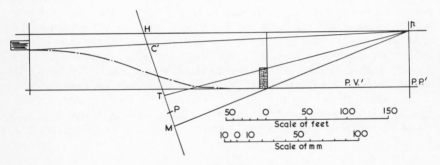

Fig. 28J.

lines in space, that are perpendicular to the Principal Plane. On the plan, from Y to P.P.' (= camera station) scales 223 feet. From Y to W scales 80 feet. If the wall stands 24 feet high, the height of the camera

$$= 24/80 \times 223 \text{ feet}$$
$$= 67 \text{ feet.}$$

The height of the hut can also be found, if required; Y to X scales 22 feet: the height of the hut

$$= 67/223 \times 22 \text{ feet}$$
$$= 6.6 \text{ feet.}$$

As to the matter of using horizontal or vertical alignments, it will be seen that considerations of obliquity, epP and the position of P, enter only secondarily. In the first instance it is only observed facts that are used. In this respect the poorest snapshot will sometimes give as much information as the best possible calibrated photograph could have done.

Chapter 9

Use of the Sun's Shadows

The height of an object standing on flat ground can be found from the length of its shadow if the sun's altitude is known. Conversely a known height and shadow-length will measure the sun's altitude. The true bearing of the shadow of a narrow vertical object is the true bearing of the sun + 180°.

The curvature of the earth in a distance of 10 miles or so can generally be ignored for the present purpose. Within this limit a value for the sun's altitude or bearing found at one place will apply at another place at a given instant. To make use of shadows may involve no more than comparing their images one with another on a single photograph, or on several taken at practically the same instant. Alternatively it may involve the solution of a spherical triangle, the Astronomical, or Celestial triangle. This is not different from any other spherical triangle that can be drawn on a spherical surface with a flat flexible ruler suitably divided, and a small protractor to plot or to read, angles. It can be solved graphically in a moment by the use of a graph or nomogram such as Fig. 31.

1. The Celestial Triangle

Given the latitude of a place, declination of the sun, and the time of day, the sun's altitude can be determined. Or it can sometimes be found given the latitude, declination, and true bearing of the sun. Given the altitude, the latitude, and the declination, the true bearing can be found. The true bearing is usually called the Azimuth.

The apices of the Celestial Triangle are named P, Z, S, as illustrated by Fig. 29. The initials stand for Pole, Zenith and Sun. The triangle is imagined to be drawn on the surface of a sphere of practically infinite radius, the Celestial Sphere.

The earth is imagined to be a very small sphere at the centre of the Celestial Sphere. The polar axis of the earth, that is, the axis of rotation, is prolonged to cut the Celestial Sphere in the north Celestial Pole (near to the star *alpha Polaris*) and in the south Celestial Pole (near to the star *sigma Octanis*). The plane of the earth's equator cuts the Celestial Sphere in the Celestial equator, and the plane of the meridian of longitude on which a photographer stands, or above which he flies, cuts the Celestial Sphere in the corresponding Celestial meridian. The sun is imagined to be a small disc on the surface of the Celestial Sphere.

The side p of the Celestial triangle, Fig. 29 (in which the sun is shown in an

66

afternoon position, with its path indicated by a dashed line), is the co-altitude of the sun; that is, the arc of the Celestial Sphere between Z, the Zenith-point above the photographer, and S, the sun. The co-altitude is then equal to 90° minus the altitude of the sun above the horizon of a given place at a given instant. The side s is the co-latitude of a place, that is, 90° minus the latitude.

The side z is the co-declination of the sun, that is, the arc of the Celestial Sphere between the sun and the Celestial Pole of the earth's hemisphere, on which the photographer stands.

Fig. 29.

Co-altitude, of course, changes continuously during the day whereas co-latitude of a place is constant. Co-declination changes by about 47° in six months, from a maximum of approximately 113° to a minimum of approximately 67°.

The angle P is the local Hour-Angle of the sun. When the sun, in its apparent daily transit from easterly to westerly on the Celestial Sphere, crosses the Celestial meridian (Z–P), of any one place, the Local Hour-Angle is zero; it changes at a practically constant rate of 15° an hour. The angle Z is the Azimuth of the sun (i.e., the bearing), measured from the meridian; it changes relatively slowly during the morning and afternoon, faster about mid-day.

The angle S is called the Parallactic angle. It is of no practical use.

In a Celestial triangle PZS, the sides s and z will generally be determinable immediately. The latitude required for finding co-latitude, s, can be taken from a suitable chart or map. The declination of the sun is given for every day of the year in published astronomical ephemerides. Then, if the Hour-Angle is known, the triangle can be solved for p and Z. Alternatively, if Z is known, it can (sometimes) be solved for p and Hour-Angle; or if p is known, it can be solved for Z and Hour-Angle.

Declination

On the 22nd December, or thereabouts, the sun, on the Celestial Sphere, is above the latitude parallel of 23°-27' south, the Tropic of Capricorn. It is then at the Southern Solstice, a "standing-still" of the sun. Thereafter, each daily apparent circuit of the Sphere carries it northward at an increasing rate. On about the 21st March, it crosses the Celestial Equator, at the Vernal Equinox. The rate of northward movement is then at its maximum. By about the 21st June, the northward movement has ceased, and it is then above the latitude parallel of 23°-27' north, the Tropic of Cancer, and so at the Northern Solstice. The return to the south begins at once. It crosses the Celestial Equator at about the 23rd September, at the Autumnal Equinox. The rate of southward movement is then at its maximum. It reaches the Tropic of Capricorn again on about the 22nd December.

For any one instant of time during this annual movement (which varies slightly from year to year) the arc of the Celestial Sphere, measured along a meridian from the Celestial Equator to the sun, is the quantity that is called the Declination of the sun.

Once given the declination, finding the appropriate co-declination (z) is simple. If the latitude of the place under consideration is north, then in the Celestial Triangle PZS, P will be the north Celestial Pole. If the declination at the date under consideration is south then the co-declination is 90° + declination. If the declination at the date had been north then the co-declination required would have been 90° − declination.

A small, convenient astronomical ephemeris, the *Star Almanac for Land Surveyors* (5) gives the declination for every day at 6-hour intervals of Greenwich Mean Time—G.M.T.—now called Universal Time, or U.T. In this ephemeris for the year, 1967, for example, under Ephemeris of the Sun, for September 27th, and against 00 hours U.T., may be seen S. 1°-16'.3; against 6 hours U.T. we see S. 1°-22'.2 and against 12 hours U.T., S. 1°-28.0. This illustrates what is about the greatest rate of change in declination: 0°-01' an hour. For the purpose of work with shadows it is not necessary to know the time of day exactly, since generally a value for declination that is correct within one degree will do. Then the date is all that is required. If it were thought worth while in some cases, to take a more exact value, it would only be necessary to take the longitude and an approximate time of day into account. The Hour Angle of the sun changes at nearly 15° an hour. This means that the sun moves, apparently, over 15° of longitude in an hour. The sun is approximately over the Greenwich meridian at 12 hours U.T. If a photograph was taken at about mid-day at a place in longitude 70° east, the declination can be looked up for: (12 hours Local Time−70°/15) = 12 hours − 4½ hours = 7½ hours U.T. In practice of course, in this case, a value can be estimated between the value given for 6 hours U.T. and that given for 12 hours U.T. For a photograph taken at about mid-day in longitude 70° west, a value for 16½ hours U.T. would be

required. This could be obtained by estimating between the value given for 12 hours U.T. and that given for 18 hours U.T.

In the absence of an ephemeris, approximate declination can be found by simple calculation. The declination of the sun does not change greatly over several years, for a given date. The earth's orbit around the sun is not circular but elliptical, with the sun in one focus of the ellipse; the earth's distance from the sun is therefore a variable quantity; as is the earths orbital velocity. But the ellipticity is small, so the variables are contained within a small range. From the maxima at the Solstices to the minima at the Equinoxes the change in declination takes a sinusoidal form. The count of days from an Equinox to the date in question, reduced by the proportion that 360 (degrees in a circle) bears

Fig. 30A.

to 365 (days in a year) can be called the arc of orbit from an Equinox, in degrees. The sine, multiplied by the maximum value, will be the declination at the date, approximately.

For example:

(a) 24th February in any year. Taking the date of the Vernal Equinox as 21st March; interval in days, 25. 360/365 = 0.986; 25 x 0.986 = 24.65° = 24°-39'; sine = 0.4171. Calling the maximum declination 23.4°; 23.4° x 0.4171 = 9.76° = 9°-46'. This is south; in February the sun has not come up to the Vernal Equinox. The 1967 ephemeris gives S. 9°-36'.7 for 12 hours U.T. The 1957 ephemeris gives S. 9°-27'.

(b) May 14th. Interval in days from 21st March = 54. 54 x 0.986 = 53.24° = 53°-14′; sine = 0.801; 23.4° x 0.801 = 18.74° = 18°-44′. This is north; the sun is past the Vernal Equinox. The 1967 ephemeris gives N. 18°-31′. 7 for 12 hours. The 1957 ephemeris gives N.18°-52′.

(c) 10th November. Taking the date of the Autumnal Equinox as 23rd September. Interval in days, 48. 48 x 0.986 = 47.32° = 47°-19′; sine x 23.4 = 17.2° = 17°-12′. This is south. The 1967 ephemeris gives S. 17°-02′ at 12 hours; 1957 gives S. 17°-09′. Alternatively, approximate values for declination can be taken grom the graph, Fig. 30A, by taking the interval, in days, elapsed since the Vernal or the Autumnal Equinox.

The Hour Angle.

When the sun is on the meridian of a place, the Local Hour Angle (L.H.A.) at that place, is zero. An hour later, it is 15° west. However, this hour should, strictly speaking, be measured by a sundial, and not by a clock. The sundial keeps Apparent Time, a well-regulated clock keeps Mean Time. The difference in a few hours is small, but over an interval of some months, it may amount to a quarter of an hour. If on the 1st September a perfectly regulated clock is set to read 12 o'clock precisely and then is started at the instant when a correctly constructed and accurately set-up sundial reads 12 o'clock, the sundial will be fast by ten minutes on the clock at the end of the month. By the end of October the sundial will be fast by 16 minutes on the clock, but at the end of December sundial and clock will agree. On about the 12th February the sundial will be approximately 16 minutes slow on the clock, but by mid-April it will have caught up, and thereafter it will gain a little and lose a little, until it reaches agreement again in September. The mean length of a day as measured by clock and dial throughout the year is the same, and hence the term Mean Solar Time, or Mean Time, which is the time kept by a well-regulated clock.

A clock that keeps Mean Time perfectly, and that happens to stand on the Greenwich meridian, is keeping Greenwich Mean Time, which is Universal Time (U.T.). The difference between what such a clock says at any instant and what a nearby accurate sundial might say at the same instant is the Equation of Time, E.

E is given in the ephemeris for 6-hour intervals of U.T., and it is given in a convenient way. To quote from the ephemeris: "The sun will transit over the Greenwich meridian when U.T. = 24h. − E."

For 1st January 1967, E is given as: at 0 hours U.T., E = 11h. 56m. 52.7s.; at 6 hours U.T., E = 11h. 56m. 45.6s.; at 12 hours U.T. E = 11h. 56m. 38.4s. This rate of change is as great as any in the year: about 7 seconds in 6 hours. As with the change in declination, the change in E in one day is not great, and generally a value for the day will do. This cannot be calculated in any easy way, but a value can be taken from the graph, Fig. 30B.

To quote again from the ephemeris: "G.H.A. Sun = U.T. + E." G.H.A. is the Greenwich Hour Angle. When the sun is on the meridian of Greenwich, G.H.A. is zero; as with Local Hour Angle, an hour later, (as measured by a sundial) it is 15° west. G.H.A. is always measured westward from the Greenwich Meridian.

For 1st January 1967, E could be taken to equal 11h. 57m. At 6 hours U.T., G.H.A. = 6h. 00m. + 11h. 57m. = 17h. 57m.

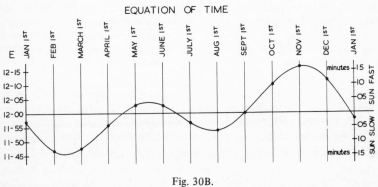

Fig. 30B.

Converting this to arc at the rate of 1 hour = 15°, gives 269°-15'. (Conversion table in the ephemeris.) Then the sun, at 6 hours U.T. on 1st January, is above the meridian of longitude 269°-15' west of Greenwich, which is to say, the meridian of 90°-45' east. Now,

$$\text{"L.H.A.} = \text{G.H.A.} \begin{array}{c} - \text{ west} \\ + \text{ east} \end{array} \text{longitude"}$$

For an observer standing on the meridian of 90°-45' east longitude, at 6h. 00m. U.T., the L.H.A. = 269°-15' + 90°-45' = 360°. The sun is on the observer's meridian. For an observer standing on the meridian of 30°-00' east, at 6h. 00m. U.T., the L.H.A. = 269°-15' + 30°-00' = 299°-15' west = 60°-45' east.

For an observer standing on the meridian of 80°-00' west longitude, at 15h. 00m. U.T.; G.H.A. = 15h. 00m. + 11h. 57m. = 26h. 57m. = 404°-15'. L.H.A. = 404°-15' − 80°-00' = 324°-15' west = 35°-45' east.

It may be seen that L.H.A. is easily obtainable if the longitude and U.T. are known. Longitude can be taken from a suitable chart or map. U.T. is put out regularly and frequently on several radio transmissions for the use of navigators. It is known at all airports and seaports. The relation between the time shown by the public clocks, and U.T., is usually known at principal post offices. U.T. can be found fairly well by observation. This is discussed under Timed Photographs.

Latitude or Longitude taken from a Chart or Map

With a sea-chart of the regular sort, such as one made by the Royal Navy or by the United States Navy, there is no doubt about what the meridians of longitude and parallels of latitude on it refer to. They are in sexagesimal degrees and minutes and they refer to the meridian of Greenwich and to the equator. If there is no chart, only a land map, some caution must be used: not all have any graticule of meridians and parallels at all. Some have a grid of squares, drawn on a projection of the graticule, which has often been omitted. Some have a graticule in grades, not in sexagesimal. On some, although they have a sexagesimal graticule, the longitudes are referred to a meridian other than that of Greenwich. The conversion of grades to sexagesimal is easy, since there are 100 grades to the right angle of 90 degrees, and the grade is divided into 100 parts. When the longitudes are referred to some meridian other than that of Greenwich, the Greenwich longitude of the reference meridian is always known. It may be given in a footnote, or the map publishers will know it. The fact that a reference meridian is not that of Greenwich can be discovered by consulting a world atlas.

It may be remarked that since the sun's declination does not change greatly for any date from year to year and is changing only very slowly from day to day near the times of the Solstices; and as E changes slowly and is nearly always the same at the same date, information can sometimes be obtained from shadows in old photographs take in an unknown year, but at a time of year which may be estimated. Conversely, if a photograph can be brought under control without the use of shadows, these may possibly be used to discover the time of year at which it was taken, and the time of day.

2. Rapid Graphical Solution of the Celestial Triangle

Figure 31 is a nomogram sometimes called a Friauf nomogram, after Dr. James D. Friauf (6). By its use almost any spherical triangle can be solved in a few moments. The nomogram is reproduced here in a small size, but it can very easily be plotted much larger. Dimensions for doing this are given later.

The way to use it is shown most simply by taking examples.

Given two sides and an angle contained, to find the third side:

In a Celestial triangle PZS
　　　　z co-declination = 88°-00′
　　　　s co-latitude = 60°-20′
　　　　P Local Hour Angle = 46°-36′
　　required, p, co-altitude.

Name the included angle, A. Name the two given sides b and c, indifferently. Then b + c = z + s = 148°-20′, b − c = 27°-40′.

On the left of the nomogram, marked Sum b and c, find 148°-20′.

On the base, marked Side a, find 148°-20′. Rule a line between these two points. On the right, marked Difference b and c, find 27°-40′; on Side a, find

Fig. 31.

27°-40′; rule a line between these two points. Find the cut-point of the two ruled lines and mark it M. (It will be realized that there is no need to rule lines at all; the instruction to do so is merely a simple way of describing how the point M may be found.)

On the parallel base marked Angle A, find 46°-36′; join the point found, to M, by a straight edge, which will cut the Side a line at the required answer, 52°-00′. The accuracy of the result obviously depends upon the scale at which the nomogram is plotted, and the chosen intervals, e.g. 1°, 30′, etc.

Given three sides, to find an angle:

In a Celestial triangle PZS
 z co-declination = 88°-00'
 s co-latitude = 60°-20'
 p co-altitude = 52°-00'
required Z, the azimuth.

Name the required angle, A. Then the side opposite (co-declination) is a. The other two sides are b and c, indifferently: b + c = s + p = 112°-20'. b − c = 8°-20'. Proceeding as before, but now of course without ruling lines, find M. On the Side a line, find 88°-00', and join the point found, to M, with a straightedge, which will cut the Angle A line at the required answer, 113°-10' approximately.

Given two sides and an angle not contained, to find the third side:

In a Celestial triangle PZS:
 z co-declination = 88°-00'
 s co-latitude = 60°-20'
 Z Azimuth = 113°-10'
required p, co-altitude.

Name the given angle, A. Then the side opposite (co-declination) is a. Name the other known side (co-latitude) b. Then c is the required side. This particular nomogram (one of many) will not give the answer directly. Assume a value for c; say, 40°. Then b + c = 60°-20' + 40°-00' = 100°-20', b − c = 20°-20'. Find the point M corresponding.

Find 113°-10' on the Angle A line; find 88°-00' on the Side a line. Rule a line between these two points, to cross the network. If this ruled line cuts M, the assumed value was correct. Since in fact M is off the line, in a position to suggest that b + c is too small, assume some greater value for c, say 50°. Then b + c = 100°-20', b−c = 10°-20'. Find the point M' corresponding. Since M' falls almost on the ruled line, and M is not far away, a line through M and M' will cut the ruled line in the required point, where it is found that b + c = 112°-20', from which c = 112°-20' − 60°-20' = 52°-00', which is the required co-altitude. This may seem tedious, but in fact it takes very little time. Another form of nomogram will deal with the case better, but the one given here is the most generally useful. It will be found that a series of points M, M', M", etc., form a curve. The example given above is not an ambiguous case; the curve will cut the ruled line in one place only. In an ambiguous case, the curve will cut in two places, so giving the two possible solutions, one of which may perhaps be rejected as being impossible or highly improbable. If the curve tends to run along the ruled line, obviously the triangle is very ill-conditioned, and so the result will be unreliable.

In all cases, if b + c exceeds 180°, take 360° − (b + c) instead, and use it along with b − c.

The nomogram may be plotted at any desired size. The graphical construction is very simple and nothing is required but a table of natural cosines, a straightedge, and a large compass for plotting a right angle by arcs.

The Angle A line is drawn, say, 20 inches long and bisected at the 90° mark. The other degree marks form a cosine scale, e.g. cos 0° = cos 180° = 1.00, which is 10 inches in the case of a 20-inch base. Cos 10° = cos 170° = 0.9848, or 9.848 inches etc. These distances are laid off from the 90° mark. At the 90° mark, set off a right angle, bisecting the whole network-to-be. At a convenient distance on this bisector, draw the Side a line. Select a point on the bisector as the apex of the whole. By ruling lines from the degree marks on the Angle A line towards the apex, transfer all of the degree marks to the Side a line. From the 0° mark on the angle A line, rule lines (for b − c) through all of the degree marks on the Side a line. From the 180° mark on the Angle A line, rule lines (for b + c) through all of the degree marks on the Side a line. This completes the construction. Every line drawn out of the 0° mark on the Angle A line must cut the bisector at the point where the corresponding line out of the 180° mark cuts it, in the sense that any two lines intersecting on the bisector must carry values that sum to 180°. An inspection of Fig. 31 will make this clear.

The construction will be much stronger if the distances along the bisector, from the Angle A line, are calculated for exact plotting.

Let the required distance along the bisector be D. Let the space between the Angle A line and the Side a line be h, and the half-width of the Angle A line be W. Let the value of the angle b−c = x°. D will be the distance from the mid-point of the Angle A line, along the bisector, to the point cut by the line whose value is b−c, which point is cut also by the line whose value is 180° − (b − c)

$$D = \frac{hW}{W - \left(W \cos x° \dfrac{H-h}{H}\right)}$$

But since the value of D depends only on the cosine and the ratio of H to h, the expression becomes

$$D = \frac{h}{1 - \left(\dfrac{H-h}{H} \cos x°\right)}$$

The calculation is of a tedious sort, and so the table of distances D has been prepared, which produces a nomogram of a convenient size. For W = 10 inches, h = 4 inches, H = 17.25 inches; as with Fig. 31:

Table 1

Angle°		D (inches)	Angle°		D (inches)
180	0	17.250	145	35	10.787
179	1	17.241	144	36	10.566
178	2	17.215	143	37	10.348
177	3	17.172	142	38	10.134
176	4	17.112	141	39	9.924
175	5	17.035	140	40	9.718
174	6	16.942	139	41	9.517
173	7	16.834	138	42	9.320
172	8	16.711	137	43	9.127
171	9	16.574	136	44	8.939
170	10	16.424	135	45	8.755
169	11	16.260	134	46	8.576
168	12	16.086	133	47	8.401
167	13	15.900	132	48	8.230
166	14	15.705	131	49	8.063
165	15	15.501	130	50	7.901
164	16	15.288	129	51	7.743
163	17	15.069	128	52	7.589
162	18	14.844	127	53	7.438
161	19	14.613	126	54	7.292
160	20	14.378	125	55	7.150
159	21	14.139	124	56	7.012
158	22	13.898	123	57	6.877
157	23	13.654	122	58	6.746
156	24	13.410	121	59	6.618
155	25	13.164	120	60	6.494
154	26	12.919	119	61	6.373
153	27	12.674	118	62	6.256
152	28	12.430	117	63	6.142
151	29	12.188	116	64	6.031
150	30	11.948	115	65	5.922
149	31	11.710	114	66	5.817
148	32	11.474	113	67	5.715
147	33	11.242	112	68	5.616
146	34	11.013	111	69	5.519

Table 1–(*cont.*)

Angle°		D (inches)	Angle°		D (inches)
110	70	5.425	99	81	4.546
109	71	5.334	98	82	4.479
108	72	5.245	97	83	4.413
107	73	5.158	96	84	4.349
106	74	5.074	95	85	4.287
105	75	4.992	94	86	4.226
104	76	4.913	93	87	4.167
103	77	4.835	92	88	4.110
102	78	4.760	91	89	4.054
101	79	4.687	90	90	4.000
100	80	4.616			

It is probably obvious that when dealing with the lower part of the plotting, that is, the part near to the Side a line, perpendiculars to the Angle A line can be set up from the 0° mark and the 180° mark, and on these perpendiculars the figures in inches listed above can be doubled for plotting; this will keep the construction under better control.

In his paper "Nomograms for the Solution of Spherical Triangles" Dr. Friauf (6) deals with seven nomograms, of which the one given here is the first. He lists seven references, of which the earliest dated is to M. d'Ocagne, "Traité de Nomographie", pp. 299-302 and 332-349 Paris, (1921).

It is surprising that these nomograms are not better known to geographers, geodetic surveyors, and navigators than they appear to be.

It is perfectly possible to check results from the Celestial Triangle against gross error or blunder by plotting with a wax pencil on an ordinary terrestrial globe. The lines drawn can be wiped off easily with a damp cloth. The observer's latitude parallel can be marked, and also the parallel above which the sun was moving on that date; e.g., if the sun's declination was 10° north, the 10° north parallel will be marked. If the Local Hour Angle is known, this can be regarded as a difference of longitude; then, on the appropriate parallels of latitude, a point can be marked as the place of the observer and another point as the place of the sun, or, strictly, as the place of the sub-solar point above which the sun was in the zenith. The co-altitude of the sun can then be read off by means of a ruler made by laying a narrow strip of paper around the equator (or along a meridian) and marking intervals of say 5° along its edge. If a line is drawn between the two points marked on the globe, the sun's azimuth can be read from the meridian of the observer, by using a small protractor. If the co-altitude is known, but not the Hour Angle, the paper ruler can be used to set off the

co-altitude from the place of the observer to the latitude parallel of the sun. This finds the position of the sun relative to the observer, and hence the difference of longitude, which measures the Hour Angle.

3. Movements of Shadows

Figures 32A to 32H illustrate the behaviour of the shadow of a column standing on level ground, in different latitudes and at two different times of the year. On Fig. 32A the latitude is 80° north, the sun's declination 10° north. The date is then either about mid April or nearly the end of August. The radiating lines are the directions relative to the meridian, the noon-line, at intervals of one hour. The heavy line passing through the hour-lines is the track of the shadow-end.

Fig. 32.

Only a part of the track is shown, since the whole track in this instance forms a long ellipsoidal figure.

On Fig. 32B the latitude is 60° north, on Fig. 32C, 40° north, and on Fig. 32D, 20° north; the declination remains at 10° north.

On Figs. 32E, F and G, the latitudes are 60°, 40° and 20° north, declination 10° south; the date is then either near the end of February or near the end of October.

In the summer the track of the shadow is concave to the equator, in the winter it is convex. At the time of an Equinox, when the sun is crossing the Equator, declination zero, the track is a straight line, as shown on Fig. 32H. Figure 32H has been made for latitude 40° north, but the statement is true for any latitude below the polar regions.

At the time of an Equinox the sun rises in the east and sets in the west. That it does not do so at any other time is apparent from a consideration of the Celestial triangle PZS. It is only when the side z (the co-declination) = 90°, and the side p (the co-altitude) = 90°, that the azimuth angle Z = 90° for any value of the side z, the co-latitude. (The angle between the east or west point of the horizon and the place of the rising or setting sun is called the Amplitude. Values for Amplitude are tabulated for all latitudes and declinations: see for instance Chamber's Seven-Figure Mathematical Tables.)

That the bearing of a shadow (= the azimuth of the sun + 180°) changes fastest around the noon hours, and the length fastest at the early and late hours, is a matter of common observation. The height of the column casting shadows in Figs. 32A to 32H is 1 unit of the scale provided. The distance from the centre of the radiating lines to the shadow-track, measured by the scale, is the cotangent of the sun's altitude. Thus on Fig. 32A the distance on the noon line is 2.7 units, = cot 20° approximately; this is the noon altitude in latitude 80° north with declination 10° north; 80° − 10° = 70° = co-altitude. Similarly with Fig. 32E, the noon distance is 2.7 units = cot 20°; this is the noon altitude in latitude 60° north with declination 10° south; 60° + 10° = 70° = co-altitude. In this way from the figures the altitude can be found, very roughly, for any hour at the latitudes and with the declinations given. This is of little value for work, but it does afford a means of making an estimate of the rate of change in the sun's altitude under differing circumstances. The figures themselves give an indication of the rate of change in bearing. Thus, with Fig. 32B, taking 8, 10 and 12 hours; cotangents are about 2.3, 1.4, 1.2; altitudes are therefore 23°, 36°, 40°; bearings are 68°, 37°, 0°; the sun rises 13° in the first two hours, 4° in the next two; the bearing changes by 31° in the first two hours, by 37° in the next two.

These figures are very approximate, but they serve for comparison with others obtained similarly, so that some rough interpolations can be made. This will give an idea of the possible effect of an error in the Hour Angle of a Celestial triangle. Generally, such an error will have only a small effect on the deduced bearing of an early or late shadow; but will have a considerable one on that of a

noon shadow. It will have a small effect on a height found from length in the case of a noon shadow, but a considerable one otherwise.

The arcs of circle, and the point M, on Fig. 32D are referred to later.

4. Convergence of the Shadow-Edges;
Horizon-Line-Finding Shadows

The sun's angular diameter, as measured at the Earth, is about 0-32′, and the Earth's angular diameter, as measured at the sun, is about $0°$-$0'$-$16''$. All rays of light that come to Earth from any given point on the sun's disc are practically parallel, but a ray that comes from one edge, or limb, of the disc makes an angle of $0°$-$32'$ with a ray from the opposite limb. If the sun is very low, the lines of the edges of the penumbral shadow of a vertical column, on level ground, diverge at $0°$-$32'$, those of the umbral shadow converge at $0°$-$32'$. But the shadow-edges that will be seen, that is to say, the lines that will be selected by most observers or by most photographic films, as being the edges, will be found generally, to converge at about $0°$-$16'$. The *apparent* edge of a shadow lies at about one-quarter of the way from the umbral edge towards the penumbral edge.

If h, the known height of a column standing on level ground, and L, the length of its shadow measured from the nearest point of the column, are used to discover the altitude of the sun from the expression

$$h/L = \text{tan altitude}$$

the result may be called A, the effective altitude of the sun. The altitude of the sun's centre, A', will be less by $0°$-$08'$.

If however the altitude of the sun has been obtained by solution of a Celestial Triangle, the result is A', and A, the effective altitude, is greater by $0°$-$08'$. This is a very small difference in practical work, certainly not worth making a correction for in most cases. It is referred to because it is *possible* to use a shadow to measure A with an error of only about $0°$-$05'$, and possibly in some extraordinary case, the information (which can be verified easily enough by experiment) may come in useful.

If C is the convergence of the shadow-edges of the two sides of a vertical column standing on level ground,

$$C = 0°\text{-}16' \text{ sec sun's altitude.}$$

This also is a small quantity. Even with altitude $60°$, C is only $0°$-$32'$. At such an altitude, the sun casts very short shadows. If these considerations are neglected, as they can be generally, the edge of a shadow cast from a vertical line is the trace of a vertical plane that contains the vertical line and the sun. This vertical plane stands parallel to all such vertical planes so produced at the same instant of time within the area covered by one photograph—and for practical purposes, within a much greater area. The edge of a shadow cast from a

horizontal line is the trace of an inclined plane that contains the horizontal line and the sun; similarly, this inclined plane stands parallel to all such at any one instant of time.

On a Vertical of generally level ground, the edges of shadows cast from vertical lines are parallel, and the edges of shadows cast from horizontal lines are parallel to the lines from which they come. Individual departures from parallelism denote local departures from the general flatness, as do individual departures from a general value for h/L in cases where h is known. Shadows lying on ground falling away from the sun are elongated more, while shadows lying on ground rising away from the sun at the same gradient, are shortened. On an Oblique of generally level ground, the edges of all shadows cast from vertical lines converge to the Horizon Line; the edge of a shadow cast from a horizontal line converges onto the horizontal line to meet it at the Horizon Line. Individual failures of vertical-line shadows to find the common point on the Horizon Line are due to locally tilted ground. The same thing would cause the failure of a horizontal line and its shadow-edge to find a point on an established Horizon Line.

Departure from true verticality or horizontality in shadow-casting lines has the same effect as locally tilted ground. On an Oblique a single large rectangular building on level ground can produce three pairs of horizon-line-finding lines: the horizontal line of the top of one face and its shadow-line; that of another face and its shadow-line; and the shadow lines of the vertical edges of the building.

With shadows cast by a mass of buildings, it is not always immediately apparent which of them come from horizontal, and which from vertical, lines. It is quite possible to make wrong assumptions, but some work with a straightedge will usually sort the lines into their groups.

5. Transference of Shadow-Lines

If two Obliques of level land have been taken from much the same view-point, of the same view, but at a different time of day, the lines of the shadow-edges may be transferred from one photograph to the other by the use of small detail on the ground. If the transferred shadow-lines are the virtual images of horizontal parallel lines on the original photograph then they remain so on the photograph to which they have been transferred. The shadow-lines may find Horizon Line points for both photographs which neither could provide satisfactorily for itself.

With, say, the morning shadows it may be possible to find a value for h/L from a vertical object, X, which casts a useful shadow in the morning but not in the afternoon. With this, the height of an object Y may be found. With the known height of Y, h/L may be found for the afternoon shadows, and so the height of a third object, Z, which casts no useful shadow in the morning but

does so in the afternoon, may be found. The same thing applies of course to overlapping photographs one of which shows X and Y and the other Y and Z.

6. Timed Photographs of Shadows

Even if it is possible to make only a flying visit to a place, if one can take some photographs of it, and a few measurements (or even none) it will almost certainly be the case that some use can be made of the shadows. If the watch-times of the exposures are recorded, it may be possible to convert these times to U.T. Then if the latitude and longitude of the place can be taken from a map, a Celestial triangle can be solved to find the sun's altitude and azimuth. Alternatively, in some circumstances, it may be simpler to use altitudes and azimuths of the sun as observed by someone else at short intervals of time (using a watch synchronized with the photographer's at a convenient place in the district or within about 10 miles).

The track of the shadow-end of a tall vertical post on level ground, on any one day, is symmetrical or very nearly so, around the meridian line. The change in declination over a few hours is of small effect.

If two or more arcs of circle are drawn on the ground around the centre of the post, the points at which the shadow-end touches the circle in both the morning and the afternoon can be marked. The line between the two marks will be east and west, and any point equidistant from both marks is a point on the meridian. The meridian passes through the centre of the post (e.g., the point M on Fig. 32D is on the meridian). If the track of the shadow-end is marked on the ground at short, preferably equal, intervals of time, the sun's altitude and azimuth for any time recorded by the photographer when elsewhere, can be obtained at once by suitable interpolation between marks; the distance from an interpolated point to the nearest part of the post is L in the expression $h/L =$ tan altitude, where h is the height of the post. The azimuth at the same instant is obtained most simply by plotting measurements which give the position of the interpolated point relative to the post and to the meridian line.

If circumstances permit, a thick plumb-line, hanging from an overhead support and provided with a heavy pointed plummet nearly touching the ground, or preferably a level floor, will be better than a post. A mark such as a large knot in the plumb-line will take the place of the top of a post.

With such a plumb-line, it is quite possible to find the meridian line on the ground far more accurately than with a magnetic compass, even given good values for the variation and secular change and for the compass error, or deviation; near the ground in any case there is always the possibility that local magnetic anomalies exist. (Incidentally, with such a plumb-line, it is possible to find the latitude within about a quarter of a degree, from the noon altitude and declination. Finding the latitude by the use of a shadow is a method of respectable antiquity, since it was done indirectly by Eratosthenes of Alexandria

in the third century B.C., as part of his famous determination of the circumference of the earth. He measured the sun's meridian co-altitude at Alexandria at the time of the northern summer solstice when. it was known. the sun shone straight down certain deep wells at Syene, and was therefore in the zenith there. In this way he obtained a measure of the arc of meridian between the latitude of Syene and the latitude of Alexandria; this arc he found to be one-fiftieth of the circumference of a circle. Knowing the linear distance—obtained possibly from the very regular travelling-rate of camels—he found that the circumference was 252,000 stadia, which, according to some authorities on the length of a stadia, was correct to within about 1 per cent.)*

If a post or plumb-line can be set up. it can be used in a different way from that described above, which does not require the assistance of an observer. The watch-times of the photographs having been recorded, the watch-time of a single observation of shadow-length can be recorded later. This will give the altitude of the sun at the later recorded time. In a Celestial triangle PZS, the side p, co-altitude, is then known; a latitude (mean of the two places) can be taken from a map, so the side s, co-latitude, is known; co-declination, side z, can be found from the declination, given in the ephemeris, or taken from Fig. 30A, or calculated for the date.

All three sides of the triangle being known, P, the Local Hour-Angle, L.H.A., can be taken from the nomogram, Fig. 31. This value, considered as westward, can be reduced for the time interval elapsed (assumed to be only a few hours) between a photograph-time and the time of shadow-measurement, giving a new value for P. With this, retaining co-declination and co-latitude in a second Celestial triangle PZS, two sides and the angle contained are known, and the third side, co-altitude, can be found; then the azimuth, Z, can be found. The change in E for the interval can be disregarded. But if the interval amounts to a day or two it can be taken into account, as can be of course the change in declination. This assumes that the watch has a regular rate, preferably a very small one, that is known. For example: Watch-time of photograph, 7th January, 14h. 15m.; Watch-time of shadow-measurement, 9th January, 10h. 20m.

Figure 30B, which gives E at the left-hand side, gives the same on the right, but in the sense of Apparent Time being ahead or behind Mean Time. In January, it will be seen, the sun is not only "slow" on the mean-time clock or watch, but is continuing to "lose".

On 7th January it is slow by 6 minutes; on the 9th by 7 minutes. This is the same thing as saying that the watch is gaining; that it has gained 1 minute on the sun. Then the effective time interval is 20h. 4m. In arc, this is 301°-00'.

Supposing that P, the Local Hour-Angle found from the observation of altitude on 9th January, is 31°-10' east, = 328°-50' west; then P for the watch-time of 7th January = 328°-50' − 301°-00' = 27°-50' west.

Alternatively of course, 31°-10' east + 301°-00' (eastward) = 332°-10' east = 27°-50' west.

* I am informed that J. L. E. Dreyer, in "A History of Astronomy from Thales to Kepler", Dover Publications Inc., 1953, states that all references to Eratosthenes were put together by Berger, |"Die Geographischen Freguieute Die Eratosthenes", Leipzig, 1880.

It will be noticed that in this it is not necessary to know the longitude or U.T. It is obvious that the shadow-observation could be made before the photographs are taken and that it should *not* be made at a time near noon (see Fig. 32).

If a meridian line has been established, and the instant (in so far as it can be determined) when the shadow of the post or plumb-line comes to the meridian, that is, the instant of the sun's meridian passage, is noted on the watch, the difference between the watch-time and U.T. can be found provided the longitude is known. A mean value for a small district will do; 1° of longitude = 4 minutes of time; 1′ = 4 seconds.

Local Mean Time, L.M.T., differs from U.T. by the longitude of the place. To quote from the ephemeris:

$$\text{"L.M.T. = U.T. } {-\text{ west} \atop +\text{ east}} \text{ longitude."}$$

and, "just as the Greenwich Meridian passage of the Sun occurs when U.T. = 24h. − E, the local meridian passage occurs when L.M.T. is 24h. − E".

To take an example: at a place in longitude 44°-10′ east, on 1st November, the instant of the sun's meridian passage is at 12 hours 22m. as shown by a watch. Longitude 44°-10′ = 2h. 56m. 40s. (conversion table in the ephemeris). Roughly, when it is noon (that is, 12 hours Local Apparent Time) at the place, U.T. will be 12h. − 3h. = 9h. At 9h. U.T. on November 1st (taking the year 1967) E is given in the ephemeris as 12h. 16m. 21s. (Fig. 30B gives about 12h. 16½m.). Then at the moment of the sun's meridian passage,

	L.M.T. = 24h. − 12h. 16m. 21s. = 11h. 43m. 39s.
but	L.M.T. = U.T. + 2h. 56m. 40s.

$$\begin{aligned} \text{U.T.} &= \text{L.M.T.} - 2\text{h. }56\text{m. }40\text{s.} \\ &= 11\text{h. }43\text{m. }39\text{s.} - 2\text{h. }56\text{m. }40\text{s.} \\ &= 8\text{h. }46\text{m. }59\text{s., or say }8\text{h. }47\text{m.} \end{aligned}$$

The watch showed 12h. 22m. at the instant when U.T. was 8h. 47m., so the watch is fast on U.T. by 3h. 35m.

Also, the watch is fast on L.M.T. by 12h. 22m. − 11h. 43m. 39s. = 0h.38m. 21s., or say 38 minutes.

A place in longitude 44°-10′ east is in the Time Zone of 3 hours east, which extends from longitude 37°-30′ east to 52°-30′ east; the Zones are 15° of longitude wide, which corresponds with 1 hour; the central meridian of the 3 hour east Zone is 45° east. This is not to say that a public clock in the Zone will show a time that is fast on U.T. by 3 hours. But if the watch had been set by a public clock, that clock is fast by 35m. on Zone Time.

Assuming that the watch is a reliable timekeeper, it could be used to time

photographs taken elsewhere in the district during the next day or two. The recorded watch-times could be reduced to U.T. and then to solve Celestial triangles nothing else would be required but the latitudes and longitudes of the places, the date, the declination, and E. From Celestial triangles PZS, with two sides, co-declination (z), co-latitude (s), and the included angle, Local Hour Angle (P), known, the co-altitude (p), and the Azimuth (Z), could be obtained for any given watch-time.

For example: longitude of a place, 43°-57' east; latitude 15°-10' north.

Watch time of photograph, 3rd November 14h. 10m.

$$\text{watch fast on U.T.} \qquad 3\text{h. } 35\text{m.}$$
$$\text{U.T. of photograph} \qquad 10\text{h. } 35\text{ m.}$$

Greenwich Hour Angle, G.H.A. is reckoned always westward.

$$\text{G.H.A.} = \text{U.T.} + \text{E.}$$
$$= 10\text{h. } 35\text{m.} + 12\text{h. } 16\text{m. } 23\text{s. (1967 ephemeris)}$$
$$= 22\text{h. } 51\text{m. } 23\text{s.}$$
$$= 342°\text{-}51'.$$

$$\text{L.H.A.} = \text{G.H.A.} \begin{array}{c} - \text{ west} \\ + \text{ east} \end{array} \text{ longitude}$$
$$= 342°\text{-}51' + 43°\text{-}57'$$
$$= 386°\text{-}48' = 26°\text{-}48' \text{ west.}$$

Declination, 3rd November, 10h. U.T. (1967 ephemeris)
$$= \text{South } 14°\text{-}54'.$$
$$\text{co-declination} = 104°\text{-}54'$$
$$\text{co-latitude} = 74°\text{-}50'$$

In a Celestial triangle PZS, P = 26°-48', z = 104°-54', s = 74°-50'; required, p, (co-altitude), and Z (Azimuth.)

For the nomogram, Fig. 31, Angle A = 26°-48'; b + c = 74°-50' + 104°-54' = 179°-44'; b − c = 30°-04'. Required, side a. This comes out as 40°-00'. Then co-altitude = 40°-00', altitude = 50°-00'.

Therefore h/L = tan 50°-00' = 1.192, h = L x 1.192. If L, a shadow-length on level ground can be measured, then p, the height of the object casting it, is found.

Taking now on the nomogram, Angle A = Azimuth; side a = 104°-54', b + c = 40°-00' + 74°-50' = 114°-50', b − c = 34°-50'; whence A comes out as 137°-30'.

The watch is only 38 minutes fast on L.M.T., so the time is afternoon, in fact 13h. 32m. L.M.T. Then the sun is west of the meridian, as of course the L.H.A. shows; this kind of consideration can help to avoid blunders. The sun's Azimuth

is 137°-30′ west of north. The bearing of a shadow on level ground is 42°-30′ east of north.

With another photograph, taken perhaps half an hour later, it would be necessary only to increase L.H.A. by the time elapsed converted to arc by the table in the ephemeris (1 hour = 15°, 1 minute = 15′) and re-enter the nomogram. Values for any intervening times could be found by simple graphical interpolation.

To repeat, the altitude found by solution of a Celestial triangle is that of the sun's centre. The effective altitude is greater by about 0°-08′. In some cases the correction may be worth taking into account.

A somewhat better value for U.T. than that obtained from a single watch-time of the sun's meridian passage can be found by taking times at which the shadow-end is, e.g., exactly at small distances a, b and c, from the meridian line, and taking the times when it attains the same distances c′, b′, a′, on the other side of the line. The mean of the recorded times can be taken as that of meridian passage. This may be worth doing if the meridian line itself has been found from observations of a long shadow-end moving through several arcs of circle, particularly if these observations were made at a date near to a solstice when the declination is changing very slowly. U.T. *can* be determined, via L.H.A., by a single exact altitude-measurement at mid-morning or mid-afternoon (See pages 83 and 85).

Altitude of the Sun from a Reflected Image

Reverting to the use of a post or plumb-line, if it is not possible to set up such things or none are available, the sun's altitude at some instant can be photographed in certain circumstances. If the image of the sun reflected from a nearby, perfectly still, dark pool of liquid, such as heavy oil, (tea has been used) is photographed along with the sun itself at one exposure, the angle at p, (the angle at the camera) between the line to the reflected image and that to the direct image, is twice the sun's altitude. To obtain the altitude in this way is to use the camera as a sextant is used with an artificial horizon such as a pool of mercury. Obviously it calls for the use of suitable filters over the lens.

It is naturally only possible to do this at a single exposure when the sun's altitude is less than half the field angle of the camera. It is quite possible, however, to photograph the reflected image of the sun, and a distant skyline, and then photograph the actual sun and skyline at a second exposure made immediately afterwards. It is necessary that the skyline be at a considerable distance, like a mile, in order to nullify the effect of movement of a hand-held camera between the two exposures. With a distant skyline, such a movement, even of several feet, is of no effect. The reflecting surface may be only a yard or so away, but the reflected image is taken of course at the infinity setting, since it is effectively at an infinite distance. The fact that the vessel holding the liquid will be quite out of focus is of no importance.

The skyline should be a sharp horizontal edge, such as that of a flat-topped hill. On each photograph, perpendicularly to the skyline (which may appear only

as a silhouette), the Principal Vertical can be drawn through P; on each, it should cut the image of the sun, or very nearly do so. In that case, if (a) the distance from P to the image of the sun on the upper photograph is m, and (b) the distance from P to the skyline is m′ and (c), the corresponding distances from P on the lower photograph are n and n′, and (d), if the epP of the prints is f, then m/f, m′f, n/f, n′/f are the tangents of four angles, half the sum of which is the sun's altitude above the horizontal plane.

If there is no level skyline it may be possible to draw, on each photograph, a line passing through some skyline object that can represent it. If there are any vertical lines of buildings, or straight trees, not necessarily on the skyline, but showing against the sky, these will indicate the zenith point of the upper photograph, and its correspondent, P.P., on the lower one. Then if the position of the zenith point can be estimated, the Principal Vertical on the upper photograph can be drawn from it through P; and at right angles to it a line to represent a level skyline can be drawn. Similarly with the lower photograph, on which the Principal Vertical can be drawn through P and the estimated position of P.P., and to which the line representing the skyline can be transferred.

If the images of the sun both stand well away from the Principal Vertical, it will be necessary to draw, through each image, the trace of a vertical plane to cut the skyline. On the upper photograph, this trace will pass through both the zenith point and the sun's image; since the zenith point will ordinarily be distant, an estimated position for it will do. In a plane triangle S–p–G, in which S is the sun's image, G the skyline point on the trace of the vertical plane, and p the camera, the angle at p is the altitude of the sun above the skyline. The distance S–G can be measured on the print. The distance S–p is the hypotenuse of a right-angled triangle in which one side is the distance P–S and the other the epP of the print. The distance G–p is similarly the hypotenuse of a right-angled triangle in which one side is P–G and the other the epP. Having the three distances, the triangle S–p–G can be plotted and the angle at p measured. Similarly with the lower photograph, on which the trace of a vertical plane can be drawn through the sun's reflected image and an estimated position of P.P., to cut the skyline at G′. In a plane triangle S′–p–G′, the angle at p is the depression of the reflected image below the skyline. Half the sum of the two angles at p is the sun's altitude above the horizontal plane through the camera.

If an image of the sun is close to the Principal Vertical, it will be enough to (a) draw the trace of a vertical plane through it parallel to the Principal Vertical (b) project P perpendicularly to the trace as P′ and (c) measure the distances from P′ to the sun's image and the skyline. If these distances (c) are m, m′ and the distance P–P′ is d, and the epP of the print is f, then d/f = tan a, f/cos a = f′. The sum of the two angles whose tangents are m/f′ and m′/f′ is the sun's altitude above the skyline, or of course, the depression of the reflected sun below the skyline.

Ordinary perpendicular projection of the sun's image to the Principal

Vertical, as when, e.g. the image of the summit of a tower is so projected, will give a result that is too great. Imagine that (a) an inclined plane cuts the camera and the sun, and stands perpendicular to the Principal Plane, and that (b) another inclined plane contains the skyline and the camera and also stands perpendicular to the Principal Plane, then the angle between the two inclined planes, as measured in the Principal Plane, is greater than the angle between the two inclined planes measured at the camera in a vertical plane that is oblique to the Principal Plane.

Even in apparently still air the surface of a liquid, even heavy oil, is apt to be rippled, and the reflected image of the sun tends to resolve itself momentarily into a group of flashing light-sources. In a small bowl, there may be some reflections from the miniscus at the edges. If the liquid is protected by a glass plate, there may be reflections from the glass, although the probability that the glass is not optically flat can usually be disregarded. A shallow muddy pool in a sheltered place appears to be the best practical reflector. Since the lower, or reflected-image photograph is the more difficult to take, it should be taken first, when the surface is perfectly still; the upper one should be taken immediately afterwards.

If an unfiltered photograph of the view is taken from the same place, (the lens being shaded) then a point on the Horizon Line of this photograph can be found, since the vertical angle from the horizontal plane to a skyline point has been measured.

With an ordinary leaf-shutter the image of the sun is a star-shaped object with long rays; these make it very easy to find the centre of the image.

7. Shadows on Sloping Ground

Since the edges of shadows of vertical lines are the traces of vertical planes, they can be used to measure the gradient of sloping ground. This is because a shadow-edge which can be seen obliquely, marks on the ground a line which is vertically beneath (or above) a horizontal line that can be drawn in the same vertical plane; the change in the space between the drawn horizontal line and the shadow-edge measures the slope of the ground.

Figure 33A is an Oblique of a piece of level ground standing above a valley. An array of trapezoids has been drawn symmetrically about the Principal Vertical. A road crosses the view from side to side, and it is known that this road is straight. The line of the road on the level ground, prolonged to left and right, is a horizontal line in the vertical plane that contains the road.

Where the road leaves the horizontal line and approaches P.P., it is falling; where it retreats from P.P. it is rising; where it rejoins the line it is at the height

of the level ground. The amount of its divergence from the line can be measured at any point.

Lines drawn towards P.P., that join the road to the drawn horizontal line, can be regarded as columns. The height of any one of these can be measured in the ordinary way by the use of a Principal Plane section (Chapter 4).

Fig. 33 A.

On the photograph, six such columns are shown. Four stand above the horizontal line, two stand below. The horizontal line, being on the level ground, is of course at P.V.' level in the Principal Plane section, Fig. 33B. There is no more difficulty in measuring the height of a column whose head stands at P.V.' level than there is in measuring that of one whose foot stands at that level. The plan-positions of the six columns can be obtained from the trapezoids. Where the array leaves the level ground, it is extended in space to the right, above the valley, by dashed lines. The head of each column standing in the valley has been

ringed, and these rings are at P.V.' level. The position of each ring in the array, is the plan-position of the point on the road on which the foot of a column stands.

The plan position of the point where the road, rising to P.V.' level, rejoins the drawn horizontal line, can also be found from the array. Where it rises above P.V.' level, going away from P.P., the lines of the array are seen through the solid ground; then it is the foot of each column that is ringed; these rings are at P.V.' level, and the plan-position of each, obtained from the array, is that of the point

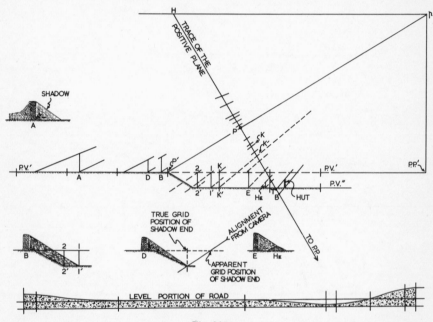

Fig. 33B.

on the road at which the head of a column stands. Similarly with the pair of columns seen through the ground in the left of the view, where the road rises into some hills.

Once one has the road and the columns on the plan (Fig. 33C) finding the column heights is fairly simple: (a) project the column-positions to P.V.', (b) transfer the points so found to P.V.' on the Principal Plane section, (c) set up verticals, (d) project the column-positions (head or foot as required) to the Principal Vertical on the photograph, (e) transfer the points so found to the Trace of the Positive Plane on the Principal Plane section, and (f) draw rays from p to cut the verticals appropriately; so the column-heights are found. Having these, and the plan-positions, a section of the road can be drawn, as shown on Fig. 33B.

Exactly the same procedure can be followed where the trace of a vertical plane provided by the shadow-edge of a vertical line is available, in place of the trace of a vertical plane, such as that provided by the road known to be straight.

On Fig. 33A a (presumably) vertical line of the wall marked A is casting a shadow on ground believed to be level. The shadow-edge is straight, so it is lying on one plane. The line of it has been extended to find a point on the Horizon Line. The line of a shadow cast from any other vertical line is in a vertical plane parallel to that which contains A's shadow-line; if this other shadow-line is straight, and does not pass through P.P., then it lies on one plane; if its extension

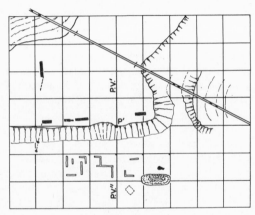

Fig. 33C.

finds the same Horizon-Line point as A's, the plane that point lies on is then parallel to the plane A's lies on; if the ground at A is level so is the ground at the place of the other.

The first part of the shadow cast from B, produces a straight line which meets A's at the Horizon Line; so it lies on level ground.

The next part makes an angle towards P.P., so it is on falling ground. (This is obvious enough in Fig. 33A, but it is not always so.) The last part of the line is straight again, and it meets A's at the Horizon Line, wherefore it is on level ground again.

A line drawn through the foot of wall B and the Horizon-Line point is a horizontal line in the vertical plane of B's shadow-edge. As with the road, two columns have been set up to join the shadow-edge to the horizontal line; these columns of course are drawn towards P.P. The plan-positions of the column-heads are obtainable from the trapezoids (extended into space from the level ground) and their heights are obtainable from the Principal Plane section. The plan-position of the point where the shadow-edge leaves the level ground, and that of the wall B, can be obtained from the trapezoids, and the height of wall B

from the Principal Plane section. Then a small vertical section, labelled B on Fig. 33B, can be drawn; this stands in the plane of the shadow-edge. A similar small vertical section for wall A can be drawn (ignoring the small horizontal angle between the shadow-line and the wall). The two small sections agree as to the effective altitude of the sun, which is a check on the work.

The work done on B's shadow could be repeated by the use of C's shadow, but this would be redundant here. With D's shadow the problem is a little different. The line of it goes to A's Horizon-Line point, but reversed, it goes to P.P. Then the vertical plane containing the shadow-edge contains the plumb-line, so the shadow-edge cannot in any case exhibit any angles. The shadow can be used, however, to measure the overall gradient of that part of the slope it lies on, if the point at which it leaves the (presumably) level ground can be found well enough by ordinary inspection of the photograph.

The height of the wall at D and its plan-position, can be found. The effective altitude of the sun is known from A. Then a small vertical section, D on Fig. 33B, can be constructed with the upper limit of the shadow shown. From the extension of the array into space, the apparent plan-position of the shadow-end can be found.

The Principal Plane section gives the plan-position of P.P.', and the height of p above P.V.'. Since the plan gives the distance from P.P.' to the apparent position of the shadow-end, then the gradient of the line descending from the camera through the apparent position, to meet the line of the upper limit of the shadow, is known. Thus the small vertical section can be completed. On this, the true plan-position of the shadow-end is vertically above the point where the line of the shadow's upper limit and the line from the camera meet. So the distance from the apparent position to the true position is found, and this can be laid off on the plan, on a line drawn through the apparent position, from P.P.'.

The small vertical section, D, gives the fall of the ground from D to the level reached by the end of the shadow. The fall happens to be the same as that found from B's shadow, for the whole fall. (C's shadow will concur). If it can be accepted from this, that the ground is level from B's shadow-end to D's, then the trapezoids in space can be dropped vertically making an array on the ground; this will make it possible to put the exposed foundations or low walls standing on low ground, onto the plan. It may be decided to drop four trapezoids. To do this it is only necessary to erect at, say, K' (on Fig. 33A), a point vertically beneath the trapezoid-intersection K, a column whose height is equal to the known amount of the fall. A line through K', to the vanishing-point on the Horizon Line found by the line through K, will be the virtual image of a horizontal line that lies vertically beneath the line through K.

A line through K', parallel (in this case) to the line running left to right through K, will be the virtual image of a horizontal line running vertically beneath the line through K. (If the lines running from left to right met at a vanishing point, as in the usual case, the "dropped" line or lines would do the

same.) To carry out the work it is only necessary to (a) draw a P.V." line at the appropriate level on the Principal Plane section, Fig. 33B; (b) drop perpendiculars from the grid-line cuts on P.V.' to the P.V." line, (c) draw a line from the foot of each perpendicular to p which will cut the Trace of the Positive Plane, (d) transfer the cut-points to the Principal Vertical, and so (e) using the cut-points, draw trapezoidal lines running from left to right. From any trapezoid-intersection, (e.g. K), a line to P.P. will cut the dropped left to right-running line at the position (e.g. K') of the foot of a column. Then lines running in the direction of the Horizon-Line may be drawn in to meet at H. The dropped trapezoids (marked by spots in their upper right-hand corners) are, of course, virtual images of the squares set out on the lower ground, in a grid-system that is part and parcel of the grid-system on the higher ground.

It may be noted in passing that if the decline from the high ground had been in one plane, all of the shadow-lines on it would have met at a vanishing-point above the Horizon Line. That part of the photograph showing the slope would have been in the condition of an Oblique of flat land, of obliquity less, by some 25°, than that of the photograph as a whole.

At E on the photograph there is a small tower casting a shadow on a heap of soil. The shadow, with the aid of a column, can of course be used to measure the height of the heap, and plan-positions can be found from the dropped trapezoids. The small vertical section E–HE, on Fig. 33B, shows the result.

The hut in the foreground is low, and so its shadow is short, but for what it is worth, it shows three pairs of Horizon-Line-Finding lines: the line of the top of the left wall, and its shadow-line; similarly to the right; and between these, the left-hand vertical corner's shadow-line, and that of the right-hand vertical corner. Also the ground-level corner nearest to the camera stands in one vertical plane with the shadow-end of the top of the corner, and a line through these two ground points will find the Horizon-Line point found by the vertical-edge shadows.

The points T and B have been carried by perpendiculars to the Principal Vertical, and transferred to the Principal Plane section, merely as a further reminder of the way in which the heights of the numerous columns are obtainable (Chapter 4).

In the foregoing, shadows were all falling towards the camera. The way in which shadows falling across the view can be used is perhaps shown well enough by the discussion of the road, and by that of shadow B. With shadows falling away from the camera, there is no change in procedure, but they are usually too foreshortened to be really useful.

Also in the foregoing, it is assumed that the array of trapezoids drawn as the virtual image of a grid on level ground could be constructed because the Horizon Line (or the place of P.P.) was discoverable (Chapter 5). The array could of course have been constructed if the ground was not level. It would still be the virtual image of a grid standing at some level, in space or underground, or cutting

through undulating ground. If a single horizontal distance had been measured, between two ground-points of the same height (as in Chapter 5), this distance would give scale to the grid, which could be considered to stand at the height of the two points. If it were known that the ground on which A's shadow lay was level, then the Horizon-Line point found by A's shadow could be used to draw a horizontal line through, e.g., the foot of wall B. The apparent place of the foot of wall B could be obtained from the trapezoids, and so could the apparent place of the head of a column joining the horizontal line to B's shadow-edge. If the foot of wall B stood at a level somewhat above or below the grid-level, the true plan-position of the foot would differ from the apparent place. This would be by an amount very similar to that by which the true plan-position of the head of the column differed from the apparent place; for the wall-foot and the column-head would be in one horizontal plane and not far apart. So it would still be possible to obtain at least a fair measure of the gradient of the slope on which B's shadow lay; and similarly with the shadow of wall D, and that of wall C. Thus, if no part of the ground was truly level, except that at A, it could still be possible to get a measure of the fall and so to drop trapezoids and make a sketch-plan of the lower ground, which could be checked for scale by, e.g., a knowledge of the size of the hut in the foreground.

Cases can be visualized in which, with a close-up Oblique taken from a local high point, small trapezoids could be dropped, or raised in two or more steps, to fit onto terraces, down which long shadows fall in stages. So control could be carried down or up, possibly into totally inaccessible places of interest. Obviously not much detail could be discernible within what might resemble a cascade of shadows, but detail could perhaps be photographed in a different light and by stereoscopic pairs of photographs (Chapter 11).

Chapter 10

An Illustration of the Use of Alignments and Shadows;

The Orientation of an Oil-Drilling Barge at Sea

On 10th January 1958, the drilling barge named the *Adma Enterprise* had just been towed into position in latitude 25°-12′-04″ north, longitude 53°-13′-13″ east, and raised on its legs out of the sea. Because of increasing swell, the marine surveyors responsible for getting it into the required position had been unable to go aboard to verify that its orientation was right, in relation to the direction of the prevailing wind.

A boat compass showed that it could not be far out; but as a Press photograph (Fig. 34A) became available, it was decided to use this to measure the bearing of the barge's fore-and-aft line. Nothing was known about the photograph except that it had been taken on 10th January in the afternoon.

To suppose that the problem is being dealt with anew: For control there is an outline plan of the barge deck (Fig. 35A) and a measurement of the height of the derrick-head above bulwark level, 180 feet.

The shadows of the legs and the hull falling on the sea, cannot be used immediately. But the shadow of the port-side stern leg is falling on the roof of a house, and by good luck the end of it just touches the eaves. The roof is tilted, but the shadow-path lies obliquely across the tilt. If the prolongation of the shadow goes to the same vanishing-point as the long shadows on the sea, it is lying on a horizontal surface. The image is foreshortened, and so the test is not conclusive, but at least it proves that the tilt of the surface is slight. It can be assumed that there is a rise of a foot in the length of the shadow.

As may be found with a moment's work with a straight edge, the horizontal and parallel lines of the hull converge fairly rapidly to the upper-right, but only gradually to the left. Then the direction of the Horizon Line is more or less parallel to the eaves of the house at the shadow-end, and so the scale will be approximately uniform along the line of the eaves. The measurement from the left-hand corner to the shadow-end is 10.0 mm, (scale on Fig. 34B) and to the right-hand corner, 21.5 mm. The plan shows the length of the eaves as 51 feet. Then the shadow-end is $51/21.5 \times 10 = 23.7$, say 24 feet, from the corner. Plotting this on the plan, it is found that a line to the point from the centre of the leg makes an angle of about 19° with the fore-and-aft line; the barge is headed about 19° to starboard of the azimuth of the sun. The length of the shadow is 39 feet.

The photograph is a high Oblique, not so far from being a Horizontal. The

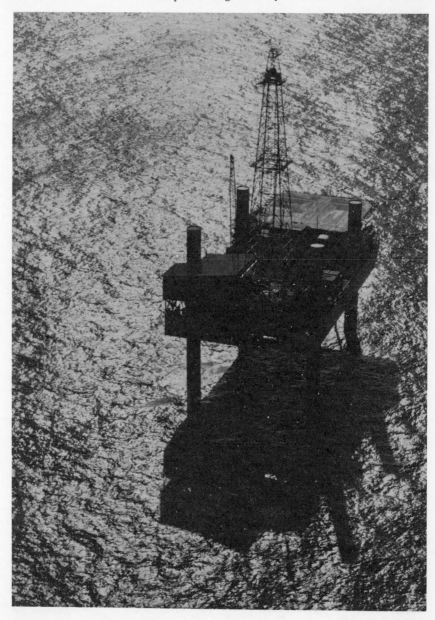

Fig. 34A. Photograph of the drilling barge "Adma Enterprise". 1958. The vessel is now the property of the Offshore Drilling Company and has been re-named "Offshore Enterprise". Reproduced by kind permission of the British Petroleum Company, Ltd.

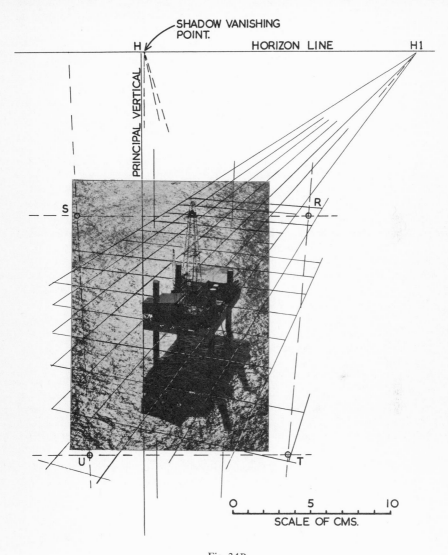

Fig. 34B.

proportion of height to width of a plane rectangle standing nearly parallel to the Positive Plane will be shown nearly correctly. A cylindrical vertical object near to the edge of a photograph will be shown disproportionately broad,* but the shadow-casting leg must be near the Principal Vertical. It can be .treated as a plane surface parallel to the Positive Plane. The width of the image is 4.1 mm, and the effective height appears to be 8.1 mm. One small correction can be made. Assuming that the obliquity is, say 70°, 8.1 mm is measured on a tilt of 20°. Then 8.1/cos 20° = 8.1/0.94 = 8.6 mm, will give a better figure.

The diameter of the leg is 10 feet, by the plan. Then the height of the leg is 10/4.1 x 8.6 = 21 feet. Subtracting a foot for the upward tilt of the shadow-path, the effective height is 20 feet. Then the tangent of the sun's effective altitude = 20/39 = 0.513, from which the altitude = 27°-09'.

Since the nearest degree will do for the present purpose, co-altitude = 63°; co-latitude = 65°. Co-declination = 112°, as for 10th January (1958) the ephemeris gives declination as South 22°. In a celestial triangle PZS, all three sides are now known. On the nomogram, Fig. 31 (or rather, on one plotted at a large scale), the azimuth required is called angle A. Then the co-declination is the side a. Co-altitude and co-latitude are the sides b and c; then b + c = 63° + 65° = 128°, b − c = 2°; from which, with a = 112°, A = 134°-30'. This is west of north, the time being afternoon. The orientation of the barge is 134°-30' − 19° = 115°-30' west of north, = 244°-30' whole circle, (North through East) or say 244°. It had been intended to make the orientation 245°, but a difference of a few degrees either way would be of no significance.

This illustrates how a piece of fairly rough work, done in a few minutes, gave a sufficient answer. But as an excercise, a much better result could be obtained by using the long shadows on the sea.

The hull of the barge is a rectangle, 106 x 190 feet by the plan, Fig. 35A. This and the numerous lines available, e.g. of the helicopter deck, can be used to make an array of trapezoids, the virtual image of a grid standing at the level of the top of the bulwarks (see Fig. 34B). The Horizon Line cannot be found very precisely, but the trapezoids are quite accurate close-in, and good enough elsewhere. The vanishing-points are named, H1 to the upper right, H2 (off the illustration) to the left.

The available vertical lines are all too close together as they stand to find P.P. accurately, and the obliquity is too high. An expedient can be adopted to find P.P. more easily and possibly somewhat more accurately. The image of each leg is the trace of the vertical plane on the Positive Plane. These vertical planes cut the horizontal plane of the sea; then their traces on the Positive Plane may be regarded as images of lines drawn on the sea. Along a line drawn parallel to the

* This effect can be seen sometimes in a photograph of a line of people, facing the camera, taken with a wide-angle lens. The human head is on the whole more of a spherical form than a cylindrical one, but the outermost heads—often with a pleasing effect—will come a little too broad; as in the more distant parts of Mongolia.

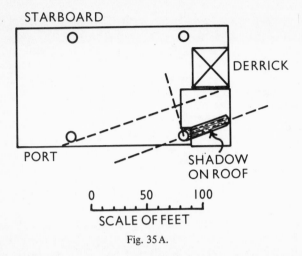

Fig. 35A.

Horizon Line at a convenient distance from it, to cut the extended images of the legs, the scale will be uniform. Along this, the space between the extensions of the legs, can be set off with the use of dividers to the left and right, so finding the two points marked R and S.

The same thing can be done again with a line in the foreground, so finding the two points U and T. Lines through R and T, and S and U, are the traces of vertical planes, intersecting at P.P. and at P.P.'. The points R, T, S and U, can now be transferred to a plan, Fig. 35B, on which is drawn a grid of rectangles to

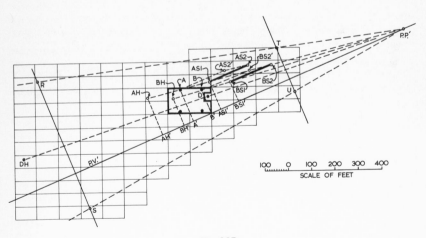

Fig. 35B.

correspond with the trapezoids. Then on the plan, lines through R and T, S and U, find P.P.'

The following are now transferred to the plan: the apparent positions of the derrick-head, DH; the centre of a leg-head, AH; the centre of an effective leg-foot, AS1; the centre of a leg-head, BH; the centre of an effective leg-foot BS1; a shadow-end, AS2; and a shadow-end, BS2. The points AS2 and AS1 have been joined by a heavy line, and similarly the points BS2 and BS1; these heavy lines are the apparent plan-positions, and so the apparent lengths, of the shadows cast from the legs A and B. On the plan, the true positions of the legs A and B, and the derrick, D, are shown. The rectangle of the barge's bulwarks has been drawn in heavy line.

DH is of course the position in which the head of the derrick would appear to lie on a grid of rectangles supported in space at bulwark-level, according to an observer looking down from the camera-station.

The camera-station is in a horizontal alignment with the derrick and the point DH. Then on the plan, the alignment of DH and D will pass through P.P.'. Similarly with AH, A and AS1; BH, B and BS1. Thus the position of P.P.' is checked.

The points R and S are the plan-positions of points which, on the Positive Plane, are on a line parallel to the Horizon Line. A line at right angles to RS, passing through P.P.', is P.V.' Similarly with the points U and T. Since P.V.' can be drawn on the plan grid the Principal Vertical can be drawn on the trapezoids. It should be found to be at right angles to the Horizon Line.

Neither H2, the distant Horizon Line point, nor P.P. are shown on Fig. 34B, but since H1, H2, and P.P. were found by what is in effect a single rectangular block of building, P could be found to a fair accuracy, if it were required (see Chapter 5). A perpendicular from H1–P.P. to H2 will (theoretically) pass through P, and similarly with a perpendicular from H2–P.P. to H1. The Principal Vertical and P would be required only if it were necessary to make a Principal Plane section; in this case it is not necessary, but it shall be done later.

On the plan, Fig. 35B, the distance D to DH scales 832 feet; D to P.P.', 887 feet. The derrick is 180 feet high. If h is the height of the camera above the head of the derrick, then

$$h = 887/832 \times 180 \text{ feet}$$
$$= 192 \text{ feet};$$

which means that the camera is 372 feet above grid-level.

AH to P.P.' scales 1133 feet, AH to A, 143 feet. If h' is the height of the head of leg A above grid-level, then

$$h' = 143/1133 \times 372 \text{ feet}$$
$$= 46.9 \text{ feet}.$$

AS1 to P.P.' scales 862 feet, AS1 to A, scales 128 feet. If h'' is the fall from grid-level to the effective foot of leg A, then

$$h'' = 128/862 \times 372$$
$$= 55.2 \text{ feet.}$$

So the effective shadow-casting height of leg A = 46.9 + 55.2 = 102.1 feet.

In the same way it can be found that the centre of the head of leg B is 46.2 feet above grid-level, the effective foot 60.0 feet below it; height of leg B is then 106.2 feet. The difference is not surprising. The heads of the legs happen to stand practically at one level. There is no reason to suppose that the sea surface was level. The legs are 105 feet apart: a swell 200 feet long, crest to crest, with a height of a few feet, is quite possible.

AS2 to P.P.' scales 685 feet. It can only be assumed that the vertical interval is 55.2 feet. If d is the horizontal distance from AS2 to AS2' (which is the true plan-position of AS2), then

$$d = 685/372 \times 55.2 \text{ feet}$$
$$= 101.7 \text{ feet}.$$

This distance lies in the vertical plane through AS2 and the camera, so it can be plotted from AS2 directly away from P.P.'; so AS2' is found.

AS2' to A (the centre of the leg) scales 208 feet. The leg is 10 feet in diameter. Then the length of the shadow is 203 feet.

BS2 to P.P.' scales 588 feet. A vertical interval of 60 feet is assumed. If d' is the horizontal distance from BS2 to BS2',

$$d' = 588/372 \times 60 \text{ feet}$$
$$= 94.9 \text{ feet.}$$

This can be plotted from BS2, directly away from P.P.'; so BS2' is found. From BS2' to B scales 220 feet. Then the length of the shadow is 215 feet.

The tangent of the effective altitude of the sun, according to A's shadow, = 102.1/203 = 0.5029, so the altitude is $26°\text{-}42'$. According to B's shadow, it = 106.2/215 = 0.4939, so the altitude is $26°\text{-}17'$. This is a good agreement. It appears that the crestal region of a swell may have been near A, the trough near B, the next crest near A's shadow-end, and the next trough near B's. Then both A's shadow and B's are, in effect, lying on level water, as it had to be assumed they were.

Accepting the mean, $26°\text{-}29'$ as the altitude, and subtracting for the quarter-diameter effect, $0°\text{-}08'$, (Chapter 9, Section 4) $26°\text{-}21'$ is the altitude of the sun's centre. Taking now co-altitude $63°\text{-}39'$, co-latitude $64°\text{-}48'$, co-declination $112°\text{-}00'$, the nomogram, Fig. 31, gives the azimuth as $134°\text{-}00'$, west of north: whole-circle bearing is then $226°\text{-}00'$.

The angle that the fore-and-aft line of the barge makes with the shadow-lines A to AS2' and B to BS2', on the plan, is 22°-00' according to a large protractor. Then the barge is headed on a whole-circle bearing of 248°. It may be of interest to record that the true answer, obtained later in the ordinary course of triangulation by theodolite, was 248°-06'. Agreement within a degree could be considered very good. It may be borne in mind that the barge is more than 200 feet long overall; the image on the negative measured perhaps a centimetre.

The heights of the legs could of course have been obtained graphically. On the plan, Fig. 35B, there are points AH', BH', A', B', AS1' and BS1', found by dropping perpendiculars from AH, BH, A, B, AS1 and BS1, to P.V.'.

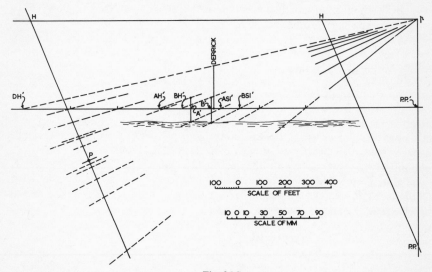

Fig. 35C.

Figure 35C shows a Principal Plane section, drawn to the same scale as the plan. The height of p above P.P.' is 372 feet. This result could have been obtained graphically by plotting data used in calculating it. The distances from P.P.' to the points AH', BH', etc., have been taken from the plan. A line from p to AH' passes through the centre of the head of Leg A, projected perpendicularly. A line through AS1, extended downwards, passes through the centre of the effective foot of leg A projected perpendicularly. The length of the vertical through A is the height of leg A; it scales 102 feet. The height of leg A above bulwark-level (plan-level), scales 47 feet. Similarly with leg B; lines p to BH', p to BS1', with a vertical through B, measure the height of the leg B; it scales 105 feet; and the height of leg B above plan-level, scales 47 feet.

The points AS2 and BS2 could have been projected to P.V.' on the plan, since the shadow-lines happen to lie almost parallel to P.V.'; so the projected position

of the shadow-ends, the appropriate sea-levels, and the projected position of heads of the legs, would have produced two projected versions of the sun's altitude. In this particular case these would have been very nearly true; but obviously if the shadows were not parallel to P.V.' the projected versions of the sun's altitude would be of no value.

On Fig. 35C the obliquity of the photograph and its epP can be found. The line p–H, the trace of the horizon plane, can be drawn. The line p–P.P.' extended, is the plumb-line. The distances, P.P.' to each of the grid-line cuts on P.V.' can be taken from the plan; each alternative cut will do; on the section these distances appear as short vertical bars on P.V.'. A family of lines radiating from p, each cutting the foot of a bar can be drawn.

Just as on any Principal Plane section, a P.V.' line can be inserted into a family of lines radiating out of p under control of a Trace of a Positive Plane, so a Trace of a Positive Plane can be inserted into a family of lines radiating out of p under control of a P.V.'. The spacing of the cuts of trapezoidal lines and the Horizon Line on the Principal Vertical, can be taken on a paper strip and fitted into the radiating lines, although the conditions for doing this are not as good as they ordinarily are when it is P.V.' that is being inserted. The conditions will be much improved in the present case if P.P. can be put on the paper strip; but it is at a great distance, about 105 cm from H. It will be more convenient to make a paper strip at, say, quarter-size and fit that in, for the sole purpose of finding the obliquity.

A quarter-size Trace of the Positive Plane is shown in position. Thus the Obliquity is found to be 67°. A paper strip at full-scale can now be prepared and be inserted to find an approximate position. Near to this, a line at the known obliquity can be drawn, to which the paper strip must be kept parallel in its final position, so finding the Trace of the Positive Plane. A perpendicular to the paper strip from p will cut in P, whose position should agree fairly well with that which could be found by use of the point H1, H2, PP. The epP of the photograph is then found: 390 mm.

As an illustration of the use of a vertical alignment, the legs of the barge could have been used to find the approximate obliquity. Going back to Fig. 34A, it will be found that a line through the heads of the bow legs is approximately parallel to the edge of the helicopter deck, which is itself level. A line through the heads of the stern legs is also approximately parallel in the same way, and lines through the heads of the port legs and starboard legs appear to go to the vanishing point of the hull-lines. Then it is likely that all four leg-heads are at one level; the sea-bed is probably flat and hard. Assuming a probable direction for the Horizon Line, a nominally horizontal line can be drawn through the head of the port stern leg. Measuring at right angles, from this line up to the head of the port bow leg is 11.0 mm. The 10 foot diameter of the leg measures 3.5 mm. A first approximation to the effective height of the leg is 10/3.5 x 11 = 31.4 feet.

The line of the port side of the port bow leg, extended, nearly cuts a corner of the house. This line is the trace of a vertical plane containing the camera and the leg. It has been put onto the small plan, Fig. 35A. A perpendicular to it, from the port stern leg, is the trace of a vertical plane, the upper horizontal edge of which is at the height of the head of the leg. From it, perpendicularly, to the port bow leg scales 97 feet. Then 31.4 feet of this leg is visible from the camera-station, over the top of a horizontal line that is 97 feet nearer to the camera. The tangent of the vertical angle, measured from the horizontal plane through the effective foot of the port bow leg up to the camera, is $31.4/97 = 0.324 = $ tangent of $17°$-$57'$ to a first approximation. A second approximation to the effective height of the leg is $31.4/\cos 17°$-$57' = 31.4/0.951 = 33.0$ feet; a second approximation of the tangent of the angle is $33.0/97 = 0.340 = $ the tangent of $18°$-$46'$. This will be enough. The obliquity of the photograph is $71°$-$14'$, or say $71°$, approximately, assuming that P is near to the images of the legs used. (If this value is amended for the known position of P, it will become about $68°$.)

Some approximation of the obliquity could have been obtained at once from the elliptical images of the heads of the legs, assuming that their mean position is in the vicinity of P. The major and minor axes of the four ellipses measure in mm; 3.5, 1.1; 3.6, 1.1; 4.1, 1.2; 4.2, 1.2. The mean major axis is then 3.85 mm, the mean minor axis is 1.15 mm. From a sufficient approximation, cosine obliquity $= 1.15/3.85 = 0.298$, Obliquity $= 72½°$ (If this value is amended for the known position of P, it will become about $70°$).

Also, the obliquity could have been found from the trapezoids if the place of P had been known. The left-going trapezoidal line at P makes an angle of $81°$-$15'$ by protractor with the Principal Vertical. This is a Pha angle at P (Chapter 7). The corresponding PLA angle, from P.V.' on the plan, is $68°$-$00'$ by protractor. Then:

$$\cos O = \tan PLA \cot Pha$$
$$= \tan 68° \cot 81°{-}15'$$
$$= 2.475 \times 0.154$$
$$= 0.3811$$
$$O = 67°{-}36'.$$

Chapter 11

Intersections with Ground Horizontals

A camera can be used in place of a plane-table to make a plan with heights of a small area containing a limited number of well-defined objects that are clearly recognizable from different view-points. Figure 36A is part of the framework of a plan of objects standing on a piece of irregularly broken ground. From a station, A, three overlapping Horizontals A1, A2, A3, have been taken, and from a station B, two, B1 and B2. Figure 36B shows the photographs. These are

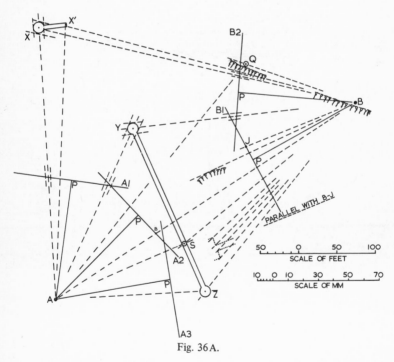

Fig. 36A.

assumed to have been taken with a camera set level on a support, such as a wooden box, itself made level by the use of a carpenter's spirit-level (see Chapter 12). The Horizon Line has been drawn on each print, parallel to the edges, through P.

A plan such as 36A can be made if the distance A–B is known and all of the

Fig. 36B.

necessary horizontal angles, e.g. X–A–B, A–B–X, have been measured. The photographs can be used to measure the angles and a simple procedure is as follows.

On the plan, plot the known distance A–B. On a transparency, plot the epP of photograph A2 as a line p–P. At P, set off a right angle and draw the Trace of the Positive Plane; on this, mark B, taking the distance P–B from the photograph, along the Horizon Line to the vertical through B. Lay the

transparency on the plan, with p on A, and B on the line A—B; prick through P
to the plan and remove the transparency.

Draw the Trace of the Positive Plane on the plan. With photograph A3 carry
out the same procedure. A position for the line A—S on the plan, as found from
A2, should agree exactly with one found from A3. If the epP of A3 differs from
that of A2, this is of no effect. In the illustrations, the epP is the same in all: 77
mm, which is very small, but it makes for convenience in the demonstration. In
plotting the Traces of the Positive Planes of A1, B2, the line to the point Y is
used exactly as the line A—B was used, the position of the line being found in
the one case from A2, in the other from B1.

Assuming that the camera was set level at each exposure, the heights can be
found easily, as in Chapter 8. To take further examples: on A2, B (top of box or
other support of camera at B) is 5.5 mm., above the Horizon Line, and on the
plan, from A to the Trace of the Positive Plane along the line A—B measures
78.7 mm; A to B measures 465 feet. If h is the height of B above A,

$$h/465 = 5.5/78{\cdot}7$$
$$h = 465 \times 5.5/78.7 = 32.5 \text{ feet, by slide rule.}$$

As a check, this can be repeated on A3. The corresponding figures are, 5.8 mm;
84.0 mm

$$h = 465 \times 5.8/84.0 = 32.0 \text{ feet.}$$

With B1, if the fall to A (top of box or other support of camera at A) is h',

$$h' = 465 \times 5.4/77.5 = 32.4 \text{ feet.}$$

On B2, the Horizon Line happens to cut the foot of a cairn, Q. Then the foot of
the cairn is at the height of the camera. To take the height of the foot of Q from
A2, the figures are 6.5 mm, 77.7 mm and 385 feet.

$$h = 385 \times 6.5/77.7 = 32.1 \text{ feet.}$$

With the tower Z, on A3 the measurements are, to foot of tower: 10.3 mm; to
top, 1.2 mm. On the plan, the distances are 78 mm and 197 feet.

$$h \text{ (foot)} = 197 \times 10.3/78 = -26.0 \text{ feet}$$
$$h' \text{ (top)} = 197 \times 1.2/78 = -3.0 \text{ feet}$$

On B1, the measurements are 15.5 mm, and 9.3 mm. On the plan, 83 mm and
308 feet.

$$h \text{ (foot)} = 308 \times 15.5/83 = -57.5 \text{ feet}$$
$$h' \text{ (top)} = 308 \times 9.3/83 = -34.5 \text{ feet.}$$

Then the tower is $26 - 3 = 23$ or $57.5 - 34.5 = 23$ feet high, and the ground it stands on is below A by 26 feet, or by $57.5 -$ (height of B above A $= 32) = 25.5$.

In practice such results as these for the height, e.g. B above A or A below B, would not be attained with prints of only 77 mm epP, but with prints of about 200 mm epP it would be expected to obtain results that agreed within 1½ to 2 feet over such distances; this is adequate for many practical purposes.

The results for the heights of objects, top to bottom, are naturally much more dependable than the heights of ground, which depend largely on the correct placing of the Horizon Line. For a particular camera, the true place of the Horizon Line on a print from an exposure made when the camera was supported on a surface made level by the aid of a spirit level, can be found experimentally. This is discussed in Chapter 12.

If the epP of two overlapping prints is identical, it does not follow that the height of an image in the overlap will measure the same on both prints. It is only necessary to consider that a vertical object subtends a certain vertical angle at p, and this angle will be the same as determined by either print.

Although this is really self-evident, it can be seen that in the case of B1 and B2 of Fig. 36A, the image of tower Y will be greater on B1 than it is on B2, in the proportion that the distance from p (= station B) to the Trace of the Positive Plane of B1 is greater than the distance on the same line to that of B2. On a large print the difference in image-size is plain to see.

The orientation, if not the position, of an obviously horizontal object can be found, e.g., the jetty seen only in photograph B1. The horizontal and parallel lines of it meet at J on the Horizon Line. J can be transferred to the Trace of the Positive Plane, and a line through J from B is parallel to the line of the jetty. If the plan-position of the jetty could be fixed, for instance by the use of a photograph taken at a point on the cliff-top at a known distance from S and from the wall, the height of B above the water level could be found. Conversely, if the height of B above water level had been found otherwise, the distance from B to the shoreward end of the jetty could have been found from the height. Assuming for example that B is 72 feet above the water level, and taking 22 mm from the photograph and 78 mm from the plan, the distance $= 78/22 \times 72$ feet $=$ 256 feet.

If the distance A–B is not known, but a distance, e.g. Y–Z, is known, the plan can be plotted with any convenient spacing of A and B on the paper, and after plotting is complete, the known distance gives the scale of the plan.

With the arrangement of photograph stations A and B on Fig. 36A, some points—the tower at X, that at Y, and Q—are fixed well, since they are cut by lines making roughly perpendicular intersections. But Z is not so well fixed, and S's fix is poor, unless it happens to be known that S is in line with Z and Y. Objects like the towers are plainly recognizable from different view-points, but in other circumstances it would be better to use two points from which the views are similar, not opposite.

In any event it is obviously an advantage to have three, or more, camera-stations rather than two.

If the objects to be fixed are close to the camera, or more particularly if the objects used to unite the various Traces of the Positive Plane on the plan are close to the camera, it is important that the camera station be a definite mark, such as a pencil mark on the box or other level support. When the camera is turned through an angle from one exposure to the next, it should be rotated as if around a nail driven through the lens vertically. An inch in ten yards subtends an angle of about 10′, which is plottable.

1. Stereoscopic Pairs

It is nearly always a great advantage to have stereoscopic pairs of photographs rather than single ones, especially so if there are a large number of not very distinct points to fix. These can often be picked out under a stereoscope and marked when they are scarcely distinguishable on a single print. Moreover some points may be found more easily in a photograph taken from a different, but similar view-point. To make a stereoscopic pair it is necessary only to take two exposures: the negative should be in the same plane at each but separated horizontally by a distance of three or four inches. This will produce a stereoscopic image that appears natural. The stereoscopic effect will persist to objects at a distance of 70 or 80 feet from the camera. For greater distances the base must be increased. It will generally be found that an apparently natural image is produced when the base is about 1/300 of the distance, or say a foot for objects 100 yards away. To produce the kind of effect that may be seen with vertical air photographs, the base length must be something between 1/5 of the least distance and 1/20 of the greatest, that is, with objects between say 100 feet and 300 feet, a base length between 20 feet and 15 feet may be used. This is intended to produce a useful exaggeration of parallax, that is, an exaggerated movement of images.

A simple procedure for taking stereoscopic pairs at a separation of a few inches or a foot or so, is to draw a line on the surface of the support, and take both photographs with the bottom front of the camera case in contact with this line.

If it is desired to take a pair at a wide separation, the simple thing to do is to keep the camera as level as possible, and at the same level all the time, and at each exposure aim at the most distant mark in the view. Then at least the pair will be "convergent", and so usable. "Divergent" pairs are not usable as a rule. It will be necessary to distinguish between the photograph taken for the purpose of making a pair, and that taken at the station point itself. If the base is small, there may be no way of distinguishing between them merely by their appearance. Perhaps the simplest method is to place some selected object in the

foreground of the view of the pairing photograph in each case, and remove it before the next station point photograph is taken.

A small pocket-stereoscope, such as that made by C. F. Casella and Co., London, is adequate for the purpose of examining pairs of photographs and picking out and marking points, but a mirror-stereoscope, as made by the same firm, is more convenient to use.

2. Photographs at Points Other than Stations

The photographs taken at the stations can be supplemented by others taken from useful auxiliary viewpoints, and these generally need not be true Horizontals, but merely nominally so, since they will be used only for short distances and small differences of height. In any case they may include something which will find the Horizon Line. The positions from which they were taken may be found from recorded notes of local measurements, or by Resection, some discussion of which follows (Chapter 14).

Chapter 12

Finding the Error of a Camera Used as a Level

A plane that is parallel to the upper and lower edges of the negative and passes through P on the negative and p in the lens system is not necessarily parallel to the plane of the base of the camera case. If the camera is placed upright on a horizontal surface, it does not follow that a horizontal plane will pass through P and p and that the upper and lower edges of the negative will be parallel to it. Then a line drawn on a print through P and parallel to the edges, will not necessarily be the trace of a horizontal plane, which is to say, it will not necessarily be the true Horizon Line. The position of this on a Horizontal taken in a particular camera is best found experimentally.

A stretch of still water at least 150 feet across makes a good horizontal plane of reference. On one side of the water, a level support for the camera may consist of a wooden box, on the top of which is laid a heavy piece of flat board about one foot square.

By the use of thin wedges and a long spirit-level (checked by reversing end for end) the board is made perfectly level. On this the camera is placed upright, facing across the water. On the far side two vertical posts are set up, carrying short horizontal cross-bars placed at exactly the same height above water as the camera lens. These marks should be practically equidistant from the camera, and placed so as to appear at the left and right sides of the view. Then the aspect of them should resemble that of Rods 3 and 4 as shown in Fig. 11A, if it be supposed that the rods carry cross-bars and that the foreground is a sheet of water. The arrangement in plan should resemble Fig. 11B.

On a print of the whole negative, P can be found by diagonals and the Horizon Line can be drawn through the images of the cross-bars. The displacement of P from the Horizon Line can be measured, and so can the angle (if any) that the Horizon Line makes with the edges of the print, or, better, with the bisector of the angle formed by the diagonal lines. This information can be used for the future, when the Horizon Line is to be drawn on a Horizontal taken with the same camera set upright on a carefully levelled support.

In practice it may not be possible to find P on a print to better than about 0.7 mm; and it may not be possible to reduce the tilt of a support-board to less than about 10 minutes, which, on a print of about 200 mm epP, is subtended by about 0.7 mm. Then a reasonably reliable result can be obtained only by taking the mean of three or four separate experiments. Between exposures, the support-board should be disturbed, and levelled anew.

What may be called the effective tip (front to back) of a camera standing on a

practically perfectly levelled support may be appreciable, whereas what may be called the effective tilt (side to side) is ordinarily too small to be detected. To find the latter, one method is to measure vertically at the left and right edges of the print, the distance from the lower edge to the Horizon Line, although measurements can be made from the bisector of the angle formed by the diagonals. To take a numerical example, with a tip of the kind to be expected, but with an exaggerated tilt:

pP of camera, infinity, 50 mm; epP of each of four prints, 200 m, width of prints, 144 mm.

No. 1, P (as found by diagonals) 1.8 mm above Horizon Line; No. 2, P 0.5 mm above Horizon Line; No. 3, P 1.1 mm above; No. 4, P 0.3 mm below. Mean result, P above Horizon Line 0.8 mm.

Measurement, mm, vertically at left and right edges of print, lower edge to Horizon Line: No. 1, 47.3, 45.2; No. 2, 48.5, 46.5; No. 3, 47.6, 46.1; No. 4, 49.5, 47.1. Mean result, left edge 48.2, right edge 46.2; difference = 2.0 mm.

These results are most conveniently expressed as tangents of angles; tip 0.8/200 = 0.004; tilt 2.0/144 = 0.014.

For the future, the Horizon Line can be drawn below P as found by diagonals, at a distance = epP x 0.004; and (a bisector of the angle formed by the diagonals having been drawn) at an angle with the bisector which can be found by the use of the tangent, 0.014. Thus, in the present case, if 50 mm is set off from P along the bisector to the right, and 50 x 0.014 = 0.7 mm is set off perpendicularly downward, the point so found is on a line parallel to the Horizon Line and passing through P.

It will usually be found that by making these corrections to the place of the Horizon Line, the internal agreement of a circuit of heights of ground is considerably improved, even though the camera is not very precisely levelled at each place. The height of objects, top to bottom, is not much affected by some displacement of the Horizon Line.

The experiment does nothing to discover the obliquity, if any, of a photograph taken with a levelled camera; that is to say, it does not discover if, when the camera-base is level, the negative is vertical; but the effect of a very slight obliquity can be safely supposed to be very small.

Distances along the Horizon Line, for use in measuring horizontal angles, can be measured from the point on the Horizon Line vertically below P. For this purpose, the precise place of P is not really required, since the angles are derived from the sum or difference of the distances.

Chapter 13

Subtense Measurement of Distance

1. The Use of a Portable Base

Distances up to about 100 metres can be measured with an error of about 1% or 1½% by photographing a suitable measuring-board held by an assistant. The board can consist of a light wooden batten about 15 feet or 4½ metres long, provided with targets (usually white) about 4 inches or 10 cm square, or circular of about the same size.

To measure a distance A—B, the board is held at B, horizontally, and perpendicularly to the line B—A, and at A the camera, normally hand-held, is aimed at the centre of the board, with the object of getting the image of the board-centre at P on a print, or nearly so.

If D is the direct distance from A to B, then

$$D = \frac{\text{half target space x epP of print}}{\text{half image width of target space.}}$$

In this of course, the distance D is derived from a right-angled triangle in which one side is half the target space. The angle opposite is that found from its tangent (half image width/epP) and the other side is D, the distance required.

To take a complete numerical example: pP of camera at infinity, 49.7 mm. Negative width, 36.0 mm. Print width (unmasked) 126.5 mm. Space between target-centres, 4.5 metres; space between images on print, 11.4 mm. Therefore

$$epP = 126.5/36.0 \times 49.7 = 174.7 \text{ mm.}$$
$$\text{half image width} = 5.70 \text{ mm.}$$
$$\text{half target space} = 2.25 \text{ metres}$$
$$D = 2.25 \times 174.7/5.7$$
$$= 68.9 \text{ metres (probably + or } - 0.7 \text{ metre)}$$

If several photographs have the same epP, then of course there is a constant; in the example above it is 174.7 x 2.25 = 393.1

It will be seen that the critical measurement is that of the image-width. In the example, an error of 0.2 mm in image-width produces a difference of 1.2 metres in distance. An error of 0.2 mm in pP produces a difference of 0.3 metre; an error of 0.2 mm in negative width produces 0.3 metre.

One effective way to measure the image-width is to use a pair of sharp dividers with a screw adjustment; take the measurement between the points as

113

carefully as possible, and "walk" the dividers along a line to multiply the distance by three or four, measure the result and divide.

In conjunction with overlapping Horizontals, distance-measurement by this subtense method can produce data for making a small plan, from a single convenient station. Where the board was when photographed, is shown by the print. If more than one station is used, where the camera was, when it photographed the board, is also shown, although not so directly.

The direct distances, D, obtained are of course the slope distances, if the board is higher or lower than the camera. Where Horizontals have been taken as well, the vertical angles up or down these slopes can be found well enough from those. The slope distance can be reduced to the horizontal equivalent by use of the expression: horizontal distance = slope distance cosine vertical angle.

If the board is held vertically, instead of horizontally, the camera is still aimed at the board's centre-point, with the object of getting the centre of the image at P. The distance found by direct calculation as in the example given will then be an apparent distance, AP. AP cos vertical angle = slope distance. Then horizontal distance = AP \cos^2 vertical angle. In practice if AP is deduced from AP = (half height of board x epP)/half height of image, and the vertical angle to the centre of the board is found, it is sufficient to make a percentage deduction from AP to obtain the horizontal distance.

Table II

Vertical angle	Percentage deduction
less than 5°	nil
5° to 7°	1
8° to 9°	2
10°	3
11° to 12°	4
13°	5
14°	6

If the vertical angle = a, then difference of height = horizontal distance tan a = slope distance sin a = AP cos a sin a = AP $\cos^2 a$ tan a.

If height of ground is deduced from distance and vertical angle, the height of the camera above ground must of course be taken into account, and also the height of the board above ground, if it is held horizontally; or, if it is held vertically, the height of that part of the board to which the vertical angle refers.

If the board was held horizontally, perpendicularly to the line to the camera, but the image of the board is far from P, it is necessary to determine the value of the angle subtended by the board, at p. In a plane triangle B1–p–B2, where B1

and B2 are the images of the targets on the board, the distance p to B1 is the hypotenuse of a right-angled triangle, one side of which is the distance from P to B1 and the other side is the epP. Similarly with the distance p to B2. The distance B1–B2 can be measured directly. Having all three sides, the triangle B1–p–B2 can be plotted at a large scale, and the angle at p found from its tangent by measurement. Then,

$$D = \frac{\text{half target space}}{\text{tan half angle at p}}$$

If this direct distance, D, is on a slope, the horizontal equivalent = D cos vertical angle, which vertical angle can be found from a Horizontal.

In the case that the board was held vertically, but its image is far from P, the angle at p in a plane triangle B1–p–B2 can be found as before. The distance then found by the use of the expression given above will be an apparent distance, AP; if the vertical angle to the centre of the board can be found, AP can be reduced to the horizontal equivalent by means of a percentage deduction taken from the table given above.

If for convenience high Obliques or inverted Obliques (see Chapter 14, Section 1) are taken to show the view and/or to measure useful horizontal angles, and the board is included left in the position where it may happen to be, instead of being moved to where it would come out at P, the problem of getting the vertical angle to the board-centre can be dealt with as follows: Draw the Horizon Line and the Principal Vertical, and mark the cut-point, H. Measure (1) board-image to Principal Vertical, and (2) board-image to Horizon Line. Calculate, or take from a plot, epP′, being the hypotenuse of a right-angled triangle in which one side is (1) and the other is the epP. Plot epP′ as if it were the epP of a Principal Plane section; draw the Trace of the Positive Plane, and on that plot H, taking the distance P–H from the print; from H set off the distance (2); rays p–H and p–point found by (2) contain the required vertical angle, approximately. The same procedure will of course serve with Horizontals. An exact value for the vertical angle that measures a moderate slope is not needed.

Two or more boards can of course be included in a single exposure. For a very small area, surveyors' rods marked in feet or decimetres could be set up at chosen points. To keep the distance-errors within about 1½ per cent. The distance to be measured should not be greater than about twenty times the height of a rod.

Irradiation will cause the images of the white divisions of a rod to come out larger than those of black divisions. Measurements of image-size must be made between image-ends of one sort, e.g. from top of white to top of white.

2. Camera-Position from Two Subtense Measurements

There should be an especially useful application of subtense methods in an inverse situation, that in which the board remains in one place but the camera is moved repeatedly. If two boards are set up vertically near to a shore-line and are photographed in a wide-angle camera from a boat, or by a swimmer using a plane-glass window underwater camera (which necessarily has a wide field-angle when used in air (see Chapter 14, Section 7) two distances obtained at a single exposure could be used to fix the plan-position of the camera relative to the boards. A survey of objects lying on a small area of inshore sea-bed in fairly shallow water could possibly be carried out by one person using nothing but a suitable camera and a plumb-line. Selected points of the area photographed undersea could be fixed on the plan by photographs taken in air at the water-surface.*

Since this kind of thing could be done only in calm water, there appears to be no reason why the "air-photographs" should not be practically Horizontals. The camera being close to the water-surface, and the targets on or near to the board-feet being close to the water-surface also, the images of these targets would be close to the Horizon Line. However, being disposed to the left and right in the view, they would be far from P, or, more explicitly, far from H, the cut-point of the Principal Vertical on the Horizon Line. A required distance, D, camera to board,

$$= \text{board height} \times \text{epP}'/\text{height of image of board} ,$$

where epP′ is the hypotenuse of a right-angled triangle in which one side is the distance from H along the Horizon Line to the board-image, and the other side is epP—or epP amended slightly for a small distance of H from P.

For example, suppose that Fig. 11A, Chapter 3, is a Horizontal of a shore-line, close to which stand Rod 3 and Rod 4. It may be imagined that the rods carry targets at top and foot, and that the space between target-centres is 12 feet. The epP of the print is 270 mm. The Horizon Line distance of Rod 3 is 88.3 mm, that of Rod 4 is 93.5 mm. Then since (it can be assumed) H coincides with P, the epP′ of Rod 3 is 284 mm, that of Rod 4 is 286 mm. Supposing that the image of Rod 3 measures 11.3 mm, that of Rod 4 11.5 mm, then

$$\text{D of Rod 3} = 12 \times 284/11.3 = 301 \text{ feet, by slide-rule}$$
$$\text{D of Rod 4} = 12 \times 286/11.5 = 298 \text{ feet, by slide-rule}$$

In this example the camera's field-angle, about 40° is rather too small to give a good fix by the two distances, which are in any case somewhat too great to be

* I am indebted to Miss Honor Frost for this suggestion.

taken from a 12-foot base, since the ratio of distance to board-height should not be more than about 20:1.

If there were a large number of points to fix, and it were possible to get prints at an exact enlargement, epP' for a given Horizon Line distance would be constant. Assuming the use of boards of equal height—possibly four or more of them distributed along a shore-line—a graph can be made, from which D may be read-off against image-height and Horizon Line distance. Such a graph is illustrated by Fig. 36C. This specimen is made for a 4-metre board and for epP 126 mm (from pP 36.0 mm and X 3.5). For example of the use of the graph, take image-height 9.4 mm, Horizon Line distance 47 mm; the figures find the point marked X, and the distance D can then be read as 57 metres.

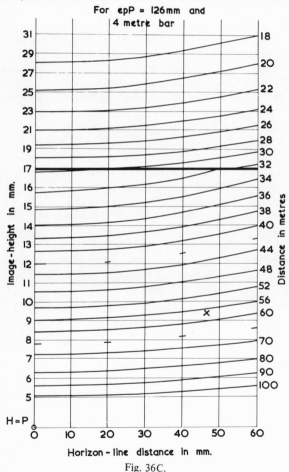

Fig. 36C.

This graph can be used with epP distances other than 126 mm, e.g. with epP = 110.0 mm, image-height 8.2 mm, Horizon Line distance 41 mm; if the epP had been 126, the image-height would have been 126/110 x 8.2 = 9.4 mm, and the Horizon Line distance similarly adjusted would have been 47 mm; the distance would be read as 57 metres. Evidently, the pP of the camera used does not signify only the epP of the print; and as with the epP, a change in board-height from 4 metres involves only a change of scale; if a board of 3 metres is used, the distance taken from the graph is to be multiplied by 3/4.

Useful approximations of much greater distances than about 20 times the board-height may of course be obtained, and quite good measurements of long distances may be obtained from a conveniently-placed existing base such as the known height of a house-corner.

If the camera is tipped down, taking an Oblique, the Horizon Line will appear well above P; and if the camera is tipped up, taking an inverted Oblique, the Horizon Line will appear well below P. In either case the Horizon Line will still be close to the images of the board-foot targets. The distance D as read from the graph, Fig. 36C, will be too small; but the possible obliquity is limited, and a useful and probably sufficient correction factor can be taken from another graph, Fig. 36D. This is made for epP 126 mm, but it can be used for any epP. For example, on a print of epP 155 mm, the measurement from P to H, downwards, is 24.6 mm; 24.6 x 126/155 = 20.0 mm. On Fig. 36D, against −20 mm, the solid line labelled 10 x Base gives a factor of about x 1.01, the dashed line labelled 20 x Base gives a factor of about x 1.015. If the distance D read from Fig. 36C (for image-height and Horizon Line distance as measured, x 126/155) is equivalent to ten times the board-height, it is to be multiplied by 1.01; if equivalent to twenty times, by 1.015, but it will be seen that it is not a critical matter. It is apparent that some upward tip of the camera has much less effect than a downward tip.

With any Oblique, in this context, the image-height should be measured parallel to the Principal Vertical, as with the height of an image contained between two Heighting Parallels (Chapter 4).

In a case where no board can be set up but there is some object such as a long

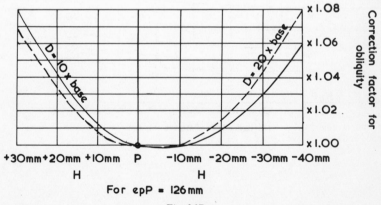

Fig. 36D.

building of uniform height, reckoning, say, from door-sills to eaves, standing on a shore-line and almost at water-level, this may serve in place of boards. The building-corners may be shown on a plan, but the height of them is unknown. Let one corner be A, the other B. Assuming a Horizontal, the vertical angle subtended by the height at A can be found from

image-height/epP′ = tan vertical angle

where epP′ is found from epP and the Horizon Line distance.

A series of distances D′ can be calculated by slide-rule, from

D′ = cot vertical angle x *h*

(= epP′ x *h*/image-height)

where *h* is taken as, say, 1.0, 1.1, 1.2, etc. With centre A and radius D′ at any convenient scale, a series of concentric circles can be drawn on the plan, each being named appropriately, 1.0, 1.1, 1.2, etc. Similarly with B, using the same scale. The result on the plan will resemble Fig. 39A, (Chapter 14, Section 5). As on that Figure, a smooth curve can be drawn through the cuts of the circles that have the same name. The plan-position of the camera is somewhere on the curve. The position can be found by drawing a "circle of position" derived from the horizontal angle A–p–B, as described in Chapter 14, Section 2; the circle will cut the curve at the camera-position.* Then the distances to A and B can be measured on the plan, and so *h′*, the real height of the building, for use at other camera-positions, can be found from

h′ = image-height x D/epP′

It is advisable to carry out some experimental measurements of known distances, with a particular camera that may be used in the field. The results are usually very good, which may be found surprising. The lenses of even quite inexpensive modern cameras appear to be very well-made, and film and printing-paper very stable.

The Construction of Graphs

A Figure such as Fig. 36C can be made quite easily with slide-rule calculations: Adopt some epP. For a series of Horizon Line distances such as 10, 20, etc. mm, calculate epP′ (or take it from a plot of epP and a Trace of the Positive Plane). Adopt a board-height. For each epP′ distance, calculate the image-height for a series of distances D in metres

image − height (mm) = board-height (metres) x ppP′/D

* A circle of position can be drawn in any case, if two shoreline marks of known plan-position are photographed. If both are boards from which a distance can be obtained, the circle gives a check on the position found by the cut-point of the two arcs of distance. If only one is a board, in some cases the camera-position can be found from one arc of distance and the position-circle.

At any convenient series of intervals on a base-line set up ordinates for Horizon Line distances 0, 10, 20, etc. mm. Draw lines parallel to the base, at convenient equal intervals, across the ordinates; label these lines with round-number values of image-height. On each ordinate, between the round-number values, plot the image-height value as calculated when using a corresponding epP′, for a given D. Through the points of equal D, draw smooth curves, preferably in colour. Since the spacing of the curves changes with varying D, it is necessary to reduce the image-height scale on the ordinates when D becomes small, to keep the graph at a convenient size overall.

It is likely that Fig. 36D itself, although it is small, will give a sufficient answer for any case where a correction for obliquity is required. The construction of such a graph is simple but tedious. If it is thought worth while to undertake it, one method is: adopt some epP; consider a plane triangle B1–p–B2, where B1 is the image of the top target, B2 the image of the lower, and p as always is the hypothetical perspective-centre of the lens-system; for a series of calculations adopt some likely value for the angle at p, say 3°; with this, calculate D in metres

$$D = \text{board-height}/\text{tan angle at } p \tag{1}$$

Let the distance p to B2 = epP″

$$epP'' = epP \sec a \sec b$$

where

$$\tan a = \text{distance P to H on the print}/epP$$

and

$$\tan b = \text{Horizon Line distance}/epP \sec a$$

In the case of an ordinary Oblique (Horizon Line above P)

$$\tan (180° - \text{angle at B2}) = \cot a/\sec b.$$

In the case of an inverted Oblique (Horizon Line below P)

$$\tan \text{angle at B2} = \cot a/\sec b$$

The image-height, B1–B2 = epP″ sin angle at p/sin angle at B1, the angle at B1 being known when the angles at p and B2 are known. The image-height should be reduced for the obliquity of the image-line to the Principal Vertical. Calling this obliquity 0′

$$\tan 0' = \text{Horizon Line distance}/epP \sec a \csc a.$$

The reduced image-height, B1′–B2′

$$= \text{B1–B2} \cos 0'.$$

With B′–B2′ and Horizon Line distance, a value for D can be taken from Fig. 36C, or calculated from

$$D = \text{board height} \times epP'/\text{B1′–B2′}$$

where epP' is derived from epP and Horizon Line distance as for Fig. 36C. The value for D, now obtained, can be compared with the true value obtained from the expression (1) above, and the ratio gives the factor to set against the P–H distance on a Figure such as Fig. 36D. This factor of course, holds good only for the adopted angle at p, which is to say, for the D found at (1), and for the Horizon Line distance entered into the calculation of tan b and of epP', and of tan 0' which is less significant. But it will be found that a factor changes only slightly over a fair range of the variables, and that it is enough to calculate with a Horizon Line distance of about 0.3 of the whole (width of print), and with two values for the angle at p, say 3° and 5°, so producing a graph with two curves. By the use of this graph a factor for a particular case can be estimated.

Chapter 14

Resection with Ground Horizontals or High Obliques

1. Resection of a Boat

Possibly the most useful resection that may be made with a small camera is one that will fix the position of a boat or a swimmer on a local large-scale chart at some instant of time.

Figure 37A illustrates three overlapping photographs taken in quick succession from a stationary boat about half a mile off shore. On a local chart, Fig. 37B, the objects shown on the photographs, A, B, C, D, E and F are identified. As shown on Fig. 37A, the three Traces of the Positive Plane, 1, 2 and 3, are assembled exactly in the manner of those of Horizontals to be used in Intersection. A tracing of the angles A–p–B, B–p–C, etc., can be made and transferred to the chart, and there manoeuvred into a position at which the rays

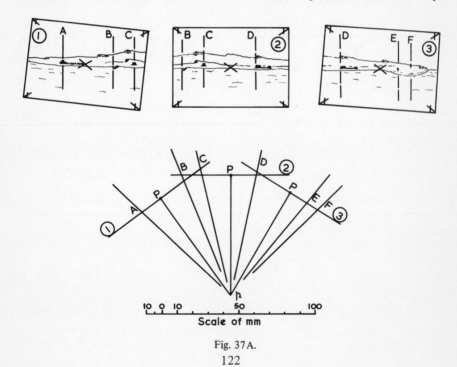

Fig. 37A.

122

cut the marks; then p is pricked through to the chart. This process is similar to that used to fit a marked paper strip into a family of lines radiating out of p on a Principal Plane section.

The angles A–p–B, B–p–C, etc., must be measured in the horizontal plane. If a photograph is a true Horizontal, the Horizon Line, which is the trace of the horizontal plane through the camera, passes through P, and lines drawn perpendicularly to it are the traces of vertical planes that pass through the camera. The distance of such a trace, from P, measured along the Horizon Line,

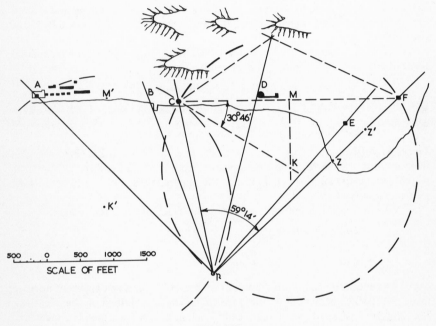

Fig. 37B.

with the epP, gives the tangent of a horizontal angle at p. Photographs taken with a hand-held camera in a boat or by a swimmer, are unlikely to be Horizontals, but they will be ordinary high Obliques with the Horizon Line above P, or inverted Obliques with the Horizon Line below P. If the Horizon Line is above P, the traces of vertical planes converge to P.P., and otherwise, with the Horizon Line below P, they converge to the zenith-point. If the traces of vertical planes are to be drawn, the position of P.P. or that of the zenith-point, must be known at least approximately. Ordinarily there will be nothing on the photographs in the way of converging images of truly vertical lines, that will find the one or other, but the obliquity is not likely to be great, and if the point

sought, P.P. or zenith, is distant, its exact position is not required. An approximate Horizon Line will usually be available in the shore-line itself. The distance of P from this will give the obliquity adequately, and then the distance P to P.P., or to the zenith-point, can be found.

The Principal Vertical can be drawn through P at right angles to the nominal Horizon Line, which it cuts at the point H, which is H of a Principal Plane section. Having the distance P–H and the epP of the print, the obliquity is found, and the distance P–P.P. (or P–zenith-point) is found. The tangent of an angle in the (nominally) horizontal plane is then found from, (1) the Horizon-Line distance from H to the cut of the trace of a vertical plane, and (2) the hypotenuse of a right-angled triangle in which one side is the distance P–H and the other is the epP.

To take an example with an inverted Oblique, Fig. 40B: P above apparent place of Horizon Line, 39 mm, epP 214 mm

$$214/39 = \tan \text{obliquity} = 5.49, \text{Obliquity} = 79° \text{-} 41'.$$

Let the distance from P to the zenith-point, along the Principal Vertical, be z. Thus

$$214 \tan \text{obliquity} = 1178 \text{ mm or, say } 1.2 \text{ metre.}$$

Traces of vertical planes to cut shore-marks and the Horizon Line can be drawn from a point 1.2 metre, measured upwards, from P, along the Principal Vertical, which can be drawn through P to cut the apparent place of the Horizon Line perpendicularly at H.

The distance p–H, required for plotting the Trace of the Positive Plane

$$= \text{epP cosecant obliquity,}$$
$$= 214 \text{ cosec } 79° \text{-} 41'$$
$$= 214 \times 1.016 = 217.4 \text{ mm.}$$

An inspection of the photograph (2) of Fig. 37A shows an apparent horizon through P (which is marked by the cross of diagonals as scribed on the negative). The obliquity of (2) is then practically negligible. Two scarp-ends appear one above the other, and another above the point D. Since the chart, Fig. 37B, shows the scarps, these alignments can be used to find an approximate chart-position of p. It is then seen that the shore-line shown on the photograph (2) must be approximately parallel to its Positive Plane; the shore-line is then almost as good as the sea-horizon itself as a Horizon Line, and so it can be used to draw traces of vertical planes through B, C and D. The C line can be copied to the photograph (1) by the use of detail, since a vertical plane through p that cuts this detail will cut it in any view taken from p. The obliquity of (1) is also negligible, but the view of the shore-line is oblique to the Positive Plane and so it does not make a good apparent Horizon Line. (Had the photographs not been taken well above water-level, the point would not have arisen. The fact that the photograph (1) is tilted with respect to the photograph (2) is of no significance.)

Verticals through A and B can be drawn parallel to that through C. Similarly the D vertical can be copied to (3) and the E and F verticals drawn parallel. At F a small piece of the true sea-horizon appears, which makes a check.

The assembly of Traces of the Positive Plane can now be made, using the epP of each print (these are identical in the illustration), and the various distances, P perpendicularly to the A line, P perpendicularly to the B line, etc. A tracing of the assembly of lines radiating out of p will transfer p to the chart.

In this, five angles have been used. Obviously the minimum required is two, but with two only, there is no check whatever on the work done or on the reliability of the chart.

If the shore-marks lie on the circumference of a circle which passes through p, then the place of p is indeterminate. This is illustrated by a circle through p, C, F, on the chart, Fig. 37B. If, for example, the point D were not by the shore, but nearly on the scarp behind, it would lie on the circle. Then the angle c–p–D would be unchanged for any position of p on the circle; similarly with the angle D–p–F. In such a case, the points C, D and F, could not be used, but the points A, B and D would give a good result which could be checked by the use of the points, A, C and F.

2. Circle-Chart

As an alternative to using a transparency, any angle found from the epP and Horizon Line distance as on Fig. 37A can be used to draw a circle of position. The intersection of two such circles fixes the position of p. The angle C–p–F can be measured on Fig. 37A. If an angle of $90° – $(C–p–F,) is set off from C–F on the chart, Fig. 37B, and a line is drawn to cut the perpendicular bisector of C–F at K, then K is the centre of a circle of radius C–K, on which circle p lies. If an angle of $90° – $(A–p–C) is set off from A–C, and a line drawn to cut the perpendicular bisector of A–C at K′, then K′ is the centre of a circle of radius A–K′, on which circle p lies.

If the epP of prints is large, better results can be obtained by measurements and slide-rule calculations. On the illustrations, the epP of all prints is the same and is small, only 78 mm, but this can be used to describe the method.

On the Trace of the Positive Plane 2, the measurements are, P to C, P to D, and on that of 3, P to D, P to F. These, each divided by 78, give the tangents of four angles, the sum of which is the angle C–p–F: (19.1/78; 16.5/78; 26.6/78; 20.5/78) = (0.245, 0.211, 0.341, 0.263); the angles are $13°$-45′, $11°$-55′, $18°$-50′, $14°$-44′. The sum is $59°$-14′. The angle to be set off from C (or from F) is then $30°$-46′, the tangent of which is 0.595. If 10 inches or other units are set off from C towards F on the chart, and 5.95 set off at right angles, a point is found through which a line can be drawn to cut K, which is then fixed by a perpendicular bisector of C–F. The angle A–p–c, and the place of K′, the centre-point, can be found in the same way; as can be any other angle, and place of the centre, when it is desired to draw the position-circle for that angle.

If an angle such as C–p–F = 90°, the centre-point of the circle is at the mid-point of the line C–F. If the angle is greater than 90°, the excess is set off at C (or F) from the line C–F, on the side remote from p, to cut the perpendicular bisector of the line as before.

A position of p, relative to shore-marks, may have to be recovered. One possible method is to set up alignments ashore. Thus the line F–p is drawn on

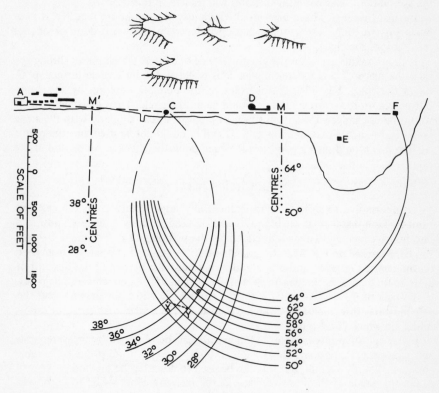

Fig. 37C.

the chart, Fig. 37B; on this line, a point Z′, in line with D and E, is found, by setting off the distance E–Z′, measured on the chart. Then a mark can be set up at Z, in line with Z′ and F. With two such alignments, a boat can be navigated into the close proximity of p. There may be natural alignments such as that of D and the scarp-end, to supplement alignments of set-up marks.

But if a sextant is available, then it is only necessary to find the point at which the angles found from the photographs, are read on the sextant. If this is to be attempted, it will save a great deal of time if a circle-chart is constructed.

Figure 37C shows a sufficient construction for the recovery of p. If, in the boat, the angle A–(p)–C is measured, and an instant later, the angle C–(p)–F, and these values are 37°-30′ and 51°-10′, the boat is at X on the chart; if, a few moments later, the point Y is found in the same way, it becomes apparent that the course must be changed immediately towards D, and a distance of a hundred yards run.

It may be noticed that if only three points, e.g. A, C, F are available, so that there is no check on the accuracy of the chart, an apparent position of p will be found relative to the supposed positions of the marks, and this apparent position is recoverable although, because of chart-error, the true position is unknown. In this case, the distance to run, e.g. from Y to p, may be quite inaccurate, but the change in the values of the angles as the boat proceeds will still lead to the recovery of the place from which the photographs were taken. In the absence of a chart of any sort, although there is no way in which p can be plotted, its position can still be recovered by the use of a sextant, failing of course two or three natural alignments. On Fig. 37A, the positions of A,B, etc., on the Traces of the Positive Planes, can be regarded as chart-positions, and a circle-chart can be made on this basis. On this, although distance has no meaning, the plotting of positions found by sextant-angles between the shore-marks will still lead to recovery of the place of p. If the circle-chart so made is at a large scale, with say ½ degree intervals between the circles, and if there are two sextant-observers and someone to plot the positions on the chart immediately, the recovery can be made in a single approach-run.

On Fig. 37B it may be observed that the angle C–K–M = C–p–F. That this is necessarily so can be seen by considering a position of p on the extension of the line M–K. With p in this position, the triangle C–p–F is isosceles; the angle C–p–M = (half the angle C–p–F) = the angle K–C–p; then the angle p–K–C = 180° – the angle C–p–F; but the angle C–K–M = 180° – the angle p–K–C; then the angle C–K–M = the angle C–p–F.

If it is required to plot distances along the perpendicular base-bisector, e.g. from M on Fig. 37C, the distance, D, is given by

$$D = ½ \text{ base cot angle.}$$

Thus if the distance C–F = 3310 feet, ½ base = 1655 feet, and the perpendicular distance M–K for the centre of the circle for the angle of 64° = 1655 cot 64° = 1655 x 0.488 = 807 feet.

It is not essential that two families of circles should have a common point, such as C on Fig. 37C. If the photograph 2 had not been taken, circles could still be made, one family on the base A–C, another on the base D–F.

It makes for easier use if two families of circles are drawn in different colours. A common choice is red (for Right-hand) and blue, which word at least contains the letter L, for Left-hand. On circle-charts with 1 degree spacing, (or less), some users prefer to colour alternate intervals completely, so producing e.g. the

"40-degree band". Adjoining this the "39-degree band" is white, and the "38-degree band" coloured again. This is useful for taking angles and plotting at high speed, four to six fixes a minute; but for leisurely work it is not necessary.

Another simple graphical method that can be used for the solution of a resection is as follows: taking for example Fig. 37B, the angle C–p–D is 25°-50', the angle D–p–F is 33°-20'; at F, from the line F–C, set off C–p–D, 25°-50', on the side of F–C remote from p, that is, on the shoreward side; at C, from the line C–F set off D–p–F, 33°-20' similarly. These two angles will find a point (near the scarp) which is on the circle through C–p–F, and is also on the line p–D produced. Then a line can be drawn through the point found, and D, to cut p. One position-circle will complete the fix of p. This method will obviously give a good result only when D is well away from the circle through p–C–F.

3. Resection from One Horizontal Angle and One Vertical Angle

Figure 38A is an inverted Oblique of a cliff, taken from a height of 50 feet above the water, close inshore. The great height makes a Principal Plane section, Fig. 38C, more open than would a more likely height such as 1 foot or 5 feet. The photograph shows two control points, A and B.

The chart, Fig. 38B, shows A at the cliff-top, B at the foot. The top of A is 238 feet above chart datum. The height of B is not known, but as seen, it was at water-level when the photograph was taken. At this moment, the tide-level was at 8 feet above datum. The horizontal distance A–B is 510 feet. by the chart. It is required to fix p, the camera-station, on the chart.

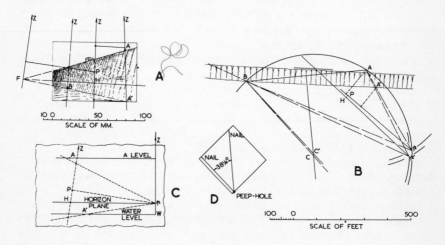

Fig. 38.

In the first instance the obliquity of the photograph can be ignored, since it cannot be very far from a Horizontal.

The vertical lines of the house on the cliff-top will do as a guide to drawing the Principal Vertical. The house happens to be well-placed, but there is usually something to serve for the purpose, even the mast of a boat afloat, if the sea is in a flat calm.

The nominal positions of the traces of vertical planes can be drawn through A and B. With the distances of these, from P, and the epP of the print (90 mm), an approximate value for the horizontal angle B—p—A can be found, and so a circle of position can be drawn, with centre C, on the chart. From the top of A to the water-line measures 57 mm on the photograph, along the nominal trace of a vertical plane, which is about 32 mm from P.

The effective distance from p to the Positive Plane is then the hypotenuse of a right-angled triangle in which the sides are 32 mm and 90 mm; it is 96 mm. The height of A above water-level is $238 - 8 = 230$ feet. If the distance from A to p on the chart is D, then

$$230/D = 57/96$$
$$D = 387 \text{ feet.}$$

Setting this off as an arc of circle with centre A to cut the position-circle, finds an approximate position for p.

Assuming that something better is required, a line p—P is drawn on the chart, by using a nominally horizontal angle P—p—A obtained from its tangent, $32/90 = 0.355$; the angle is $19°$-$30'$. The nominal place of A', a cliff-foot point in alignment with A and p, is marked. From A and A', perpendiculars are let fall to p—P. The distances from p to the feet of these are 370 feet, 285 feet.

On the photograph, perpendiculars from A and A' (probable position) are let fall to the Principal Vertical.

A Principal Plane section, Fig. 38C, can now be made, with, water-level line, and 50 feet above it, Horizon Plane, and plumb-line through p and W. From the plumb-line, the distance 370 feet is measured along the A-level line, and 285 feet along the water-level line, to find the points marked A and A'. On a transparency, p, P, and the Trace of the Positive Plane are plotted; on this the necessary distances from P to the A and A' perpendiculars are taken from the Principal Vertical, and the appropriate rays are drawn from p. The transparency being laid on the drawing with p on p, the rays p—A and p—A' are fitted as well as possible to the points A and A' on the A-level line and water-level line. P is then pricked through to the drawing, and the Trace of the Positive Plane drawn. The distance P—H is then transferred to the Principal Vertical on the photograph, through which the Horizon Line can be drawn.

Graphically on the Principal Plane section, or by calculation from the obliquity now found ($82°$), the distance from P to the zenith-point, z, is now found, and this can be plotted along the Principal Vertical; then traces of vertical

planes can be drawn through A and B. The Horizon-line distances of these traces, from H, with the distance p—H taken from Fig. 38C, give the tangents of two horizontal angles the sum of which is the angle B—p—A (38°-10′). With this, C′, an improved position for the circle-centre, is found, and a new arc of circle is drawn to pass near p as found originally.

On the photograph, P to A measures 42.0 mm; P to the cut of A—A′ and the Horizon Line, 37.0 mm. Let the latter point be h.

In a right-angled triangle with sides 90.0 mm and 42.0 mm, the hypotenuse is 99 mm; this is the side p—A in a plane triangle A—p—h. Similarly in a right angled triangle with sides 37 mm and 90 mm, the hypotenuse is 97.3 mm, and this is the side p—h. A to h measures 40.0 mm. Having all three sides in the triangle, this can be plotted and the angle A—p—h found, either by the use of a large protractor or by the tangent method; it is 24°-00′. The height of A above the horizontal plane = 230 − 50 = 180 feet. If D is the horizontal distance from A to p.

$$D = 180 \cot 24°\text{-}00′$$
$$= 180 \times 2.246 = 404 \text{ feet.}$$

This replaces the 387 feet found by approximate methods, and so p′, the corrected place of p, is found on the chart.

To recover the place of p′, a mark might be set on the cliff-top above B, on the line p—B extended, if there are useful details on the chart near the drawn line. A boat could be taken slowly along the alignment until the angle B—p′—A, set on a sextant, "came-in". Failing a sextant, a sighting-board, a kind of primitive quadrant, might be used. This is shown on Fig. 38D. The board is about a foot square, with the required angle (38¼°), drawn on it. Long thin nails are driven on the lines. The peep-hole (a hole in a small piece of tin plate nailed to the board-edge) should be, (in Newton's phrase used in another context) about "the bigness of a pease". In a perfectly calm sea, it is not difficult to keep the board horizontal and to maintain two points, such as B and a mark set behind it, on the cliff-top, in line with one nail until A appears above the other. With an angle such as 38° it is quite possible to watch two things practically simultaneously. This will at least bring a boat back into "the right parish", and limit the searching that may otherwise be necessary.

4. Resection from One Horizontal Angle and Transverse Obliquity

On Fig. 38B the cliff-top and cliff-foot lines are parallel. The cliff-top line appears to be level, since on the photograph it meets the cliff-foot line at the Horizon Line, at F, as found by the foot-line. Through F a line to the zenith-point z is drawn, and from it, a perpendicular H′—P is let fall to P. If the photograph is rotated clockwise through 90°, the line F—z becomes the Horizon Line and a perpendicular to P becomes the Principal Vertical. The cliff-lines

become the traces of horizontal and parallel lines. The obliquity, O of the rotated photograph can be found, for

$$\tan O = epP/P- Fz$$
$$O = 90.0/76.0 = 1.18$$
$$O = 49°\text{-}43'.$$

Then approximately, the line p'—H on the chart must cut the cliff-lines at an angle of $90° - 49°\text{-}43' = 40°\text{-}17'$.

On a transparency, the horizontal angles B—p'—H and H—p'—A could be plotted, with a series of lines drawn at an angle of $40°\text{-}17'$ from p'—H, and this transparency could be fitted on the chart so that p—B cut B, p'—A cut A, and the cliff-top line lay parallel to one of the series of lines. In this way, the place of p' could be found without recourse to the height of A.

In this case the (real) obliquity is $82°$, near to $90°$, and so the length of the line P—Fz is not very different from that of the line F—H. In general, it is not the obliquity, of the photograph considered as rotated, $(49°\text{-}43')$ that is required, but the horizontal angle H—F—p'.

The distance H—F measures 78.0 mm, P—H 12.0 mm. In a plane triangle H—F—p', there is a right angle at H. The side H—p' is the hypotenuse of a right-angled triangle with sides 12.0 mm and 90.0 mm; it is 90.8 mm. Then

$$\tan H-F-p' = 90.8/78.0 = 1.164$$

from which the angle is $49°\text{-}21'$. The line on the chart, p'—H, must make an angle of $90° - 49°\text{-}21' = 40°\text{-}39'$, with the cliff-lines.

Such useful cliff-lines are seldom, if ever, seen, but a substitute may be found in a line of buildings facing the sea, on a cliff that does not obscure most of them from below.

5. Resection from One Horizontal Angle and Two Vertical Angles

The usefulness of this variety of resection is best illustrated with a shore position the height of which is unknown. Given two points of known plan-position and known relative height, the horizontal angle between the two, and the vertical angle to each, the plan-position and height of the camera, relative to the fixed points can sometimes be found. The horizontal angle provides a circle of position. Each vertical angle defines a cone; the intersection of the two cones, projected to the plan, gives a position-line to cut the circle of position in the plan-position of the camera, after which the height can be found from either of the vertical angles.

On Fig. 36B suppose that the station B, from which the photographs B1 and B2 were taken, is not on the plan Fig. 36A, but that the object S and the tower X are on the plan; and that the photographs show nothing that could be

used to resect the camera-station B, except these two things S and X; that the height of the top of S, relative to a datum, is −12 feet, the top of X + 77 feet.

Given the epP of the prints, the horizontal angle S−B−X is obtainable at once, and so a position-circle can be drawn on a plan, Fig. 39A. The top of S is 12.0 mm below the Horizon Line on photograph B1 (Fig. 36B) and the distance to the Trace of the Positive Plane is 78.0 mm (Fig. 36A). Then the tangent of the vertical angle is 12/78. If it is now supposed that the top of S is the base of a cone in space, contours at equal height-intervals can be drawn on this cone. The contours, on the plan, will be circles around S as centre, and the radius for each of them can be found easily. A contour at a height of + 25 feet in the local terms will be 37 feet above S, the height of which is − 12.0 feet. If R is the radius of the contour, $37/R$ = tan vertical angle = 12/78.

$$R = 37 \times 78/12 \text{ feet}$$
$$= 240 \text{ feet.}$$

This is of course the same thing as putting $R = h \cot v$, where h is the height interval and v the vertical angle, but it is apparent that the vertical angle need not be evaluated at all.

78/12 = 6.5, is a constant for a series of contours. For the + 30 contour, R = 42 × 6.5 = 273 feet. Then to draw a family of contours at 5 feet vertical separation on the plan, Fig. 39A, it is only necessary to increase the radius, R, by 273-240 = 33 feet, for each 5 foot increase in height.

In exactly the same way, contours on the cone with its apex at the top of tower X can be imagined to exist, and to be projected similarly to the plan. On photograph B2, (Fig. 36B) the top of X is 8.2 mm above the Horizon Line, and the distance to the trace of the Positive Plane is 77.7 mm (Fig. 36A). Tangent of the vertical angle = 8.2/77.7.

For the + 25 foot contour,
$$R = 52 \times 77.7/8.2$$
$$= 493 \text{ feet.}$$

For the + 50 contour,
$$R = 27 \times 77.7/8.2$$
$$= 256 \text{ feet.}$$

Then the change in radius for 25 feet change in height = 493 − 256 = 237, so the change for 5 feet is 47.4 feet.

On Fig. 39A the two families of contours have been drawn; several more than necessary are shown.

Now whatever the position of station B may be, it must be such that the height of it, as found from S, is the same as the height as found from X. Then it must be at the intersection of some contour derived from S, with one of the same value derived from X. On Fig. 39A a line is drawn through all the available

intersections; this is a line of position for B, and the cut-point of the line with the circle of position found from the horizontal angle S—B—X is the place of B. The height of B can be found by interpolation between either family of contours: B stands on a 32 foot contour, as found from either S or X.

In this instance, one cone is ascending, the other descending, but the situation is essentially unchanged if both ascend or descend. In a particular case, it is apparent almost immediately whether or not the conditions are such that a fairly

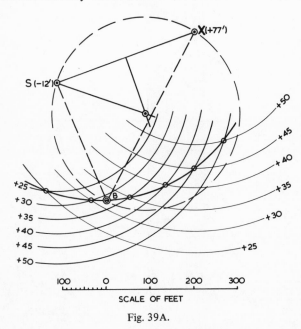

Fig. 39A.

reliable result can be expected. In general, the steeper the vertical angles, and so the closer the spacing of contours, the better the result, provided that the circles produce a position-line that cuts the position-circle at a large angle.

6. Simultaneous Resection of Two Points

If at a point X, the horizontal angle between two fixed points is measured, and also the angle between one of the fixed points and a point Y; and at the point Y, the horizontal angle between two fixed points, and also the angle between one of these, and X is measured, the positions of X and Y can be found. In some cases the conditions will be poor and the results unreliable, but this is shown up by the necessary construction. The principle used has been partly illustrated by the finding of a point on Fig. 37B; the point that lies on the alignment p—D, and on the circle of position through p, C, F.

Figure 39B shows six common situations in which the same principle can be used. In each of these cases, points A, B, C and D, are points whose plan-positions are known. Points X and Y are points at which horizontal angles as marked 1, 2, 3, etc., have been found from Horizontals (or high Obliques). Construction lines are shown in dashes, and the disposal of the measured angles 1, 2, 3, etc. is shown by the angles 1′, 2′, 3′, or (1 + 2)′, etc.

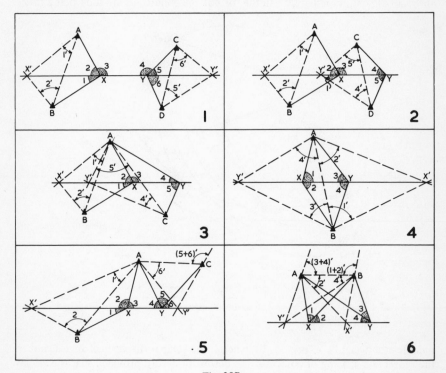

Fig. 39B.

Plotting of the angles 1′, 2′, etc., finds the plan-position of the line X′–Y′. The positions of X or Y on this line can be found by the use of a transparency on which has been drawn the line X–Y, of unknown length, from a point on which line rays have been drawn at, e.g. the angles 1 and 2 appropriately.

Alternatively, since X′ lies on a circle that passes through A, B, X, AX′ BX′, are chords of the circle, the centre-point of which can be found by perpendicular bisectors of the chords. Similarly with Y′.

Obviously, in case 1 for example, angles 1 and 2 cannot be measured directly, but having the sum of 1 and 2, and the angle 3, they are found immediately, since 1 is the sum of the three less 180°.

In case 5, with two points on the same side of XY, the angle 6 is considered to be like angle 6 of case 1, but reversed in its relation to the line joining the fixed points. Similarly the angle 5 + 6 of case 5 is considered to be like angle 5 of case 1, but with the direction of the ray reversed; in case 5, the angle Y'−C−A = angle 4.

In case 6, in which only A and B are used, and these both lie on one side of XY, it is sometimes better to proceed as follows: on a line of any convenient length, preferably 10 units, plot the angles 1, 2, and 3, 4, so finding positions of A and B relative to X and Y. This gives the distance A−B in terms of the scale used in plotting. The true distance being known, the true distance X−Y is found. The work can then be replotted on a transparency, which can be fitted to the plan. This procedure is sometimes the best with case 4. The plotting work itself in all cases shows whether or not the result is likely to be reliable.

In any case of doubt as to where to dispose of the measured angles, it is always possible to find an approximate position for X and for Y, or at least, to show that a good result will not be forthcoming, by plotting the X data on one transparency, and the Y data on another, and using the two together, while keeping the X−Y line on both transparencies coincident. This is troublesome, but it can clear up difficulty about the correct disposal of angles.

In a difficult case, in which there are several fixed points involved, not only two, three, or four, there is some advantage in using a heavy transparent material, and sticking a narrow strip of it along X−Y (edge to the line), on the underside of the upper transparency, and another such strip on the upper side of the lower one. The two stuck-on strips can be kept edge to edge as the upper transparency is slid along as necessary, over the lower.

By the use of three, or even more, transparencies, quite complicated problems in what might be called multiple-simultaneous resection can be solved graphically; there may be three unknown points, X, Y, Z, all interconnected, and associated with fixed points in ways that at first may appear quite inadequate. The answer (in so far as it can be obtained) is found when every available measurement has been taken into account and everything fits. In the cases illustrated, there are no auxiliary fixed points to provide checks, but in practice there will usually be at least two. The photographs will usually show points or marks that can be pressed into service in this way. X and Y, when established on the plan, can be used to intersect some mark, the position of which may be found by the use of other photographs, taken elsewhere.

A point Y, as photographed from X, may be a very distant sharp point perhaps on the horizon. If a point Ya, at a convenient distance from X, can be interpolated into the line X−Y on the ground—perhaps by visual alignment—then of couse Ya serves as Y, and its position can be found. Thus, if photographs have been taken as X (or before they are taken) it may be possible to set up a mark at X, and another mark on the line X−Y, on the side of X remote from Y. Then if the ground between X and Ya is impassable, but Ya can be reached

otherwise, it can be found from the visual alignment of X with the set-up mark beyond.

7. A Comparision of Resection by a Camera Held by a Swimmer, with Resection by Sextant-Angles Observed from a Boat

One advantage of an ordinary plane-glass window undersea camera is that it can take photographs in the open immediately before or after taking them undersea. Figures 40A and 40B are two inverted Obliques taken in this way with a

Fig. 40A.

Calypsophot camera. These were taken by Miss Honor Frost when swimming in Mellieha Bay in Malta, while engaged on the survey of the Mortar wreck*. Miss Frost has found that to get such photographs the plane-glass window must be streaming wet, that is, covered by a film of water that has not begun to break up into droplets. The original prints, enlarged x 5.90 from 36 mm film, showed fore-shore details quite sharply. As a test of what could be done, they were used to resect the position of the divers, who were engaged in lowering a marker-block carried on two forty-gallon drums, to the sea-bed; the position of the block had been fixed by sextant-angles taken from the boat when alongside it an

* "First Soundings on the Mortar wreck, Mellieha Bay, in 1967", Honor Frost. In publication by the Gollcher Foundation (National Museum, Valetta, Malta).

Fig. 40B.

Fig. 40C.

instant previously. Figure 40C* shows the result that the fix by camera, at the plotting-scale of 1/5000, coincided with the fix by sextant. The arrowed rays from p on Fig. 40C note the directions between which the sextant angles were read, and the figures give the approximate distances in feet to the shore-marks used by the observers. The two Traces of the Positive Plane are shown in position, with, on Fig. 40A's, rays to three scarp-points and two shore-line points, and with, on Fig. 40B's, rays to two scarp-points, four shore-line points, and both sides of the church on the hill. This particular comparison, which may be the first of its kind ever made, is remarkable for its very high apparent precision. The original plotting for purposes of the comparison, was done on available 1/2500 scale plans, which happened to adjoin perfectly when assembled, that is to say, changes if any in the paper-size were uniform. The sextant-fix was plotted with great care by semi-graphical methods using the natural tangents of the recorded angles, and the camera-fix in the same way, using the angles as obtained from the photographs by tangents. In the result, the sextant-fix plotted at about 1¼ mm (10 feet) to shoreward of the camera-fix, which was considered to be an excellent agreement. It was then remembered that, for what it was worth, the camera was to seaward of the divers by some small distance. The head of the right-hand diver in 40A is seen in profile. His head probably measures some 9 inches, 0.75 foot, nose to back of cranium. On the original print, this measured 13.0 mm. From p to the Trace of the Positive Plane at the diver's position, measured 222 mm. Calling the distance in feet D,

$$0.75/D = 13.0/222$$
$$D = 12.8 \text{ feet.}$$

So the final agreement was apparently within a yard. This result was of course fortuitous, and no doubt arose from compensation of small errors, since even if the angles had all been measured by theodolite mounted on a fixed platform in the sea, the remainder of the work, being necessarily carried out by graphic plotting on paper plans, could not be expected to give a result approaching such an accuracy. Some of the rays were more than two feet long at the 1/2500 scale. Nevertheless the coincidence was very gratifying.

In all the illustrations of resection (and intersection) the Trace of the Positive Plane has been drawn at its actual distance from p, to scale. In practice it is rather better to double the distance, and double the distances from P, as taken off by dividers along the Horizon Line. In some cases, in practice, this will put the Trace behind the reference-points on the plan.

*Map based on Directorate of Overseas Surveys Map D.O.S. 152 Sheets 10 and 13 by permission of the Controller of H.M. Stationery Office, with additional information from air photography flown under Directorate of Overseas Surveys' contract by Hunting Surveys Ltd, August 1968, by permission of Director of Public Works, Malta.

Chapter 15

Intersection with Ground Obliques

For the purpose of making a plan with heights, overlapping Obliques taken from any available high points can be more effective than Horizontals.

A levelled camera-support, as may be used with Horizontals, is not difficult to arrange, and may be very useful. In some circumstances it may be worth while to construct a support with which obliquity can be set, or read; that is, a support by which a given fore-and-aft tip can be given to the camera, while lateral tilt is obviated. If this were to be done, for instance at an archaeological site where repeated surveys were required at different stages of an excavation, repeated photography from the same fixed stations would be very easy to deal with by the use of set constructions on transparencies.

In the ordinary course, with a few Obliques taken from two or more high stations overlooking an area of which no plan exists, the obliquity has to be discovered from internal evidence. Once this is found it is as easy to deal with Obliques as with Horizontals.

Possibly the most generally useful example of what can be done is given by a case in which, in certain conditions of light, submerged artifacts are plainly visible under shallow water at or near to the foot of a sea cliff. If these are photographed from two view-points, the distance between which can be measured later, a plan can be made and some measure of the heights of submerged objects can be obtained.

Assuming that some form of levelled support for the camera is available, the camera is placed on it facing the direction required and a pencil-line is drawn on the support along the front of the camera-case. Keeping the camera in contact with the line, it is tipped downwards until the sea-horizon is near to the upper edge of the view, and an object, preferably near to the Principal Vertical, is in the foreground. Photograph 1 is taken. The camera is then tipped down further, until the object is in the background, and some other object is in the foreground, again preferably near to the Principal Vertical. Photograph 2 is then taken. Photograph 3 is taken at the final tip downwards, and this one probably includes the view it was desired to take originally. The camera is now turned around a mark made under the lens, into a different horizontal direction; a new pencil-line is drawn, and the process of taking overlapping Obliques repeated in reverse until the sea-horizon is photographed again. A further change of direction probably brings the other camera-station into view. The result is some seven prints, overlapping vertically in two sets of three which overlap laterally, and a single print showing some part of the sea-horizon and the second camera-station.

Figure 41A shows three overlapping Obliques, A1, A2 and A3 taken from station A. A1 shows the sea-horizon and a buoy, O; A2 shows the buoy and some submerged structures which appear in the overlap with A3. Given the epP of the prints, a multiple Principal Plane section can be constructed, from which P.P. of A2 and P.P. of A3 can be found. In this section, the Apparent Horizon is marked AH, and the true Horizon Line is above it by the amount of the Dip (Chapter 6).

Fig. 41A.

The difference is really negligible in this case, in which the height of the cliff is only about 60 feet; the Dip is then $\sqrt{60'}$, or 8', an angle which is scarcely plottable in fact. With a camera set level, side-to-side, the sea-horizon should be parallel to the print-edges (Chapter 12) and so the Principal Vertical can be drawn on all three prints. The construction of the section is begun by drawing the Trace of the Positive Plane for A1, setting-off the trace of the horizontal plane p–H, A1, and perpendicular to it, the plumb-line p–P.P. The buoy, O, is projected to the Principal Vertical, and the line p–O drawn on the section. By the aid of a transparency used as with the Horizontals (Chapter 11) the Trace of the Positive Plane of A2 can now be introduced, using the buoy as the common

point; the Trace of the Positive Plane of A3 is introduced similarly, using some part of one of the structures as a common point.

On the illustration, epP of all the prints is the same, 140 mm. Obviously relatively small prints can be used with photographs intended only for bringing down a Horizon-Line parallel to a lower large print.

Prints A2 and A3 are now under control. It is required to use them in the first instance to measure horizontal angles, so that a ray such as A1, A2, A3, can be drawn on a plan in the proper relation to another ray such as A4, A5, A6, and to yet another such as A7, as shown diagrammatically on Fig. 41A. These rays are the plan-positions of the various multiple Principal Verticals, and so are marked P.V.'. Print A2 could be used to measure the horizontal angle at Station A,

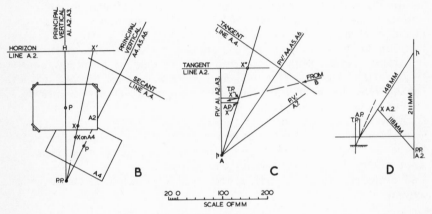

Figs. 41B, 41C and 41D.

between P.V.' of A2 and the object X, which is assumed to appear again on a print A4, which in turn, can be used to measure the horizontal angle between X and P.V.' of A4.

Figure 41B is the Positive Plane A2 (with the Positive Plane of A4 shown alongside). On the Positive Plane of A2, the Principal Vertical is drawn; the distance P–P.P. and the distance P–H have been taken from the Principal Plane section. Through H, the Horizon Line is drawn. From P.P. a line through X cuts the Horizon Line, at X'.

Figure 41C is part of a plan being constructed. On this, P.V.' for A2 is drawn, and a 'Tangent Line' for A2; the distance p–Tangent Line = p to H A2 on the Principal Plane section. The distance H–X' is taken with dividers from the Positive Plane and set off from P.V.' along the Tangent Line on the plan, so finding the point X". A line p–X" makes, with P.V.', the PLA angle corresponding with the Pha angle made by the line P.P.–X' with the Principal Vertical. This is a variant of the method for graphical conversion of angles discussed in Chapter 7

The Tangent Line on the plan is so called here, because in the expression given in Chapter 7,

$$\text{tan PLA} = \text{tan Pha sec O}$$

the distance X″ to P.V.′/the distance p to H on the section = tangent of the PLA angle; where the distance, X′ to H/the distance H to P.P. = tangent of the Pha angle; and the distance H to P.P./the distance p to H = secant of the obliquity.

In using this method for the conversion of angles, it is naturally only the ratio of the distances that is required. With a print A4, the distance H–P.P. may be inconveniently great. To take figures, suppose it is 318 mm, and p to H is 272 mm. Secant of obliquity = 318/272 = 1.169. In place of the Horizon Line on the Positive Plane of A4, a Secant Line could be drawn at 11.69 units from P.P., and a Tangent Line at 10.0 units from P.P.′ (= p) on the plan; or, obviously, a Secant Line at 5.84 units and a Tangent Line at 5.0 units. On Fig. 41C, the Tangent Line for A4 is drawn at 9 inches from p, supposing that to have been a convenient distance on the paper; then a Secant Line for A4 is drawn at 9 x 1.169 = 10.52 inches on Fig. 41B. With Horizon Line (or Secant Line) and Tangent Line drawn, it is the work of a moment to transfer an angle from Positive Plane to plan. In practice the Positive Planes would not be laid together as shown on Fig. 41B, since of course each Positive Plane construction is independent of others. The Pha angle at P.P. between the Principal Vertical of A2 and the Principal Vertical of A4, cannot be measured directly, since part of it is at the obliquity of A2 and part at the obliquity of A4.

If a distance, e.g. P.P. to H, is too great to be found graphically at all conveniently, then

$$\text{P–P.P./epP} = \text{tan obliquity}$$
$$\text{P–H} = \text{epP cot obliquity}$$
$$\text{p–H} = \text{epP cosec obliquity.}$$

On the plan, shown diagrammatically on Fig. 41A, the angle between the P.V.′ line for A1, etc., and the P.V.′ line for A4, etc., is of course obtained from the sum of the PLA angles derived from the Pha angles, e.g., H(A2)–P.P.–X, X–P.P.–H(A4), until the angle to station B is reached.

With measured ground distances such as those shown on Fig. 41A in diagram, A to 1, 1 to 2, etc., the ground distance A–B is obtained by plotting. The B series of photographs are used to produce rays from B to intersect those from A, and so to fix plan-positions of such points as can be found on an A photograph and again on a B. The intersections fix the true plan-positions of objects, submerged or not.

In practice it will not be found necessary (or possible) to intersect more than a few points: but with a few points fixed, and hence an appreciation of what the

obliquity (and the refraction of light) does to the apparent places of submerged things, some detail can be filled in by careful sketching.

In the absence of any levelled support for the camera, it is possible to "bring down" the sea-horizon to a lower view fairly well by aligning an edge of the camera-case with the sea-horizon. This will usually involve moving the eye from the view-finder to a position in which the horizon can be seen over the case. If there happen to be several things on the sea, among which a line parallel to the horizon can be drawn on a photograph A1, this line can be copied to a photograph A2, with care, from which a similar, lower line, can be copied to A3. Similarly the Principal Vertical of an A1 can be used at least as a guide to the Principal Vertical of an A2, but with a hand-held camera there is no certainty that it was tipped downwards in one vertical plane, without any horizontal rotation. However, the result overall may be a useful sketch with some control.

1. Heights of Submerged Objects

Assuming that the camera was supported, and tipped around a horizontal line, some measure of the heights of submerged objects can be found. The results cannot be expected to be very accurate, but they may be useful. The heights cannot be measured directly by the use of Principal Plane sections, because the refraction of light at the interface between the water and the air produces displacement, in the vertical sense, of the photographic images. According to the law of refraction (7) called Snell's Law, in 1626, after Willebrord Snell, of Leyden,

$$n \sin i = n' \sin i'$$

where i is the angle of incidence and i' the angle of refraction, measured from the normal to the interface, and where n is the refractive index of the first medium and n' that of the second. The refractive index of water can be taken as 1.33, that of air being 1.0 Then,

$$1.33 \sin i = 1.0 \sin i'$$
$$\sin i' = 1.33 \sin i$$

The apparent place of a small submerged object as seen on a photograph is the point on the water-surface from which the ray of light from the object came to the camera. This ray travels from object to camera in one vertical plane. In air it travels at an angle i', which can be measured. Then the angle i at which the ray travelled from the deep to the surface is found. The apparent place is of course unique to a given view-point. If the apparent place as seen from A is cut by a plan-line, and the apparent place as seen from B is cut similarly, the intersection of the lines is the true plan-position of the object. The distance from the true place to an apparent place, with the angle i, measures the depth of the water, for if the distance is s, and the depth d, $d = s \cot i$. With a submerged vertical object of appreciable height, there is one true place as found by intersection, an apparent

place of the foot, and an apparent place of the top. Since the two depths can be found, the height of the object is found.

On the Principal Plane section for photographs A1, A2 and A3, Fig. 41A, the buoy O (close to the Principal Vertical) was used as a common point, in the overlap A1–A2. The buoy having been intersected from A and B its horizontal distance from A is known; this distance (being practically equal to the distance as projected to P.V.') can be set off along the trace of the horizontal plane, and a perpendicular let fall to cut the ray p–O. Through the point so found the water-line is drawn on the section. Thus the height of p above water level is found. On A2, what appears to be a block of masonry lies below P, on the Principal Vertical. In this case it can be dealt with easily. Assuming that at least two opposite corners of the block have been intersected from A and B, so that it can be plotted on the plan, the horizontal distances from A are known, and these can be set off on the section, and verticals (T.P.) drawn to contain the block. The distances from P of photograph A2 to the nearer and farther lines of the top, and to the line of the foot, can be transferred to the Trace of the Positive Plane, and the three rays p–A.P. drawn to meet the water-line. The three i' angles P.P.–p–A.P. are found: 46°-15', 42°-00', 41°-45'. (These, on a plot at a large scale, would be found from their tangents.) The three sines are, 0.722, 0.669, 0.666. Then the three sines i are 0.541, 0.502, 0.499. The three angles i are 32°-45', 30°-08', 30°-00'. These are set off at the water-line from the verticals at the A.P. points, producing the lines which cut the T.P. verticals at the top and foot of the block, so finding its height and depth below the surface at the plan scale.

With a point that stands well away from the Principal Vertical, it is really a matter of choice whether to project to the Principal Plane or to make a special vertical section. If the first course is followed, a projected version of the angle i' is used to find a projected version of the angle i. If a special section is made, in the vertical plane containing the point and the camera, i' is obtained from that section. This is illustrated in the case of the point X of the photograph A2. On Fig. 41D, the horizontal distance from p (station A), to T.P. of X, is assumed to have been obtained by the intersection of X from A and B. The height of p above water-level has been taken from the Principal Plane section. The plane triangle P.P. (of A2)–p–A.P. has been drawn by the use of the side-lengths of the plane triangle P.P. (of A2)–p–X (on A2) as follows: P.P. (of A2) to X, 118 mm, from the Positive Plane, Fig. 41B; P.P. (of A2) to p, 211 mm, from the Principal Plane section; p to X, 148 mm, is the hypotenuse of a right-angled triangle in which one side is the epP of A2, 140 mm, and the other side is P to X on A2, 48 mm. A line p–X then cuts the water-line at A.P. The angle P.P.–p–A.P. is found (on a large working plot) to be 33°-36'; this is the angle i', from which $i = 24°$-30'. The latter angle is set off at A.P. from the vertical, cutting the T.P. vertical at the sea-bed; so the depth is found, at the plan scale used to plot the horizontal distance p (station A) to T.P.

If the work is done by projection to the Principal Plane the result is effectively the same. In its projected form, i' becomes 32°-12′, whence i becomes 23°-37′; but of course the space A.P.–T.P., from which the depth is derived, is reduced by projection. In this example, if the space A.P.–T.P. as found in the special section (Fig. 41B) is taken as unity, the depth = cot 24°-30′ = 2.19. The horizontal angle involved (Fig. 41C) is about 18°-30′. Then the depth as found by projection to the Principal Plane is, cos 18°-30′ cot 23°-37′ = 0.948 x 2.287 = 2.17, by slide rule. T.P. and A.P. of X, as projected to the Principal Plane, are marked (T.P.′) and (A.P.′) on Fig. 41A.

It is not really necessary to calculate angle i, given angle i'. For graphical work on images that are normally shadowy at best, it is enough to amend angle i' itself, by multiplying it by a factor like 0.75.

Table III

Angle i'	Multiplier
20°-30°	0.74
30°-35°	0.73
35°-45°	0.72
45°-50°	0.71
50°-55°	0.70

In the example of work above, $i' = 33°-36′$ was found to produce $i = 24°-30′$. By the Table above, 33.6° x 0.73 = 24°.5. Again, i' 46°-15′ gave i 32°-45′; 46.2° x 0.71 = 32.8°. For plotting with a protractor a line probably only a couple of cm long, this is a sufficient accuracy.

2. False Horizon Line

If on photograph A1 the sea-horizon had been obscured by land or cloud, but a distant point, M, was visible, and could be found on a local chart or map, this could be used as a false horizon point. If the chart showed that the shore-line from M for some distance to the right in the view, stood perpendicular to the line A–H (which line, as P–H, on the photograph A1 cuts a headland and so could be drawn on the chart) that part of the shore-line on the photograph would be parallel to the horizon. Having an approximate height h, of camera above the water, and D, the distance to M, it is enough to put $h/D = \tan a$, where a is the depression of M below the horizontal plane.

Failing a piece of shore-line perpendicular to the line A–H, another distant point, N, (photograph A1) may be recognized and found on the chart. The distance D being known, $h/D = \tan b$, where b is the depression of N below the horizontal plane.

Since a photograph with the sea horizon included, (although not visible) is a high Oblique, it will be enough to treat it as a Horizontal. To take a numerical

example: P of photograph A1, to M, 28 mm; epP of print, 140 mm; p to M is then the hypotenuse of a right-angled triangle of sides 28 and 140; P to M = 143 mm. A to M itself is 1 220 feet by the chart.

Height of camera 60 feet, above water level.

$$60/1220 = \tan a = 0.049$$
$$m/143 = 0.049$$
$$m = 7.0 \text{ mm.}$$

P to N, 66 mm. Then p to N = 155 mm. A to N itself 540 feet.

$$60/540 = \tan b = 0.111$$
$$n/155 = 0.111$$
$$n = 17.2 \text{ mm.}$$

If an arc of a circle of radius 7.0 mm is drawn with M as centre, and another of radius 17.2 mm with N as centre, the Horizon Line, above M and N, should be tangential to both arcs. The result would be more reliable if there were another point at the left of the view.

With a point as close as N to a cliff 60 feet high, the height of the camera above water-level must be known quite accurately since, as may be seen in the example, an error of two feet in the height will produce an error of 0.5 mm on the photograph; but with a point at, say, two miles away, a good estimate of the height will do. At 10,000 feet, an estimated height of 60 feet gives $\tan b = 0.006$, 30 feet gives $\tan b = 0.003$, and (say) 155 x 0.006 = 0.93 mm, 155 x 0.003 = 0.46 mm; a 30 foot error produces only 0.5 mm. With a good approximation of the place of the Horizon Line, a good approximation of the vertical angle to a surface point such as O can be found. Since a small error in obliquity of a low Oblique produces only a small error in PLA angles, the distance to the point intersected is known at least to a fair approximation, and so at least an improved estimate of the height can be obtained, which will give an improved version of $\tan b$.

3. Stereoscopic Pairs

As in any work done from ground-stations, it is worth attempting the taking of stereoscopic pairs (Chapter 11). With a camera pointing down, there is no distant mark to aim at with the intention of keeping the camera axis practically parallel to one direction at both exposures of a pair. Some help may be got from the use of a plank of wood, resting on steady supports. If this can be arranged, the camera can be kept aligned with one edge of the plank as it is moved along it from one exposure to another. In this way a base of several feet may be

obtained. It is usually possible to "fuse" individual objects fairly well even if they are submerged. The distortion on each print is very much the same. The stereoscopic photographs should be positively identifiable for what they are, as distinct from those taken at fixed points.

Chapter 16

Intersection with Air Obliques
1. Level-Square Ground Control

Figures 42A and 42C are low level air Obliques of the area photographed by Horizontals in Chapter 11. The epP of each print, the photograph S and the photograph E, is 231 mm. On each, P is inside a trapezoid drawn in a solid line; this is the virtual image of a 100-foot square set out on the only piece of level ground available. This makes a very small control but it can be used to demonstrate a method of making a plan, Fig. 42E. By the use of the system described in Chapter 1, arrays of trapezoids are generated to cover the prints and to find the Horizon Line; hence, the Principal Vertical.

The array of trapezoids is the virtual image of a grid of 100-foot squares, standing at the level of the ground on which the initial square was set out. If some object on the ground occupies the same apparent position in the grid as seen from the two different view-points, that object stands at the level of the grid. The apparent position of the cliff-edge from the grid-point 5B to the grid-point 6A, and again from 5B to opposite the object S, is the same according to both photographs. Then these parts of the cliff-edge stand at the level of the grid and they can be put on to the plan at once. Nowhere else is such agreement in apparent position seen, so everywhere else the ground is above or below grid-level. The positions of things can be found only by intersection.

The Principal Plane section for each print can be made by the use of the method described in Chapter 4. Figures 42B and 42D find the place of P.P. on each Principal Vertical and the place of P.P.' corresponding to P.V.' on the plan, Fig. 42E.

On Fig. 42B, p–H measures 297 mm; H–P.P. 473 mm. As discussed in Chapter 15, a method that is a variation on the method described in Chapter 7 can be used for the conversion of angles at P.P.: 473/297 = secant O = 0.1592. If a Secant Line is drawn on the Positive Plane of the photograph S, at 15.92 inches from P.P., and a Tangent Line at 10.0 inches from P.P.' on the plan, Pha angles on the Positive Plane can be converted to PLA angles for the plan immediately. On the Positive Plane, rays are drawn to cut A, Z, S, etc., and prolonged to cut the Secant Line. The intercept of each ray, taken with dividers from the Principal Vertical, is transferred to the Tangent Line on the plan, on which the rays P.P.' to A to Z to S, etc., can then be drawn. Working in exactly the same way with the photograph E, rays to A to Z, etc., are drawn from P.P.' of photograph E, to intersect the points A, Z, etc.

Heights are obtainable from either photograph. For example the top and foot

148

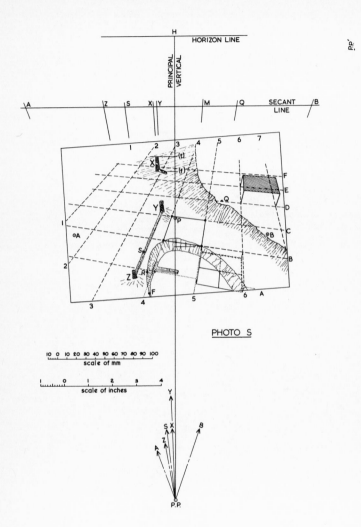

Fig. 42A.

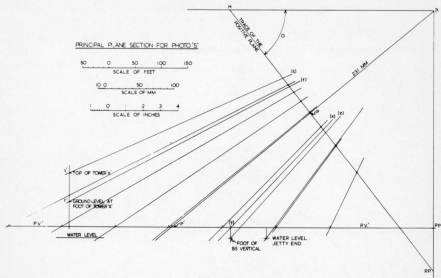

PRINCIPAL PLANE SECTION FOR PHOTO 'S'

TRACE OF THE POSITIVE PLANE

231 MM

50 0 50 100 150
SCALE OF FEET

10 0 50 100
SCALE OF MM

1 0 1 2 3 4
SCALE OF INCHES

t' TOP OF TOWER 'X'

t'' GROUND LEVEL AT FOOT OF TOWER 'X'

P.V.'

WATER LEVEL

P.V.'

PP'

FOOT OF B5 VERTICAL

WATER LEVEL JETTY END

PP'

Fig. 42B.

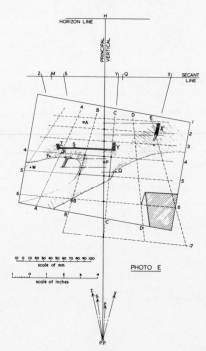

HORIZON LINE H

PRINCIPAL VERTICAL

Z M S Y Q X SECANT LINE

PHOTO E

10 0 10 20 30 40 50 60 70 80 90 100
scale of mm

1 0 1 2 3 4
scale of inches

PP

Fig. 42C.

(t) and (f) of the tower X are projected perpendicularly to the Principal Vertical of the photograph S; the positions of the perpendicular-feet are transferred to the Trace of the Positive Plane on the Principal Plane section (Fig. 42B) and the rays to t′ and f′ drawn; on the plan (Fig. 42E) the intersected position of tower X is projected perpendicularly to P.V.′ and the projected distance from P.P.′ is transferred to P.V.′ on the section, where a vertical is set up to cut the rays from p at t′ and f′. So it is found that the tower is 53 feet high, and stands on ground at 47 feet above grid-level.

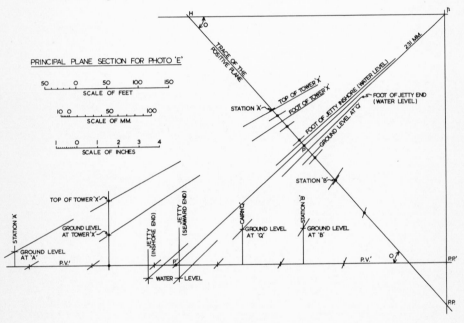

Fig. 42D.

The height of grid-level above water-level is obtainable in the same way; the grid is found to be 20 feet above water-level according to either photograph, which, with similar agreement at the tower, checks the work done. Similarly, any points above or below the grid that can be clearly recognized on both photographs can be intersected and their heights found, e.g. some cliff-edge marks, R and F, which are below grid-level.

On the photograph E, the foot of the cliff is partly out of sight, but it appears on the photograph S. The water-line at the cliff-foot is 20 feet below grid-level. It can be put on to the plan by dropping trapezoid 5/6—A/B vertically downwards by 20 feet. (This process is discussed in Chapter 9, Section 7.) On the photograph S, a perpendicular to the Principal Vertical is let fall from B/5; the distance from P is transferred to the Trace of the Positive Plane on the section,

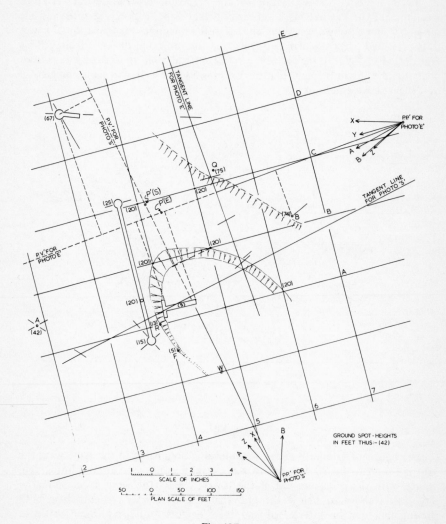

Fig. 42E.

Fig. 42B, so finding (x); a line p–(x) cuts P.V.$'$ at (y). (The distance P.P.$'$ to (Y) so obtained, can also be found from the plan, as a check.) From (y) a vertical 20 feet long is drawn downward, and from the foot, a line to p, cutting the Trace of the Positive Plane at (z). P–(z) is transferred to the Principal Vertical, from which a perpendicular can then be drawn to pass below B/5. A line from B/5 to P.P. cuts the perpendicular at the place where B/5 has dropped 20 feet vertically.

Since the vanishing-points of the dropped trapezoid are the same as those of its counterpart, the whole trapezoid can be drawn. It is shown in solid line where it lies on the water, in broken line where it is under the ground. The plan-position of the cliff-foot can be taken at once from the dropped trapezoid.

The height of the ground at the point B (Fig. 42D) comes out as 74 feet above water-level, which can serve as a datum for all heights on the plan. The ground at the cairn, Q, is 75 feet above this datum. If there were two more points at this level in the vicinity, it might reasonably be assumed that this area of the high ground was all at about 75 feet above datum. If there were several objects in the area, it might be worth while to raise a trapezoid by 55 feet above the grid-level, as a simple means of getting the objects onto the plan. As a demonstration, the trapezoid D/E–6/7 has been so raised on both photographs. The raised trapezoid is shaded to distinguish it from its counterpart below.

It is not essential that a raised or dropped trapezoid should remain the image of a horizontal square. It can be made the image of a tilted rectangle, with a vertical projection to the plan, which is a square. Thus, two adjacent corners of a grid-square can be raised by a given amount, and the opposite two corners by a different amount, to make a fair overall fit on a piece of ground standing at a known tilt. This can be called "tilting a trapezoid"; plan-positions are unaffected (see page 21). To so tilt a trapezoid involves working at two pairs of corners separately, or at all four corners separately. The lines of the tilted trapezoid will not usually find either of the vanishing-points of its horizontal counterpart.

In a case where control can be set out, the four corners of a large square on level ground are ideal. But obviously it is only the corners, marked by paint or otherwise to appear on the photographs, that need be at one level. If it is impracticable to set out a square (or other rectangle) although still possible to mark four well-separated points all at one level then they will serve almost as well as a square, since they can be used to create the image of a square on level ground. It is of no significance if one or more of the created corners (i.e. points as found by paper-strip method, Chapter 2) appears to be underground or in the air; it remains a point at grid-level if it was created by the use of four points themselves at grid-level; and it is of no importance if a physical object, apparently on the ground, appears to coincide with the point on one photo-graph, but does not do so on another taken from a different view-point; this only shows that the ground is above or below the grid at the place of the created corner.

The great advantage of control consisting of a level square (or other rectangle) or of the means to create the image of one, is that the Horizon Line, and

therefore the Principal Vertical and the obliquity and the place of P.P., can be found at once. But in practice, it is often existing available control that must be used, and this may consist of the plan-positions and heights of several scattered points at different levels. Three such points, well-placed, will provide a minimum of control.

2. Control Points at Different Levels

Looking at the photograph E, Fig. 42C, and its Principal Plane section, Fig. 42D, assume that the control consists of the plan-positions of tower X, 67 feet above datum, station A, 42 feet above datum, the seaward inshore end of the jetty, at datum, station B, 74 feet, and cairn Q, 75 feet above datum. The photograph shows nothing that will find the Horizon Line, but the towers will find an approximate position of P.P.

With this, a nominal Principal Vertical can be drawn through P. The distance P–P.P., with the epP, gives a nominal obliquity:

$$P–P.P./epP = \tan O$$

since $$epP/P–H = \tan O$$

$$P–H = epP/\tan O$$
$$p–H = P–H \text{ secant } O$$

A nominal Horizon Line can be drawn at the distance P–H from P, at right angles to the nominal Principal Vertical. On a drawing, a P.V.' line of length p–H can be set off, and a Tangent Line drawn through H at right angles to P.V.' On the Positive Plane (e.g. Fig. 42C) rays can be drawn from P.P. through the jetty-end and through B, A, Q and X to cut the Horizon Line at intercepts which can be transferred to the Tangent Line. From this the PLA angles corresponding with the Pha angles of the Positive Plane are obtained. With these PLA angles, plotted on a transparency, the nominal place of P.P.' on the plan can be obtained by resection (Chapter 14); as part of this operation, the nominal place of P.V.' on the plan is found. If the plan shows an object the image of which is at P on the photograph, the P.V.' line should pass through this object.

On the photograph, perpendiculars to the nominal Principal Vertical are let fall from the control points, and similarly on the plan, perpendiculars from the control points to P.V.'. On the Principal Plane section, the rays from p, to the control points as projected to the Principal Vertical and transferred to the Trace of the Positive Plane, can then be drawn. From the plan, the control points as projected to P.V.', along with P.P.', can be taken on a transparency on which a P.V.' line is drawn; from this line, the known heights of the control points can be set off perpendicularly. The result on this transparency will resemble the

P.V.' line of Fig. 42D, from which rise the verticals to tower X, to B, to A, etc. The transparency can be laid on the family of rays from p; if it fits on all the rays, and P.P.' on the transparency falls on P.P.' on the section, the place of P.P. as found originally is correct.

If P.P. as found originally is on the Principal Vertical, but is slightly displaced along the line, the rays from p will cut the appropriate points, and the transparency can be fitted everywhere except at P.P.'. In this case a perpendicular from p to the P.V.' line on the transparency will find the true place of P.P.' on P.V.' and the true place of P.P. on the Trace of the Positive Plane. The trace of the horizontal plane, p—H, can then be drawn parallel to P.V.'.

If P.P. as found originally is not on the Principal Vertical, the transparency will not fit; the Principal Vertical, as drawn, is making an angle with the true position of the line. If the angle is not very great, the resection of P.P.' on the plan will not expose the fault. One somewhat crude but simple way to deal with the situation, is to consider the effect of imparting a slight rotation to the Principal Vertical, as drawn through P. If this is done clockwise the perpendiculars from control points, on photograph and on plan, will all rotate clockwise altering the spacing of perpendicular-feet by amounts dependent upon the lengths of the perpendiculars; but a rotation on the Principal Vertical will be reflected by a smaller rotation on P.V.' on the plan. If the rotation on the photograph is regarded as a Pha angle at P, the tangent of the corresponding PLA angle at P' on the plan will be = tan Pha cos obliquity, that is, with a small rotation, and obliquity like 45°, PLA will be like 0.7 of Pha.

Bearing in mind that a short perpendicular near P will be very little affected by a small rotation, the direction in which rotation is required, and the approximate amount, may be decided at once and a trial may be found to produce such an improvement that nothing more is needed but a final small change. If everything fits in, except P.P.', this can then be found by dropping a perpendicular from p, which also will find P.P.

The better way, however, is to make use of the principle of a Crone construction (one of several such constructions devised by Major R. Crone, R.E. when he was Superintendent of the Survey in India). In this, only three control points are required. Figure 43A shows the photograph E reproduced to scale. Its epP = 231 mm. (For the purpose of this discussion the correct places of P.P. and H are marked.) P.P.E. is an erroneous version of P.P., as found with very scanty information, possibly no more than an intelligent guess in the first instance.

The distance P—P.P.E. is 206 mm. Then,

$$206/231 = \tan O = 0.892$$
$$\text{P--HE} = 231/\tan O = 260 \text{ mm}$$
$$O = 41°\text{-}46'$$
$$\text{p--HE} = 260 \sec O = 350 \text{ mm}$$

where HE is the erroneous place of H corresponding to the erroneous place of P.P. It is decided to use the three points X, J and B whose heights are 67, 0, 74. (J is the seaward end of the jetty, inshore). The intercepts of the Pha angles on

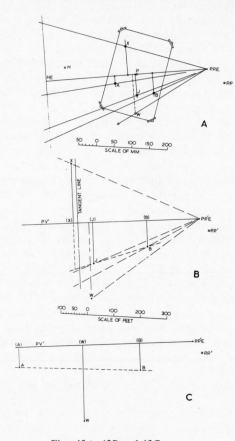

Figs. 43A, 43B and 43C.

the Horizon Line through HE are transferred to a Tangent Line at 350 mm from P.P.'E on a transparency and so, on a plan, Fig. 43B, P.P.'E is found by resection. (The supposedly unknown correct place of P.P.' is marked.) The resection places a P.V.' line on the plan.

Figure 43D is a Principal Plane section. On the Trace of the Positive Plane, the points X, J, B, HE are taken from the Principal Vertical, and rays are drawn through them from p. The line p–HE is the trace of the (erroneous) horizontal plane. Along it, the distances p–(B), p–(J), p–(X), are taken from the plan,

measuring from P.P.'E. Perpendiculars from p–HE through the points are let fall to cut the rays appropriately at X′, J′, B′.

The known height of X is 67 feet. From X′, 67 feet is set off downwards, by the plan scale, so finding X″. The known height of J is zero, so J′ = J″. The known height of B is 74 feet, which, set off downwards, finds B″. If P.P. as

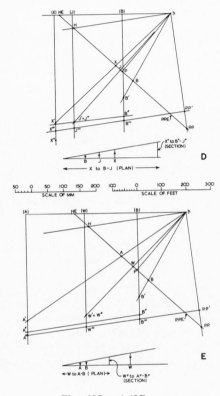

Figs. 43D and 43E.

found originally had been in the right place, the points X″, J″, B″, would all lie on one line parallel to p–HE. If P.P. as found originally had been on the Principal Vertical, but displaced along the line, the points X″, J″, B″, would all lie on one line. This line would be parallel to the true place of the trace of the horizontal plane; then a perpendicular from p to the line X″, J″, B″, would be the true plumb-line passing through the true place of P.P. and the true place of P.P.′.

The fact that X″, J″, B″, do not fall on one line indicates that the Principal Vertical as drawn is at an angle to the true position.

Then the drawn perpendiculars (Fig. 43A) are not the images of horizontal lines; they are not parallel to the true Horizon Line. What may be considered as the effective tilt of these lines can be discovered as follows.

On the plan, Fig. 43B, draw the line B–J to cut the extension of the X perpendicular. Take the overall length of this perpendicular as the base of a right-angled triangle, as shown on Fig. 43D.

On Fig. 43D draw a line B″–J″ to cut the X perpendicular. Take the distance from X″ to this line, as the height of the right-angled triangle, as shown. Draw the hypotenuse of the triangle.

On the base, set off, from the acute angle, the various distances, to B, to J, to X, as shown; these base distances are the lengths of the perpendiculars X–(X), J–(J), B–(B), on the plan. Erect verticals to the hypotenuse. The lengths of the verticals are the displacements of the points X″, J″, B″, from the line X‴, J‴, B‴, which is the true place of P.V.′ in the section (or is very nearly so; but the original place of P.P. was in gross error). A perpendicular from P to X‴, J‴ and B‴, is the plumb-line; parallel to X‴, J‴ and B‴, is the Trace of the Horizontal Plane.

The direction, up or down, in which the lengths of the verticals are to be plotted from X″, J″ and B″ is usually obvious, since the three resulting points X‴, J‴, and B‴ should fall into one line. If photograph, plan and section are placed together as in the Figures, the perpendicular (X)–X is up, (J)–J is down, (B)–B down. These directions are repeated by the directions of the verticals from X″ to X‴, up, J″ to J‴, down, B″ to B‴, down, that put the points into line. This repetition of direction indicates that the Principal Vertical, as drawn on the photograph, must be given a clockwise rotation. (If the perpendiculars' directions must necessarily be opposed each for each by the verticals' directions to get the three resulting points to fall into line, this indicates that the Principal Vertical must be given an anti-clockwise rotation.) The angle of rotation required is the acute angle in the small triangle of correction: it is about 9½°.

If this angle of correction is applied clockwise to the Principal Vertical as drawn, it moves P.P.E. into the line P.P.–H, which is the correct place. The distance from P.P.E. (as moved into position) to P.P., is available on the section, Fig. 43D. The point HE also moves into the line P.P.–H, and the distance from HE to H is available on the section. In this example, starting with a P.P. in gross error, the result is not perfect; but a repeat of the work, starting with the now amended place of P.P., would produce the right answers.

To take a further example, in which all three points are on the same side of the Principal Vertical: point A, 42 feet, B, 74 feet, W, zero. (The point W, which appears only on the photograph E, is assumed to have been put on to the plan by some means). P.P.′E is found on the plan, Fig. 43C, by resection (the true position is marked). The Principal Plane section, Fig. 43E, is made as before, and the line A″–B″ drawn. On the plan the distance from W to the A–B line is the

base of the triangle of correction, and the distance W″ to the A″—B″ line is the height; the hypotenuse is drawn. On the base line the distances from the acute angle to A, B, W, are the lengths of the perpendiculars on the plan; the heights of verticals are the required distances A″—A‴, B″—B‴, W″—W‴. All are downward. Since the perpendiculars are downwards on the plan, the required rotation of the Principal Vertical is clockwise. The resulting line A‴, W‴, B‴, is the P.V.′ line, as before. The correction triangle gives the angle of rotation required. As before, a perpendicular from p to A‴, W‴, B‴, is the plumb-line and p—H is parallel to A‴, W‴, B‴. As before, the distance from P.P.E to P.P. is available on the section, as also is the distance HE to H. Also as before, the result is not perfect, since the original error was large. A re-working would give the right answer.

In this discussion, it has been assumed that the Horizon Line on the photograph was not determinable, but that an approximate P.P. could be found. The principles are not changed if the converse is the case, since with epP known, an approximate position for the Horizon Line gives an approximate position for P.P. at once; epP/P—H = tan O; P—P.P./epP = tan O; P—P.P. = epP tan O.

This Crone construction can be used to deal with the problem that arises when it is intended to set out, on the ground, four marks at a common level to create the image of a square (as discussed in Chapter 2) but it is found that one point, S, must be placed at a different level for lack of flat ground; and there are no means of measuring this difference of level.

With four points of known plan-position, three being at a common level, P.P. and the Principal Vertical can be found on the Positive Plane and P.P.′ and P.V.′ on the plan, by the use of the three. The distance from P.P.′ to the point S, as projected to P.V.′, can be set off along the line p—H of the Principal Plane section, and a vertical let fall to cut P.V.′; from the cut-point, a line to p cuts the Trace of the Positive Plane; this cut-point is transferred to the Principal Vertical from which a perpendicular is set off to pass by the photo position of S.

A line from S to P.P. cuts the perpendicular in the position sought—the place of S reduced to the common level of the other points.

As an example of this, suppose that on the photograph E, Fig. 42C, it is required to correct the photo-position of tower X, to what it would have been if the tower stood on ground at the level of the small square set out around P. On the plan, the distance of X from P.P.′, projected to P.V.′, is available, and so can be set off on the Principal Plane section, Fig. 42D, along P.V.′, which is at the flat-ground level of the small square. From the point found (the foot of the vertical through tower X), a ray to p will cut the Trace of the Positive Plane; the cut-point can be transferred to the Principal Vertical, from which a perpendicular can be drawn to pass beneath the photo-position of tower X. This perpendicular is cut by a line from X to P.P., so finding the marked point, (black spot) which is the reduced position of the tower-base; the mark is in the horizontal plane of the small square set out around P.

3. Effect of Dip of the Horizon

In the kind of work discussed here it is unlikely that the height of the camera will be such that the dip of the horizon will be significant, or that the distances to the control points will be great enough for the positions of their images to be affected by the earth's curvature or refraction in the atmosphere. If the sea-horizon appears on a photograph, the correction for dip can be applied easily (Chapter 6), if it amounts to a plottable angle.

If in one case control points at great distances are used, their given heights must be reduced for curvature and refraction before being taken into sections constructed as Figs. 42D and 42B. The amount of the reduction, for distances up to 20 miles or so, can be found by taking

$$C = D^2 \, 0.022$$

where C is the reduction in feet, D the distance in thousands of feet. For example, with $D = 47,000$ feet, $47^2 \times 0.022 = 49$ feet, by slide-rule. The given height, above sea-level or other datum, of a point 47,000 feet distant must be reduced by 49 feet.

The expression includes the effect of refraction. It is derived from the fact that in many conditions of the atmosphere at fairly low levels, vertical angles as measured from the horizontal plane can be cleared of curvature and refraction effects by the application of a correction of about 4.5 seconds of arc per thousand feet of distance. (When vertical angles are used to deduce the heights of distant points, the correction is applied in the sense of "raising the observed line of sight".) The tangent of 4.5 seconds is about 0.0000217. The angles involved are small. If d is the distance in feet, $C/d = \tan a$; if $\tan a$ is taken = $0.0000217D$, then $C = dD \, 0.0000217 = D^2 \, 0.0217$, or for slide rule, $D^2 \, 0.022$.

Chapter 17

Undersea

What is generally called Sous-Marine (or S/M) photography is always necessarily close-up. The performance of light in water is very poor. There is not any certainty that it always travels in straight lines, even over short distances. The behaviour of ocean currents and tidal streams can be predicted with good accuracy, but the small thermal eddies in the sea are like local draughts in air; they behave in a random fashion. In the locally varying temperature, density and clarity of the water, light is scattered, and what may be considered as individual rays become slightly bent. Things are not so bad as they appear to the unprotected eye of a swimmer in shallow water, for the apparent heaving and swaying of solid objects is due to the distortion of the shape of the eyeball by water-pressure as a swimmer moves.

By daylight, with the sun high above a calm sea, quite sharp photographs can be taken at several metres, even ten metres or sometimes more, in shallow water. By the use of powerful artificial lighting, they have been taken at six metres and more at great depths, and with the use of flash, at very short distances, at all depths. The usual distance is only two or three metres at most. Appreciably greater distances seem to be out of the question at present. Distant objects are seen at best, through a luminous fog. At the short distances, over which the light can be assumed to travel in practically straight lines, quite good angular measurements can be made, and so quite good values for dimensions of things can be obtained. But it is probably true to say that attempts at achieving great precision are out of place. Methods that will give a fair answer with the minimum of trouble are suitable to S/M work of the kind discussed here.

The refraction of light passing through two media, water outside the camera and air within, presents a small problem. Attempts at disposing of it by using a camera filled with clear water have been tried and abandoned long since. As the camera must be filled with air, or at least with some dry gas, then either it must be fitted with refraction-correcting lenses, such as the Aquar-Ivanoff (8), or the photograph as taken must afterwards be rectified in some way. There are a large number of ordinary plane-glass window S/M cameras in use, that is, cameras not provided with any refraction-correcting lenses. These cameras do have one advantage: that they can be used to take air photographs immediately before or after S/M photographs. There is a very simple way in which S/M photographs taken in such cameras can be, not exactly rectified, but used, so that the effects of refraction are nullified to a sufficient degree for the practical purposes of applying simple graphical work. There is of course no escape from the fact that

with a plane-glass window, the field-angle, S/M, is considerably reduced: which does not occur if refraction-correcting lenses are used.

The effect of refraction of light at the interface between the water and the plane-glass window, and again at the interface between the glass and the air, is essentially that the image is enlarged relative to that of an air photograph taken

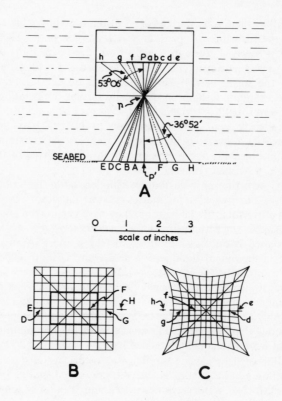

Figs. 44A, 44B and 44C.

at the same distance; this would be in the ratio of about 1.33 to 1, that is, in the ratio of the refractive index of water to that of air. But if the pP of the camera is supposed to be increased at the same ratio, a large part of the effects of refraction are removed.

Figure 44A is a sectional drawing showing a camera taking a Vertical of a square grid, Fig. 44B, lying on the sea-bed. On Fig. 44A, p (the lens) is considered to be a pin-hole which will admit light but not water. It is 2 inches

above the sea-bed (to use a scale in the same units all round). The pP of the camera, as found in air, is 1 inch. From the point G of the grid, a ray enters p at an angle *i*. To re-state Snell's Law,

$$n \sin i = n' \sin i'.$$

For a ray passing from water to air,

$$\sin i' = 1.33 \sin i.$$

The ray from H, entering at an angle of 36°-52′, is refracted to h at an angle of 53°-06′. Similarly, a ray from G is refracted to g, and so with the other rays. On the grid, the spaces P–F, F–G, G–H, etc., are equal: 0.5 inch. In air the corresponding negative spaces P–f, etc., would be all 0.25 inch. But S/M, P–f is about 0.35 inch, f–g about 0.4 inch, g–h about 0.6 inch. The further is the area under consideration from P, the more is the S/M image enlarged.

If the camera at the point shown as Fig. 44A had a very large field-angle, the appearance of the grid on the negative would be that shown at Fig. 44C. This appearance can be called pin-cushion distortion. With a camera of normal field-angle, such as 55°, the area that would be actually photographed S/M is that enclosed by a heavy rectangle on Fig. 44C. Within the rectangle, the pin-cushion distortion is not very pronounced. In fact the spacing of the lines P–a, a–b, b–c, is 0.167, 0.174, 0.188 inch. From the mean, 0.176, the variations are only about 1%.

If the grid-area outlined on Fig. 44B were to be photographed in air, the resulting rectangle on Fig. 44C would be smaller; S/M, it is 1 inch wide, in air it would be 0.75 inch wide. If the S/M negative, as available, were to be used in the ordinary way (Chapter 3) to determine the pP of the camera, measurements on the negative would be used in conjunction with known exterior measurements, e.g. radial distance on negative, 0.5 inch, radial distance on base 0.75 inch, base to lens 2.0 inches:

$$0.5/pP = 0.75/2.0$$
$$pP = 1.33 \text{ inch.}$$

The air pP of camera at Fig. 44A = 1.0 inch. Its S/M pP = 1.33 inch. Angles, as deduced from radial measurements from P on the negative, and S/M pP 1.33 (or, in practice, with S/M 1.33 x degree of enlargement of a print = S/M epP) would be correct, approximately.

In the pin-cushion effect, Fig. 44C, it is noticed that straight lines which pass through P′ on the sea-bed photograph as straight lines passing through P. This is true for any photograph, not only for a Vertical. All other straight lines on the sea-bed photograph as curves convex to P. In practice, for graphical work, this curvature can be disregarded.

1. Measurement of S/M pP

S/M pP for a particular camera is best found experimentally. Like pP, it varies with distance-setting, but naturally it also varies with the size of the incoming angle and, slightly, with the size of the aperture. The experimental apparatus required

Fig. 44D.

is an angle-measuring device. The simplest makes use of the principle of alignment of foreground and background marks.

 Figure 44D shows an apparatus made for the purpose of this experiment (and others), but a much simpler construction will serve well enough. In Fig. 44D, the apparatus is shown standing vertically, but it can be used horizontally or at any angle. The base consists of a braced sheet-metal plate painted with concentric

circles in bands 2 cm wide. Above the base, and parallel to it, three bars with 2 cm divisions cross the central axis (only one of these is necessary). At the top is a platform supporting a machined plate into which a camera-lens housing can be fitted, so that the camera points exactly at the centre-point of the base.

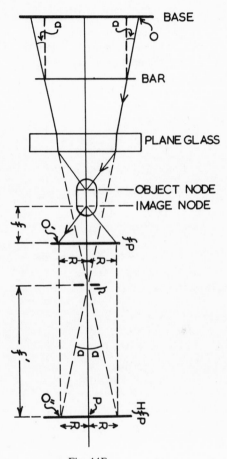

Fig. 44E.

S/M photographs taken from the platform show the images of the bars superimposed on the image of the base. From alignments, of certain bar-divisions with base-divisions, the values of the tangents of incoming angles can be obtained, from which the S/M epP of prints can be found.

Figure 44E shows such an apparatus in diagrammatic form: a base, a bar crossing, the plane-glass window, the object and image nodes of the lens-system,

the negative plane at a Principal Distance f. A ray of light in water leaves the point O on the base at an angle a, passes the bar, enters the glass and is there refracted, emerges from it into air and is refracted again, goes to the object node, passes to the image node and emerges on a parallel course to go to O' on the focal plane fP.

The angular changes undergone by the ray are produced by the differences in refractive indices of the three media, water, glass and air, but the glass, having parallel faces, has no effect on angles; it does produce a small lateral shift in the ray. To take a numerical example, with indices 1.33, 1.52, 1.0 and a ray entering at 17° and thickness of glass 5 mm.

$$n \sin i = n' \sin i'$$
$$1.33 \sin 17° = 1.52 \sin i'$$
$$\sin i' = (1.33 \sin 17°)/1.52$$
$$= 1.33 \times 0.2924/1.52$$
$$= 0.2559 = \sin 14°\text{-}49'.$$

In transit through the glass, the ray is displaced from the point of entry by (5 mm tan 14°-49') = 5 x 0.2645 = 1.32 mm, inwardly towards the central axis, assumed to be the optical axis of the lens-system. In the absence of refraction in the glass, the ray would emerge displaced from the point of entry by (5 mm tan 17°) = 5 x 0.3057 = 1.53 mm. The passage of the glass produces a displacement of 0.21 mm, in an outward sense.

On emerging from the glass into air,

$$1.52 \sin 14°\text{-}49' = 1 \sin i'$$
$$\sin i' = 1.52 \times 0.2559$$
$$= 0.3889 = \sin 22°\text{-}53'$$
$$\text{But } 1.33 \sin 17° = 1 \sin i'$$
$$= 0.3889 = \sin 22°\text{-}53'$$

Apart from producing the small displacement, the refractive index of the medium, glass, intervening between water and air, is of no effect; and the small displacement is of no practical effect. It may be argued that in the example the 0.21 mm displacement is that which, considered geometrically, would be produced by a movement, of the point photographed, through the same distance which is negligible. But in any case, the experimental determination of S/M pP depends upon observation of the results of all events, from whatever causes arising.

If on Fig. 44E the base-radius and bar-radius, measured from the central axis, and the distance between base and bar, are all known, the tangent of the angle a is known. On the negative the corresponding radius R is measured.

If it be supposed that the entering ray does not undergo refraction, it will go to a hypothetical point p, from which point the alignment of the intercept on the bar with the base-point of origin would be seen. Having passed through p, the ray will go to a hypothetical focal plane HfP, on which the image of O will be at O″, at a radius R equal to R at fP. Since $R/f' = \tan a$, $f' = R \cot a$; f' is the S/M pP. The fact that HfP, and possibly p also, may be outside the camera, is of no significance. An unknown angle a can be discovered if R and S/M pP are known.

CMS

Fig. 44F.

To take a sample photograph used in an experiment with the apparatus shown in Fig. 44D: experimental S/M photograph No. 43, Fig. 44F. The original print was enlarged × 6.18 from a 35 mm negative. Distance-setting 1.3 metres. The base and bar divisions are of 2 cm.

Taking top bar, left, 10.00 divisions; right, 10.00 (arrowed)

coincides with base, left, 15.33 divisions; right, 15.33

differences = 5.33 5.33

mean difference 5.33 = 10.66 cm. Space between top bar and base, 65.8 cm

$\tan a = 10.66/65.8.$

Measurements on photograph: P to 10 divisions, left 5.00 cm. right 5.00, mean 5.00

$$\tan a = 5.00/f'$$
$$f' = \frac{5.00 \times 65.8}{6.18 \times 10.66}$$
$$= 49.94 \text{ mm.}$$

Taking a larger angle, with top bar 15.00 divisions, base, left, coincident, 23.00 divisions, right, 23.00 divisions, measurements on photograph, left, 7.59 cm, right 7.63 cm,

$$f' = 50.64 \text{ mm.}$$

With a larger angle again, top bar 21.00 divisions, base 32.31 and 32.33 measurements 10.85 and 10.95,

$$f' = 51.25 \text{ mm.}$$

In this, with setting 1.3 metres, the bar is in sharp focus, the base nearly so. In another case, the base-point would be chosen, and the corresponding bar-point found by measurement and interpolation. Even with the large apertures normally used S/M, it is found in practice that there is no difficulty about focus. It was to deal with possible focusing difficulties with some cameras that the three bars in the apparatus were provided, but it was soon found that they were redundant; there is always sufficient depth of field with lenses of short focal length. The circles were provided to discover something of paper-distortion or even of lens-"distortion", but ordinarily, these can be disregarded. Arrangements were made also for rotating the camera in the plane of the platform parallel to the base, but it was found that differences, if any, in f' arising from the use of different parts of the lens in this way could also be disregarded. The results will vary with aperture, but only slightly: S/M the aperture is almost invariably large, as used in the experiment. There is a slight effect of irradiation in that the images of the white divisions are slightly larger than those of the black. Measurements of coincidence should take this into account. (On Fig. 44F, the inversion of part of the base-image was caused by the apparatus being used horizontally in water not quite deep enough to submerge it entirely.)

With a set of S/M photographs, of which Fig. 44F is a sample, the following results were obtained. In each case the same three sets of coincidences on the top bar were used, i.e. 10, 15, 21 divisions.

Distance setting	Small angle	Medium	Large
0.98 metre	51.16	51.69	52.08
1.12	50.47	51.24	51.66
1.30	49.94	50.64	51.25
1.70	49.22	49.79	50.62

These results are shown on Fig. 44G. The lines were drawn to fit the figures as well as possible, and were made parallel by adopting the arithmetical device of plotting a control-line from the means at each distance. The spaces along the

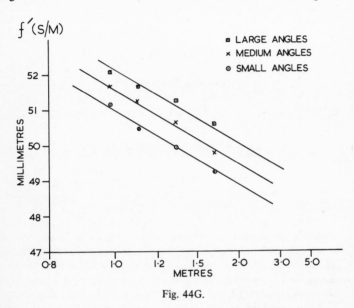

Fig. 44G.

base-line were obtained from the spaces of the distance marks themselves, measured around the circumference of the lens-housing. These then are the observed results for S/M pP, from whatever causes arising. The lines can be extended somewhat as shown.

The distance-setting of a camera used S/M will not ordinarily be recorded, but a value can be assumed and if necessary amended when a distance has been discovered. The photographer will have judged the distance and set accordingly. He may have judged a distance to be about 3/4 of the actual distance; goggles, or even naked eye, behave much as a window does; but since the camera "sees" as much as the eye sees, the proper setting is that for 3/4 of the actual distance. It is not a very critical matter. It will be found in practice that even a several mm uncertainty in S/M epP can often be tolerated. Since everything in the field is

close to the camera, and the overall field angle available is not great, angular errors that numerically may appear quite large are of small practical effect.

If it is intended to work only in the centre area of a print, a value for S/M pP would be taken from the lower line on such as Fig. 44G; if on practically the whole of the print, from the middle line. The top line might be used for an item near the edge if the photograph contained nothing else of interest.

With S/M pP known, the S/M photograph can be treated as an air photograph, but naturally, it will be necessary to do a certain amount of fitting-in of slightly discordant measurements.

Fig. 44H.

A simple form of experimental set-up for determination of S/M pP can be arranged in a shallow pool with a level bottom, ideally something such as a children's paddling pool with a concrete floor. Figure 44H shows such an arrangement in plan, and the view that should be obtained of two control-bars, one seen superimposed on the other. Such a device could be made in wood, if well-painted and not immersed for too long.

There does not appear to be any overriding reason why a camera in a watertight housing could not be used in the same way as a S/M camera, provided that the relative positions of the lens and the glass window are constant at all times when the camera is in the housing. The glass window of a S/M camera is optically flat, which may not be the case with the window of a housing. An apparatus such as that illustrated by Fig. 44D could be used to discover any serious defects.

2. Cross-Rod Control

Just as the simplest form of control for air photographs is a square on level ground, so the simplest form for S/M is a square, but S/M there is no particular virtue in it being level, since there is no true horizon line which could be taken into account as in the case of, e.g. a sea-horizon in an air photograph. In any

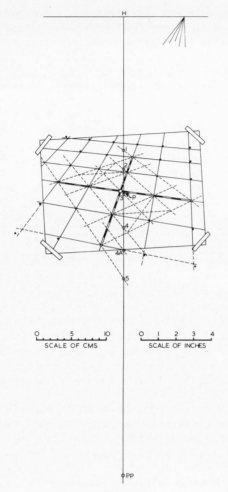

Fig. 45 A.

event it is not practicable to mark out a square on a sea-bed, level or otherwise. The square must be easily portable, and such that it can be set out in an instant, in one plane of reference the tilt of which can be found if it is required. One device is a cross-rod (Fig. 45A). This can consist of two rods, marked with equal divisions in black and white, hinged together at the centre-point and provided with a stop and holding-device to ensure that when open, the rods stand mutually at right angles. Closed-up, the thing is effectively one rod; opened out it forms a square. An alternative form consists of a tube and a rod carried inside

it. The rod can be withdrawn and passed into a hole bored at right angles through the centre of the tube, which is strengthened at the centre by a short external tube welded on. The rod is provided with a stop to fit into what is in effect a miniature funnel formed at the mouth of the transverse hole through the tube; this is to make it easy to slip the rod in and to ensure that it is inserted from the correct side. But whatever form is adopted, it is necessary that the rod when folded or stowed for transport should be round or at least ellipsoidal in cross-section, not rectangular. A rod of thin rectangular form, when it is being towed by a swimmer, will tend to whip about in a way that may be dangerous; especially if the swimmer himself is being towed by a boat.

The cross-rod laid down as shown in Fig. 45A, forms a plane of reference. The dimensions of objects, standing in or above or below the plane, as projected to the plane, can be found by intersection, and the dimensions perpendicular to the plane can be treated as + or − heights from a horizontal plane.

If in some instance it is required to make a final drawing on a horizontal plane, that is, a true plan, the tilt of the reference-plane can be found by the use of an arc-and-float fitting, as devised by Miss Honor Frost and illustrated in Fig. 47. This is practically self-explanatory, but in use the rod carrying the arc is placed so that it lies on the steepest slope, while the transverse rod is horizontal. A tilt-measuring photograph is then taken, after which the arc and float are removed. On Fig. 47 the arc-reading is 90°; so the surface the rod lies on is level.

The cross-rod is used precisely as a level square on the ground, photographed from the air. Figure 45A is a 51° Oblique, of S/M epP 317 mm, found from, S/M epP (at distance-setting, probably assumed, 2 metres), 49.4 mm; enlargement x 6.42. The rods are 1.6 metre long, divided into decimetres. This would be a long rod to handle, but it makes a better illustration than one of more likely length such as 1.2 metres.

The straight dashed lines show the way in which an array of trapezoids can be built up within the area covered by the rod, and extended a little outside it. The solid lines show how another array can be built diagonally if required. In building such arrays it is obviously necessary to use some average positions. The trapezoid formed by joining the ends of the rods with straight lines will find vanishing-points, but the trapezoid formed by joining say, the mid-point of each arm of the cross, as shown by the divisions, will not find quite the same vanishing-points; the scale of the photograph is changing radially. But in practice there is no real difficulty in choosing and marking average, accepted vanishing-points, near to those found by using the rod-ends, and on this basis, a "Horizon Line" can be drawn, and a "Principal Vertical" perpendicularly to it through P. The black spots adjoining the solid-line trapezoid intersections on Fig. 45A mark the true positions of those intersections. It is seen that in this example the error introduced by using straight lines and average positions is not very great.

The "Horizon Line" so found is of course the horizon line of the reference plane. If this plane is in fact horizontal, the Horizon Line as drawn is in a

horizontal plane through the camera. A ray of light that in fact travelled in this plane to the camera (supposing that the camera had an extremely wide field-angle capable of receiving it) would appear to have come from a point about 18° above the horizontal plane, since with a 51° Oblique the normal to the glass would be inclined at 39°, which would be the ray's entering angle; the ray would be refracted to an angle of 57°, in which direction it would lie at 18° below the horizontal. It would in fact appear to have come from the region in

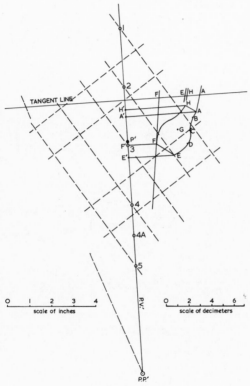

Fig. 45B.

which the lines of the solid-line trapezoids, correctly drawn as curves through the black spots marked, would find, not a vanishing-point, but what might be called, happily, an area of general osculation.

The Horizon Line as drawn is required only for the purpose of finding the corresponding "Principal Vertical" (which is the Trace of a Principal Plane perpendicular to the plane of reference). Along this, cut-points of the images of (nominally) equal spaces are marked, as on Fig. 45A. The Principal Vertical is transferred to a plan of squares, as P.V.′, Fig. 45B. This plan is of course

standing in the plane of reference. The plan-spaces corresponding with the
Principal Vertical spaces are taken on a paper strip, for fitting into the
appropriate rays as drawn on a Principal Plane section, Fig. 45C; once again,
some average position will have to be found, and accepted. In this accepted
position, the paper strip should be found to be practically parallel to the Trace
of the (nominally) horizontal plane, p–H. By slight adjustment of the position

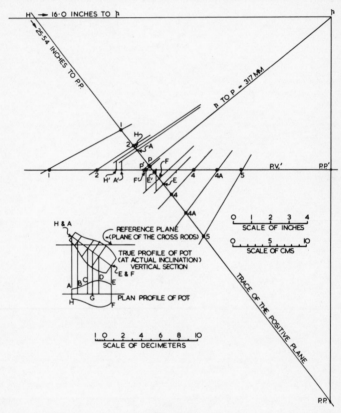

Fig. 45C.

of H on the Trace of the Positive Plane, and possibly some final slight
adjustment of the position of the paper strip, a final position for the trace of the
(nominally) horizontal plane is found, and a final position for P.V.' parallel to it.
The position of H on the Positive Plane is amended accordingly. On the section,
at right angles to the final P.V.' line, the (nominal) plumb line is drawn, so
finding P.P. and P.P.'. The former is marked on the Principal Vertical, the latter
on P.V.' on the plan.

From the Principal Plane section, the distances H to P.P. and to H to p are obtained, and so the secant of the obliquity is found; in the present case, secant = 25.54/16.0 = 1.596. Taking for convenience a Tangent Line at 12 inches from P.P.' on the plan, a Secant Line is drawn on the Positive Plane at 12/16 x 25.54 = 19.15 inches from P.P.

Fig. 45D.

The Secant Line is shown on Fig. 45D, a copy of Fig. 45A cleared of the trapezoidal lines which have served their purpose. Angles at P.P. can now be converted to angles at P.P.' immediately, in the ordinary way, that is, the intercepts of rays drawn from P.P. to the Secant Line can be transferred to the Tangent Line and rays drawn from P.P.' accordingly. On the plan, Fig. 45B, the grid-lines, which have served their purpose, are now supposedly erased.

Fig. 46.

Fig. 47. Cross-rod with arc and float device attached for measuring slope. The arc, divided into 10° intervals, is immediately detachable and replaceable. (Photograph by Honor Frost.)

Given another photograph taken from a direction more or less at right angles to the first, intersection of points and measurements of heights can proceed exactly as with a pair of air photographs. To take a particularly difficult object, the pot shown on Fig. 45D. The points E, D, C, B, A and H are supposedly recognizable from both view-points. F can be seen only from Fig. 45D. G is a white pebble placed by the diver.

By intersection, plus the single ray to F, the plan-profile of the pot can be drawn (Fig. 45B). The points H, A, E and F are then projected to P.V.′ from

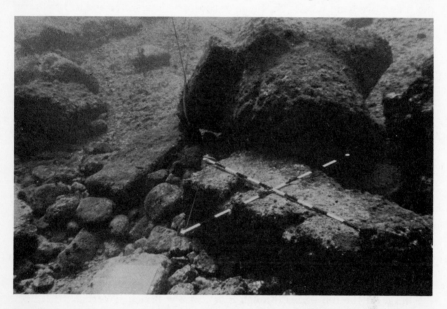

Fig. 48. A column-base and other masonry in 7.3 m. of water, washed down from the ancient Outer Harbour of the reef-island off Sidon, Lebanon. 1966 survey by Honor Frost, in publication *Bulletin du Musée de Beyrouth* at the time of writing. (Photograph by Honor Frost.)

whence they are transferred to P.V.′ on the Principal Plane section (Fig. 45C). The same points are projected to the Principal Vertical (Fig. 45D) and transferred to the Trace of the Positive Plane (Fig. 45C). Rays from p through the points so found, cut verticals through H′, A′, F′ and E′, on P.V.′. The mean height of H and A above the reference plane is thus found, and the mean fall from the reference plane to E and F. H, A, E and F, as chosen and marked originally, were judged to lie in one tilted plane cutting the pot in halves on its long axis. Since the height of A above the plane comes out the same as the height of H, and the fall to E the same as the fall to F, it appears that the line HA is parallel to the reference plane, as is also the line FE. Then the four points

do in fact lie in one tilted plane. The length of this plane, as projected to the plan, is the distance from the line AH to the line EF; it is 4.2 decimetres by the plan scale. The mean height of A and H is + 1 decimetre, the mean fall of E and F − 2.2 decimetres. Then the length of the pot, as may be found by plotting as shown on Fig. 45C, is 5.2 decimetres. The various radii of the pot are correctly shown on the plan-profile, and the positions of these can be transferred by projection as shown.

The use of the pebble at G is that it is a definite point on the highest part of the decorative band it rests on. It can of course be intersected and its height can be taken. This gives a fixed point on the profile of the pot in section. Such definite small marks, judiciously placed, so as to be positively identifiable from two view-points, are very valuable. Small white pebbles seem to be as good as anything else. Compared with such a thing as a pot, many objects are easy to deal with; for example, a large rectangular block of masonry, such as that illustrated in Fig. 48. With this photograph and one other, it would be quite possible to obtain some fair measurements of the large column-base in the background. Obviously three, or more, photographs taken from different view-points of the cross-rod and adjacent objects are better than two. Three-line intersections are much to be preferred to two-line.

3. Single-Rod Control for Single Photograph

It is possible to get the camera into the vertical plane containing a single rod laid on the sea-bed, and then to photograph the rod so that the image passes through P on the print. A plumb-line attached to a float suspended above the rod is a great help in accomplishing this. If the photograph shows a plumb-line rising from the rod, and the image of the line lies on the image of the rod, then (if the water is still) it is certain that the camera was in the required vertical plane. If the image of the rod passes through P, it is in the Principal Vertical. If it does not quite pass through P, it can be projected to the Principal Vertical, which, for practical purposes, can be considered to be parallel to the rod image, and to pass through P. Then an array of trapezoids can be constructed easily.

To the Trace of the Positive Plane on a Principal Plane section (in which the p−P distance is of course the S/MepP), P, and the rod-division spaces can be transferred from the photograph, rays can be drawn from p, and a paper strip inserted to find P.V.′; this line being drawn, it can be divided into equal parts measured from P′, and from these, lines can be drawn back to p to cut the Trace of the Positive Plane. So the spacing on the Principal Vertical of a series of trapezoidal lines perpendicular to the Principal Vertical is found. The spacing of the foreground-to-background-going lines can be found by the method described in Chapter 5.

The trapezoidal lines perpendicular to the Principal Vertical can be used as Heighting Parallels, although each space will refer to a different height-interval.

Having the height-interval (as found on a Principal Plane section) to which each space refers, it is not at all difficult to interpolate equal height-interval marks along the Principal Vertical. These can be used, with the aid of a pair of dividers, to estimate heights of objects standing to left or right, on the sea-bed provided that these heights are small, and are suitable to the height-intervals marked. Alternatively, it is a simple matter to construct two arrays of trapezoids, at a chosen vertical height-interval. To do this it is only necessary to raise the P.V.' line, and the marked equal spaces on it, vertically on the Principal Plane section, and from the marked points on the raised P.V.' line to draw a new family of lines to p, cutting the Trace of the Positive Plane. This finds, on the Principal Vertical, the cut-points of the raised array of lines that are to stand perpendicular to the Principal Vertical. The spacing of the foreground-to-background-going lines can be found, as previously, with the lower array. Having constructed the raised array, the intersections can be joined to the corresponding intersections below. This produces ranks of vertical-line images like an array of posts of known height, which should all point to P.P. If these lines are retained, and most of the upper array erased, the appearance will be like that shown on Fig. 46. "Post-tops" can of course be joined by "cords" if required, as shown. Such an arrangement can be a most useful aid to sketching, since it keeps constantly in view the way in which the scale of images is changing horizontally and vertically. The method is obviously only suitable for a case in which a number of things are scattered about on a fairly flat piece of sea-bed: the relative positions and widths and lengths of objects can be found quite well from the ground-level trapezoids; the height can be estimated from the known height of the "posts" adjoining.

4. Stereoscopic Viewing

Despite the effects of refraction with a plane-glass window camera it is perfectly possible to obtain stereoscopic pairs for viewing purposes. In these, it may not be possible to "fuse" images over much of the field, but they can often be fused individually. The resulting solid images are of course distorted to some extent, but points on them can be readily identified and marked for intersection. With a cross-rod in use, there is of course no need to distinguish photographs taken in an attempt to get stereoscopic pairs, from any others. With a single rod and plumb-line and float, the fact that a photograph was not taken in the vertical plane containing the rod is (usually) immediately apparent. If trapezoidal lines are drawn on both photographs of a successful attempt at a stereo-pair of a cross-rod, taken at a small separation, such as a few inches, it is sometimes possible to "fuse" the drawn lines, when they will be seen to stand in the water like thin bars. This can be very useful in estimating the true positions of objects which cannot be intersected, but it calls for precise drawing, and it will ordinarily only work well in the immediate vicinity of the cross-rod bars

themselves. With stereoscopic viewing, the real form of an object that cannot be made out at all in single photographs is often made quite plain, despite distortion. Thus, for example, what may or may not be a shallow depression as seen in single low-oblique photographs, may be seen quite plainly under the stereoscope as half of an amphora broken through on the long axis, embedded in a concretion.

5. Sun-Shadows S/M

There seems to be no known case in which sun-shadows in a S/M photograph have been used. If those appearing on one taken in very shallow clear water were ever to be used, it would be necessary to take account of the fact that the shadows are cast by refracted light.

In the expression h/L = tan altitude, the altitude found S/M would be too great, and if the sun's true altitude was known, the effective altitude S/M would be greater than the true. If the apparent co-altitude of the sun is i', the true co-altitude is i, where $\sin i = 1.33 \sin i'$. Conversely if the true co-altitude is i the effective co-altitude is i', where $\sin i' = 0.75 \sin i$. This is believed to be the explanation of the miracle of the dial of Ahaz, referred to in Chapter 20 of the Second Book of Kings. The shadow of the gnomon of a sundial can be caused to retreat towards the gnomon by immersing the whole dial under clear water. This fact appears to have been well-known to the Rosicrucians.

Chapter 18

Old Photographs of Buildings

It is quite possible to get, out of old photographs, a good deal of information about proportions and even actual sizes of buildings that have long since vanished. Sometimes something can be found out about the gardens too. The only real difference between this work and that discussed before, is that the photographs would be relatively close-up as a rule, and they would have numerous usable vertical and horizontal lines, so that control, in the sense of means for finding the Horizon Line, the orientation of the Positive Plane relative to that of some facade, and the epP of the photograph, with the position of P, are generally available. The photographs would ordinarily be Horizontals, taken on a stand.

Sometimes a tall building may have been photographed by a camera provided with rising-front, or tilting-front and tilting-back arrangements. When a rising front is used, the lens, still in its normal horizontal position (optical axis horizontal), is moved vertically upwards, relative to the focal plane, which remains vertical. The result is a Horizontal in which P is displaced from the centre-point, upwards along the Principal Vertical on the negative.

The effect of tilting front and tilting back used together in the usual way (optical axis remaining horizontal), is the same as with a rising front; the photograph is a Horizontal in which P is displaced upwards on the negative. If, although rising-front or tilting-front-and-back was used, the camera itself was tilted (or rather, tipped) to look upwards, then, provided that the arrangement left the optical axis perpendicular to the focal plane, the result is an inverted Oblique, but with the place of P moved upwards on the negative.

Other possible moving-part arrangements are, cross-front, swinging-front, swinging-back, which correspond to rising-front, tilting-front, tilting-back if it be supposed that the camera provided only with the latter set of movements is laid over on its side, that is, rotated through 90° around the optical axis. Overall, however, even if there has been some mis-use, photogrammetrically speaking, of the movements, the photograph should generally respond, if it is treated as being in fact what it appears to be, according to the behaviour of the images of vertical lines. This is really to say that for geometrical purposes a line through the (hypothetical) perspective-centre of the lens-system, perpendicular to the focal plane, can be regarded as the optical axis, although it may be in fact standing at an angle to that axis. It can never be assumed that the (apparent) position of P will be at the centre-point of the print.

181

In the matter of the use of vertical lines, which if parallel show that the photograph is a Horizontal, and which if converging downwards show that it is an Oblique, or, if converging upwards, an inverted Oblique, the fact that a tall building may have been made to appear upright in the eye of a beholder, by being built slightly tilted-in, Parthenon-fashion, does not seem to be discoverable on a photograph. This kind of tilting-in is slight, and is of course different from the quite considerable tilting-in that there may be in an old tower. The latter may be shown quite definitely by comparison with other presumably vertical lines. These may be of houses, or even tall straight trees, which are either parallel, or converge downwards to P.P., or converge upwards to a zenith point, whereas the tower lines do not conform.

The simplest case is that of a view of a façade, taken looking full-face at the wall. If the vertical lines are parallel, and the horizontal lines are also parallel, the photograph is itself an elevation of the façade. The scale is uniform all over it, as in the case of a Vertical of a piece of flat land.

If the vertical lines converge, and the horizontal lines are parallel, or vice versa, the photograph of a façade can be treated as an Oblique of a piece of flat land. If a photograph shows two or more façades, in principle each can be treated as a separate Oblique of flat land; where façades adjoin, and stand mutually at right angles, the horizontal lines of one Oblique become the vertical lines of that adjoining, and vice versa.

Figure 49A is of a photograph mounted on a drawing-board, which thus becomes the Positive Plane. The vertical lines AA', BB', CC', are parallel, so the photograph is a Horizontal. The horizontal lines BA, B' A', etc., converge to X and Y on the Horizon Line.

Considering the façade BB'–CC' as an Oblique, Y is H on its Horizon Line, X is its P.P., and YX is its Principal Vertical. The façade can be covered with an array of trapezoids built on the diagonal lines B'–C and B–C' and lines parallel to B–B' and C–C', so producing lines 1, 2 and 3 which are equally spaced on the façade itself. If the place of P, (or the epP of the print, see Chapter 5) can be found, the lines B, 1, 2, 3 and C–plus extension of the series if necessary to 4, 5, etc., beyond the C line, or to − 1, − 2, etc., beyond the B line—can be used in the Principal Plane section of the Oblique, to discover the obliquity. The Principal Plane section of the Oblique will be the horizon plane of the Horizontal in which a plan is to be made (Fig. 49B).

In a Principal Plane section, the angle H–p–P.P. is a right angle. Given the distance H–P.P., a circle of position for p can be drawn. (Chapter 14, circle-chart). The centre of the circle is the mid-point between H and P.P., and the radius = ½H–P.P.

If the distance XY of the Horizontal, which is the distance H.−P.P. of the Oblique, is bisected, and a circle of radius ½XY is drawn on the Positive Plane of the Horizontal (regarded as the Principal Plane of the Oblique), p is somewhere on this circle. If, from the lines of another building or other block of the same,

Fig. 49A.

Fig. 49B.

standing at an angle to the first, two more Horizon Line points such as X′, Y′ of Fig. 49A, are found, another such circle of position for p can be drawn on the Positive Plane. (Regarded as the Principal Plane of a second Oblique.) The intersection of the two circles is the place of p, relative to X and Y (= H and P.P. of the first Oblique), and relative to X′ and Y′ (= H and P.P. of the second Oblique). A perpendicular from p to the Horizon Line XY finds P, and the distance pP is the epP of the print. Failing a second block of building, the

(probably) rectangular piece of paving in the foreground of Fig. 49A can be used to find the Horizon Line points X″, Y″, which can also be used to draw a circle of position for p.

Another way of looking at these arrangements is to consider that on the Positive Plane of the Horizontal, p is an isocentre (p. 53 Fig. 27). On Fig. 49A, the line BA in nature stands (or so it may reasonably be supposed) at right angles to the line BC in a horizontal plane. BA finds the Horizon Line at X, BC finds it at Y. If from any point on the Positive Plane, a line is drawn to X, that line, in nature, is parallel to BA. If, at right angles to the line just drawn, another line is drawn to Y, that line, in nature, is parallel to BC. The cut-point of the two lines is a point on a circle of position, from any point on which the angle between X and Y is a right angle. At the isocentre, the angle between X and Y is a right angle; but the angle between X′ and Y′ is equally a right angle.

There can be only one point at which both angles as measured will be right angles; this point is p, which is the isocentre Iso 1 of Fig. 27, p. 53. On a Horizontal the distance from P to Iso 1 (or to Iso 2 = epP.

Having found the epP of the print (5.0 inches on Fig. 49A), and the place of P, what may be considered either as the Principal Plane section of the Oblique of the façade B–B′, C–C′ or as a plan in the horizon plane of the Horizontal, can be drawn, (Fig. 49B). Through the Trace of the Positive Plane, the rays p–B, p–1, etc., can be drawn, and a paper-strip can be fitted into them, so finding the obliquity of the façade BC to the Positive Plane. Setting off a right angle at B, and drawing the ray p–A finds the corner A. Thus it is found that the distance B–A is 3 inches, B–C is 4 inches. From this point onwards, it is simplest to regard Fig. 49B as a plan.

On Fig. 49A the point B is 1.52 inches above the Horizon Line. On Fig. 49B the distance p–B (Trace of Positive Plane) is 5.14 inches, and p–B (plan) is 7.0 inches. If h is the height of B above the horizon plane, then

$$h/7.0 = 1.52/5.14$$
$$h = 2.06 \text{ inches.}$$

On Fig. 49A, B′ is 0.44 inch below the Horizon Line. If h' is the corresponding fall, then

$$h'/7.0 = 0.44/5.14$$
$$h' = 0.59 \text{ inch.}$$

So the height of the building, to the eaves, is 2.65 inches, in terms of the length being 4 inches, the width 3 inches. The same result for the height should be obtained from the corners A and C. There is of course no need to perform these calculations, since any of the results can be obtained graphically by plotting and scaling, but the calculations can be done on a simple slide-rule in a moment and they save time.

Elevation drawings of either façade can be made by the use of trapezoids on the photograph and corresponding rectangles on the drawings.

Protuberances from the façades can be dealt with readily: for example a flag-pole projecting from the face B—A, Fig. 49A: The points F, F′, on the Trace of the Positive Plane, Fig. 49B, are taken from verticals let fall to the Horizon Line on Fig. 49A. The rays from p contain the length of the pole: 0.45 inch in terms of BC = 4 inches.

The pitch of the roof can be found, approximately. At B on Fig. 49A the line B—S makes a slight angle to the left of the vertical through B. On the plan, 49B, this indicates that the angle A—B—S is probably 45°. Then the pitch of the roof over B—A is probably the same as that over B—C. It is likely that the line A—T, 49A, projected to the plan, would also be at 45° to A—B. Then the probable place of T can be cut-in on the plan. T is 1.67 inches above the Horizon Line, and on the plan, the two T distances required are, 5.40 inches (Trace of Positive Plane) and 9.2 inches (plan). If h is the height of T above the horizon plane,

$$h = 1.67/5.40 \times 9.2$$
$$= 2.84 \text{ inches.}$$

The height of the eaves is 2.05 inches, so the rise is 0.79 inch. From T to the wall-face AB measures 0.53 inch on the plan, so the pitch of the roof is 0.79 in 0.53, or 1.5 in 1.

Since the lines A—T and B—S (Fig. 49A) meet at Z, and a line from Z to the eaves at the top of the vertical through 3 is parallel to the roof-line above C, it is very likely that the roof out of sight behind C has the same pitch as the rest.

On Fig. 49A, a form that may be made out to be an adult lady, is walking on the path by the house, beneath the flag-pole. The distance from the Horizon Line down to the ground she stands on, measures 0.44 inch. The lady herself measures 0.26 inch. If her height is in fact, say 5.6 feet including hat, then the fall from the horizon plane to the ground she stands on is,

$$0.44/0.26 \times 5.6 = 9.5 \text{ feet,}$$

since the scale is uniform along a vertical line on a Horizontal. The distance from the Horizon Line down to the foot of the wall immediately behind the lady, on the alignment from the camera, measures 0.41 inch. Transferring the point to the Trace of the Positive Plane Fig. 49B, the usual two required distances from p are, 5.30 and 7.80 inches. If h' is the fall from the horizon plane to the wall-foot, then

$$h' = 0.41/5.30 \times 7.80$$
$$= 0.60 \text{ inch}$$

as found for the fall to B′. If 0.60 inch = 9.5 feet, 1 inch = 15.8 feet. Then the house, 4 × 3 × 2.65 inches, measures 63 × 47 × 42 feet to the eaves, plus 0.79 =

12.4 feet to the ridge, which is 0.53 = 8.4 feet in from the eaves. The flag-pole is 0.45 = 7 feet long. The distance from p to B is 7.0 inches = 111 feet.

The fall from the Horizon Line to the outer edge of the path, on the alignment to the lady, measures 0.47 inch. If D is the distance from p to the path-edge,

$$9.5/D = 0.47/5.30$$
$$D = 107 \text{ feet.}$$

This makes the path 11 feet wide, as found by plotting on the plan. This appears to be a reasonable width. The lady is about in the middle of it or about five feet from the wall, which she might well need to be, to walk past the rotund-looking bush against the wall.

The top corners of the steps, on the path-edge, can be cut-in by rays from p. If it is assumed that the steps go down at one width, the foot-corners can be cut in also, e.g., one corner is aligned with the point A. So it is found that the steps cover 10 feet horizontally in the descent.

The lower left corner of the steps is found to be 110 feet from p. Towards the point, from p to the Trace of the Positive Plane measures 5.6 inches; and it is 0.73 inch below the Horizon Line. Then the fall to the foot of the steps,

$$= 0.73/5.6 \times 110 \text{ feet} = 14.3 \text{ feet.}$$

Since the fall to the path is 9.5 feet, the steps descend 4.8 feet in 10 feet, a reasonable gradient. There appear to be about a dozen steps, so each is about 0.4 foot, say 5 inches high, and 0.83 foot, 10 inches, wide.

The nearer lady measures 0.47 inch high. The ground she stands on is 1.22 inches below the Horizon Line. If again a height of 5.6 feet is assumed, the pavement stands at

$$1.22/0.47 \times 5.6 = 14.5 \text{ feet,}$$

below the horizon plane. Then the pavement stands at the level of the foot of the steps, i.e. the ground is flat. The most distant corner of the pavement is 1.10 inches below the Horizon Line; p to Trace of Positive Plane, 5.18 inches.

If D is the distance from p,

$$14.5/D = 1.10/5.18$$
$$D = 68 \text{ feet.}$$

Similarly the distances to the other corners or points can be found, and with rays from p, these can be put on the plan, Fig. 49B. With very careful work, a rectangle of the pavement, now known to lie on ground at the level of that at the foot of the steps, can be used as a trapezoid, to be subdivided, and extended to reach to the steps; this would be difficult because of the rapid foreshortening, but if it were done, it would give a check on the work or result

in some reasonable adjustment of the plan to fit in as well as possible the path-width, steps-lengths and distance from pavement to steps.

In practice of course anything whose real size could be estimated would be pressed into service to give further measures of the scale. An adopted scale will ordinarily be the mean of several found from different objects or creatures.

Horses or ponies are of course of various heights to the shoulder, but a hackney or a carriage horse, or saddle-horse, will be about 15 to 16 hands; 1 hand = 4 inches. A pony drawing a small dog-cart or governess-car will be about 13 hands, a pony ridden by small children about 9 or 10 hands. The wheels of carriages are more various, but at least the range of diameters of wheels of two-wheelers was between 3½ and 4½ feet, the fore-wheels of four-wheelers between about 2½ and 3, the rear wheels about 4½. Ladders as used by builders almost invariably have round rungs spaced between 9 and 9½ inches, centre to centre.

Round rungs can be recognized by their relative slimness, compared with the rectangular-runged ladders used by gardeners, which being often home-made, are less reliable, but the space is usually between 10 and 12 inches.

The length and breadth of bricks vary considerably, but the thickness, which is useful for heights, is fairly constant; although bricks of three-inch thickness are not uncommon, in general it is fairly safe to take 4 bricks + mortar, as set in a wall = 1 foot.

In Great Britain and in Germany, bricks of $2\frac{5}{8}$ in. thickness are common, and it can be taken that 14 bricks = 40 inches. In France, Italy, and the United States, a thickness of $2\frac{3}{8}$ inches is commonly used, and with this, 14 bricks = 3 feet. These examples of sizes merely indicate the kind of thing that can be done, given in some particular case, an item of knowledge that may be acquired locally.

1. Vanishing-Points

In finding vanishing-points it is sometimes an advantage to double or treble the lengths of vertical lines of buildings. This of course has no effect whatever on the positions of the vanishing-points, but it may make then easier to find if they are distant, as in the case of low buildings on which the horizontal lines converge at small angles.

If two vanishing-points of horizontal lines are at equal distances, left and right, from the apparent summit-corner of two façades standing obliquely to the Positive Plane (e.g. the apparent summit-corner line B–B', Fig. 49A) then the Principal Vertical is along the summit-corner line; the façades (of whatever length) stand symmetrically around the Principal Plane.

If the horizontal lines of a façade are found to be perfectly parallel, the horizontal lines of a façade at right angles (assuming that one such is visible) will converge to intersect at the cut-point of the Principal Vertical and the Horizon Line; this cut-point, on a Horizontal, is P.

It is quite possible for two Horizon-Line vanishing-points to be both on the one side of a building. This can occur when the building is near to, say, the left of a view, almost facing towards the camera, but the right-hand façade is in view.

The apparent summit-corner will then be to the left side, one vanishing-point will be a long way off to the right, the other to the right also, but to the left of P. This changes nothing, although of course a circle of position for p will have a great radius; epP will be a relatively short ½ − chord of the circle.

2. Inverted Oblique

With an inverted Oblique, the distance (p–P in the case of a Horizontal), found by letting fall a perpendicular from p as found by circles of position, to the Horizon Line, is the distance p–H of a Principal Plane section. The point p remains an isocentre, and it is in fact Iso 2 of Fig. 26 (p. 52) if that Figure is inverted; p–H = H–Iso 2 (See Fig. 50B, then Fig. 50A).

In a real case of such a photograph it might not be apparent at once that it was an inverted Oblique. The tower might be built tilted-in. In the illustration (fortunately, because it makes it small overall) the camera must have had a wide field-angle, and so the obliquity is rather obvious; the–presumably–erect small building in the background is canted over at a considerable angle. The vanishing points X and Y are found, and so the Horizon Line is fixed. A line from A' to Y, and a line from C' to X, will cut at the position of the foot-corner diagonally opposite to B'. Diagonals of the trapezoid so formed will cut at the centre-point of the base of the tower. The same can be done at the summit. Then the central axis of the tower can be drawn, and this axis will go to the zenith-point. It can be assumed that the (presumably) vertical lines of the small building, and the (probably) vertical lines of two trees, meet at the zenith-point. The up-and-down lines of the tower meet at the same point, on the central axis of the tower. Then there is no doubt that the tower is vertical, not tilted-in, and so it follows that the photograph is indeed an inverted Oblique. If the tower had been tilted-in, its lines would meet below the zenith-point.

A perpendicular let fall from the zenith-point to the Horizon Line is the Principal Vertical, which cuts the Horizon Line at H; p is on the Principal Vertical, and on the circumference of a circle of radius ½XY, with centre at ½XY. The distance p–H = the distance p–H of a Principal Plane section, p is an isocentre.

A Principal Plane section, Fig. 50B can be made: p–H, in the Horizon Plane, is 5.50 inches. H–Z, on the Positive Plane, is 17.90 inches. This latter distance may not be very accurate, but a little uncertainty in a rather long line can be tolerated. The line H–Z is the Trace of the Positive Plane. A perpendicular from p to H–Z, finds the place of P. The distance p–P (5.22 inches) is the epP of the photograph. It appears likely that the photographer used a rising-front but tilted the camera as well; P is above the centre of the photograph, which may not have

Figs. 50A, B and C.

been trimmed, since its relative dimensions correspond with those of a ½ plate–4¾ x 6½ inches. The angle Z–H–p is the obliquity; the bisector of the angle P–p–Z would find isocentre 1, and a line at right angles to this bisector finds isocentre 2. The distance H–isocentre 2 = the distance H–p. Angles measured at p on the Positive Plane, are measured at isocentre 2; just as, with a Horizontal, angles measured at p are measured at isocentre 1 (Figs. 26 and 27 should make the point clear).

Figure 50C is a plan, on which p–H is 5.50 inches as found from Fig. 50A.

As with the Horizontal, the ratio of the width of the façade BC to that of the façade BA can now be found. But BC is rather narrow to work on. The width can be doubled or trebled, by ordinary extension of the trapezoid B–B', C–C' using the vanishing-points Y and Z. So the positions of the vertical lines C2–C2', C3–C3' are found. The cut-points of these with the Horizon Line X–Y, along with the cut-points of the lines A, B, C, are transferred to Fig. 50C, and rays drawn appropriately from p.

A paper strip marked with equal spaces is inserted, thus getting the line B–C on to the plan where, incidentally, it should be found to be parallel to p–(Y). Assuming that the two façades do stand at right angles, the place of the corner A is cut-in on the plan, B–A being parallel to p–(X). It turns out in this case that the tower is square, with sides of 2 inches to the scale of the paper strip.

The height of the corner B can now be found. With an inverted Oblique, it is perhaps simpler to plot than to calculate. From B on the plan, Fig. 50C, a perpendicular to the p–H line, is 6.04 inches from p. This distance is set off on the horizon plane p–H on Fig. 50B, from p, so finding B, from which a vertical is erected. On Fig. 50A a perpendicular from B to the Principal Vertical, is 3.20 inches above H. This finds (B) on Fig. 50B. A line through (B) from p, cuts the vertical at 4.00 inches above the p–H line; so the height of the tower, above the horizon plane, is 4.00 inches, the width being 2.00 inches. Working in exactly the same way with B', the foot of the tower, it is found that this stands at 1.00 inch below the horizon plane, so the overall height of the tower is 5.0 inches. This can of course be verified by working with the corner A, or for that matter, with the imaginary corner C3, as shown in Fig. 50C.

If there is some interesting detail on the façade, and a sufficiently clear enlargement can be obtained, the façade can be covered with an array of trapezoids obtained by sub-division of the main trapezoid B–B', C–C'. Also, of course, if there is something in the picture that can be used, as were the ladies of the Horizontal, to give a measure of the scale, an approximate scale-bar can be added to the elevation drawing and to the plan.

If the base of the tower had been masked by other buildings, it would still be possible of course to find the vanishing-points X and Y, if there were other horizontal lines on the structure, well below the top. Imaginary corners, such as C2 and C3, could still be added to widen the façade, by the use of any well-separated pair of horizontal lines converging to Y. In expanding the

trapezoid formed by the available horizontal and vertical lines of the façade, diagonals of like kinds, meet on the line Y–Z, or on Y–Z prolonged. Also, as usual, a perpendicular from the line Y–Z, to X, will pass through P; a perpendicular from line X–Y, to Y, will pass through P; and of course a perpendicular from the line X–Y, to Z, will pass through P. (Chapter 5).

If there is a hole in a wall, such as the curious circular opening in Fig. 50A through which the inner edge of the wall opposite to A–B can be seen, this may be used to find the thickness of the walls at or near to the top. The line of the inner edge of the wall can be prolonged to cut the line B–C; through the cut-point, a line from Z can be drawn to cut the Horizon Line; this cut-point can be transferred to Fig. 50C, and a ray drawn through it from p, to cut the line B–C. Then, as shown, the thickness of the wall is found. Similarly, lines tangential to the inner and outer sides of the circular opening can be drawn from Z to cut the Horizon Line, and by the use of Fig. 50C as before, the thickness of the wall B–C may be found.

The smaller building in the photograph has a most lop-sided appearance, a result of the wide angle and the obliquity. The presumably horizontal and parallel lines of the façade facing towards the camera are parallel to the Horizon Line. Then the horizontal and parallel lines of the other visible façade will meet at the intersection of the Principal Vertical and the Horizon Line, the point H. In the Principal Plane section, Fig. 50B, H may be considered as being the P.P. of Fig. 50A considered as a low Oblique, the Horizon Line of which passes through Z. In such an Oblique the (actually horizontal) lines of the façade are vertical, and so they go to the P.P.

These illustrations, the Horizontal and the inverted Oblique, necessarily deal with simple structures, but with quite complicated ones, much can be found out. It is really only necessary to bear in mind the central fact that once the place of P, and the epP of the print, are discovered, the photograph resolves itself into a record of angles measured at p. The attitude of some principal part of a block of buildings relative to the Positive Plane having been discovered, and its proportions found, such things as the diameters and heights of round towers and arches can be found in the same terms, and it may well be possible to do something with parts of gardens adjoining the building. Obviously two photographs are better than one. If both show moveable objects in the same places or apparently the same people or shadows in much the same places or gardens in the same condition, they are likely to have been taken on one occasion, and so probably by the same camera. If epP for one can be found, it may apply to the other also. A second point may be resected (Chapter 14) on a plan made from the first point p, by the use of horizontal angles, or horizontal and vertical angles; and alignments may be found. Then, having two points p on the plan, some points may be intersected. The second photograph may show some scale-finding objects for comparison with those on the first.

It is probably apparent that the façade B–C on Fig. 50A can be drawn

parallel to p–(X) on Fig. 50C, without the use of a paper strip, and that the same applies to the façade B–C on Figs. 49A and 49B. However, in the general case the use of a paper strip does give some internal check on the work in process, and in the special case of a single façade, standing at an angle out of the corner of a building which shows two façades at right angles, the only way to discover the angle at which this wall stands may be by the use of a paper strip. In

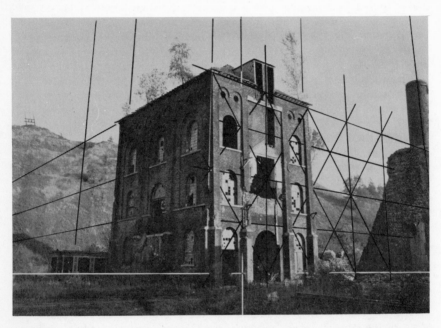

Fig. 50D. Partial construction of trapezoids on one façade of an ancient industrial building. An inverted oblique of 78°. The proportions of the building are discoverable (and its dimensions, approximately). (Photograph by Honor Frost.)

order to use this, it may be necessary to extend the façade, as with B–C on Fig. 50A. The way to extend a façade is further demonstrated with Fig. 50D. This illustrates a partial construction on a photograph of an ancient industrial building, the Borinage mine building in Belgium. It is an inverted Oblique of epP 209 mm (original print) and obliquity 78°. The buttresses give an appearance of tilting-in, but the building is erect. The general proportions are about 1.0, 1.25, 1.37 high, and the actual size could be estimated from the fact that there are approximately 50 bricks in each of the four vertical spaces formed by trapezoids on the façade, the height of which is covered by 4.26 such spaces. Then the height is about 4.26 x 50 = 213 bricks = approximately 213/14 x 3 feet = 46 feet to the eaves; from which the width = 33 feet, the depth = 42 feet. On this

basis, the small buildings' entrances are 5.5 feet high, which seems low, but there is probably some part of them concealed by grass; or the Belgian bricks may be somewhat thicker than the French.

To revert to a remark made in the Preface, it will sometimes be found that a drawing or painting of an architectural sort will respond to treatment as a photograph. It is not entirely unknown for an artist to paint on top of a large underexposed photographic print, or to transfer some points or lines from a photograph to paper, or even by measurement to canvas (this presumably to avoid what may be regarded as the mere labour of drawing lines in a true central perspective or one-eyed view, if that is a right way for a two-eyed creature to look at things). But long before the development of photography, the *camera lucida* was sometimes used to draw outlines, even by very skilled artists. The sketch-master device is a kind of modern development of the *camera lucida*. A much cruder arrangement can be made simply by fixing a sheet of glass vertically on a support, and providing a means for looking through it from a fixed peephole at a distance of a foot and half or so, the peep-hole being opposite the centre-point of the glass. Lines of the view as seen through the glass can be drawn on it with a wax pencil (provided that the glass is perfectly clean and dry). The lines can then be traced on paper, which can then be mounted on board and set on the easel, while the glass, from which the wax lines can be erased with methylated spirit, is dismantled and concealed if that is thought desirable. Photographs can also be converted into what are apparently pen drawings by inking-in, with a waterproof ink, all that is considered to be necessary; the un-inked photographic images can then be removed by bleaching. So it is possible that what appears to be a free-hand drawing, or a painting, may sometimes conceal in part, or in the whole, the use of some form of artificial aid in the geometric sense.* Even with genuinely free-hand work, the common practice of some artists, of holding a pencil at arm's length, to measure and compare the tangents of angles as measured at one eye, will tend to produce a central perspective. Dr. Schwidefsky (1) says that "as early as 1726, Capeller plotted a map of the Pilatus massif from free-hand 'prospects' of this mountain". Overall it is not necessarily surprising that sometimes a picture will respond, at least in some degree, to a photogrammetric treatment. With at least one painting (a Utrillo) it appears to be possible to demonstrate that the artist changed his view-point during the process of the work, possibly without moving the picture. It tends to produce two discrete points p, with practically the same epP. It is perhaps going rather far to deduce from this that he could draw, or paint, with either hand, at one stage looking past the left edge of the picture, and at another stage, looking past the right edge, the picture being placed vertically, partially blocking his view. It is difficult to suggest that this kind of deduction might be

*"Art and Photography" by Aaron Scharf (Penguin, 1968) contains a great deal of information on this matter. An excellent article entitled "Camera and Camera Obscura" in "Things" (People, Places, Things, Ideas series, Grosvenor Press, London, 1954) also discusses the subject, referring to the work of Caualetto and Bellote and that of Josiah Wedgwood and his son Thomas. This article mentions the 17th century use of small versions of camera obscura in sedan chairs and carriages (and inside boots, and in drinking vessels in which images were projected onto the surface of white wine).

of some actual use to someone, but it is even more difficult to refrain from mentioning it.

It is not to be expected that the results of working from old photographs will be very precise. Principal distances may be long, and vanishing-points hard to find. With drawings or paintings, as may be imagined, a certain looseness is to be expected; the work calls for a bold approach with an exceedingly thick pencil. But if precision is wanted, it must be looked for elsewhere than in old photographs or the works of artists. Just where to search in the case of buildings and gardens long since vanished and the plans of them no longer available, it may be hard to discover. It is always possible to take the advice the flute-player offered to Alphonse Daudet—to look in the library of the grasshoppers. What cannot be known may perhaps be imagined well, but knowledge of some relative dimensions will help to keep the sense of proportion alert.

Chapter 19

The Creation of Images on Photographs

To create the image of a proposed building on a photograph is to work in reverse. Instead of deducing dimensions from existing images, given dimensions are used to construct the images. Figure 51A shows a camera, p, taking a Horizontal of existing buildings and the site of a proposed building. The enormously enlarged print shown standing between the camera and the view is placed at the correct Principal Distance from p, so that, as seen from p, the images of buildings would be superimposed on the buildings themselves. The dotted line on the print is the Horizon Line in the horizontal plane that cuts the

Fig. 51A.

buildings themselves on the dotted line marked. The point at which a ray from p, to a mark on an existing building, cuts the print, can be defined by co-ordinates, measured from P along the Horizon Line, and from the Horizon Line vertically. Such co-ordinates for any image-point of a proposed building can be found readily, for plotting on a Horizontal taken from a known position on the building-plan; provided that the necessary ground heights and building-heights are known.

Figure 51B is a plan of the buildings shown on Fig. 51A, with the outline, N1 to N7, of the proposed building. Figure 51C is the Horizontal (print of the whole negative) taken at p of Fig. 51A. The camera is assumed to have been supported, and made as level as possible by the use of a spirit-level.

196

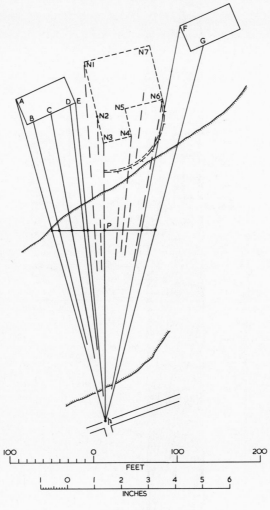

Fig. 51B.

To take a numerical example, the height of the ground on which the existing buildings stand is 84 feet above some known datum; height of ground on which the proposed building is to stand, 68 feet above datum; height of existing buildings, top to bottom, 80 feet; height of proposed building, 112 feet as to the part N1, N2, N6, N7, 96 feet as to the part N2 (lower) N3, N4, N5. The height of p is unknown, but since the distance from camera to buildings is only about 100 yards, this will not be required.

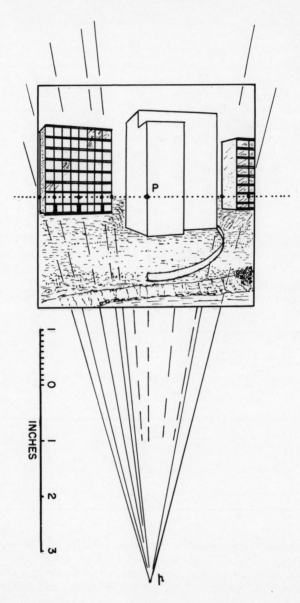

Fig. 51C.

On the print, Fig. 51C, the place of P is found by diagonals, and the Horizon Line is drawn through P at right angles to available vertical lines, which, being parallel, show that the photograph is a Horizontal as intended.

On the plan, Fig. 51B, lines are drawn from p to definitely identifiable points, A, B, C, D, E, F and G and these points are marked on the Horizon Line, Fig. 51C. The procedure used to find the epP of the print is that described in Chapter 3; that is to say, the Trace of the Positive Plane is fitted into the family of lines radiating out of p, Fig. 51B. Rays are then drawn from p to N1, N2, etc. (which points will be in sight) and also to N5, N7 (which will not be in sight). The cut-points of these rays on the Trace of the Positive Plane are transferred to the Horizon Line, Fig. 51C, and verticals drawn through the points.

The height of the ground at the existing building A–E is 84 feet above datum. The height of the building itself is 80 feet. Along any vertical line on a Horizontal the scale is uniform. By measurement, on Fig. 51C it is found that the Horizon Line is 0.21 of the height of the building, from the ground-level; then the horizon plane through the camera is at 80 x 0.21 = 17 feet above ground-level at A–E, or 84 + 17 = 101 feet above datum. The height of N1 (summit) above datum is 112 + 68 = 180 feet = 79 feet above the horizon plane.

On the plan, Fig. 51B, the two required distances p–N1 are 6.91 inches (to Trace of Positive Plane) and 416 feet. If h is the image-height of N1 summit above the Horizon Line,

$$h/6.91 = 79/416$$
$$h = 1.31 \text{ inches.}$$

The foot-corner N1 is at 68 feet above datum, = 33 feet below the horizon plane. If h' is the image-height, below the Horizon line,

$$h'/6.91 = 33/416$$
$$h' = 0.55 \text{ inches.}$$

In exactly the same way all the required image-heights are found and plotted. The points being joined appropriately, the proper perspective appearance appears. As a check on the work, lines N7–N1, N6–N2 (upper), N5–N2 (lower), N4–N3, should all meet at the Horizon Line, along with the lines from the corresponding foot-points, and similarly with the lines N2 (upper)–N1, N6–N7, N4–N5, N3–N2 (lower) and the lines of their corresponding foot-points. The mid-point on the Horizon Line between the two vanishing-points should be found to be the centre of a circle, passing through p and both vanishing-points. The redundant lines e.g., N7–N1, are erased.

In exactly the same way as with the outline, horizontal lines of storeys can be inserted, or, in the case of a simple façade, the outline can be used as a trapezoid in conjunction with the corresponding rectangle of an elevation drawing, both being sub-divided by diagonals in the ordinary way (see Chapter 1). Details can

then be filled in by sketching, but this final work calls for considerable artistic ability.

The work is best done on a matt or semi-matt print, as large as can be made conveniently, with the end-product in view—that is, a photograph, probably glossy, of the finished work. Lines can be drawn in pencil with touches of white ink. Things to be obliterated from the print can be covered with white process ink and worked on afterwards, or it is possible, although difficult, to cut through the emulsion only and peel the image off, later working on the exposed paper backing. This involves soaking, which may result in some distortion.

A building may have numerous curved lines. Any curve whatever can be resolved into a series of points projected to the plan, and the height of each point can be found from (presumably available) elevation drawings or other data. To take an example of this: On Fig. 51B there is a curving wall springing from the corner N1. Including the corner, nine equally-spaced points are marked on it. The wall is to be 6 feet high, and to follow the existing slope of the ground. The heights of the nine ground-points, above datum, are, 68.0, 63.5, 59.0, 54.5, 50.0, 45.5, 41.0, 38.7 and 38.7 feet. The corresponding fall from the horizon plane in each case is then, 33.0, 37.5, 42.0, 46.5, 51.0, 55.5, 60.0, 62.3 and 62.3 feet. The plan-distances from p are 380, 362, 346, 330, 317, 305, 295, 289 and 289 feet. The distances from p to the Trace of the Positive Plane are 7.03, 7.05, 7.05, 7.05, 7.03, 7.00, 6.96, 6.91 and 6.91 inches.

If h' is the fall from the Horizon Line (Fig. 51C) to the image-point at the foot of the end of the wall, then

$$h'/6.91 = 62.3/289$$
$$h' = 1.49 \text{ inches.}$$

If h'' is the fall to the wall-top, then

$$h''/6.91 = 56.3/289$$
$$h'' = 1.36 \text{ inches.}$$

These small calculations are done by slide rule, and the results are (taking the foot of wall only), working downhill, 0.61, 0.73, 0.86, 0.99, 1.14, 1.28, 1.41, 1.49 and 1.49.

The necessary rays from p cut the Trace of the Positive Plane, Fig. 51B, in points which are transferred to the Horizon Line, (Fig. 51C) and the distances found are set off on verticals appropriately. Smooth curves drawn through the points so found produce the image of the wall. The top and bottom having been drawn, the thickness can then be sketched in, since it would be too slight to plot in the ordinary way.

In the case used for illustration, the view is very restricted, and there is only a single large image to deal with. In practice, the image may be quite a small thing

on a very large print, showing a sweep of countryside or the sky-line of a city. The principles remain exactly the same; but instead of a local plan, on which p and the building-to-be can be plotted, it may be necessary to use a large-scale map, on which p is a mile or more from the building site, and on which the ground-plan of the building is only perhaps a quarter of an inch across. The object may be to show how a new building in the country will agree with the landscape, or what effect the appearance of a new city building may have on another's even at some distance away. In the former case, it may be necessary to add to a photograph—perhaps a view from a low hill, down over falling land—not the building only, but some part of a road scheme or garden lay-out. In the latter case it will probably be possible to show only the upper part of the building sticking up out of a sea of roofs. In either case, a distance such as p to N3 may be a mile or more. This distance can be measured on the large-scale map, but the other distances, to points only a little way away on the map from a point such as N3, are best obtained by adding increments to the distance as measured to N3; these increments can be obtained from the local building-plan; this is better than measuring all of the required distances directly, individually, on the map; because the distances obtained by adding accurate increments to a large distance that is only a good approximation to the fact, will be at least internally consistent with one another. To get the horizontal angles correctly, there is much to be said for using a simple theodolite at p because the epP of a very large print may be a metre or more. At p, angles such as those represented on Fig. 51B by the angles A—p—E, A—p—F, etc., can then be measured accurately. On the building-plan, a line such as the line through N3 going to p, can be plotted at the right orientation by the use of the map; then on the building-plan a perpendicular from say E, to the N3—p line, can be measured accurately. The length of this perpendicular divided by the distance from N3 to p plus the increment to the foot of the perpendicular, is the tangent of the horizontal angle E—p—N3; the angle found can be added to the angle A—p—E; this produces quite an accurate version of the angle A—p—N3. Similarly, the angles A—p—N1, A—p—N4, A—p—N5, etc., can be obtained. This will be far better than attempting to measure such angles on a map, when the proposed building only occupies a very small space, perhaps a foot from p on the map. To plot the angles on a drawing-table, it is only necessary to draw a long line to represent the line p to A; on the line, to mark off a convenient distance, such as 100 centimetres; set off a right angle, draw a line, and from the foot, plot the natural tangents of the horizontal angles measured from A.

The theodolite can be used at p to pick out the Horizon Line, by setting the telescope level. But in practice, it will be simpler to use it to measure vertical angles to points, in one vertical plane, than can certainly be identified on the photograph. If the differences between vertical angles is small, they can be used directly, without calculation: e.g. if two vertical angles are $+ 0°\text{-}21'$, and $- 0°\text{-}11'$, and the space, on the photograph between the images of the two marks

chosen and sighted on, is 8.2 mm, then the Horizon Line stands at $21/32 \times 8.2 =$ 5.4 mm, by slide-rule, below the upper mark. At least three such pairs of Horizon-Line-finding observations should be taken at p. It is a great advantage if a photograph taken from p is available when the theodolite observations are being taken, since then the identifications are certain. Obviously, what the points sighted on are, or where they stand on the map, is of no significance whatever. Any object which can be seen by the eye directly, or through the telescope, will serve, if it has distinct upper and lower points that can be sighted on, and can be found and marked on the photograph.

The foot of a proposed building may be obscured by intervening objects. This raises no special difficulty. The whole image can be plotted regardless, in the first instance, but when the fair-drawing starts the vertical lines are of course drawn down only to the points at which they meet existing buildings' intervening images. In some cases it may be necessary to ascertain whether an existing building shown on the photograph is behind or in front of the proposed building. This is not quite so obvious as it may appear; in the case of a city sky-line, a view of a flattish mass of roofs with projecting towers of different heights and sizes, it is not invariably easy to identify immediately a particular item on the photograph, on a plan or map. However, this can cause trouble only inside the narrow angle subtended by the proposed building as seen from p; the containing lines can be drawn on the map, and there will be only a limited area to investigate.

In this work it is good practice to use the photograph to construct the image of a building that is already there. Horizontal and vertical angles to this building can be measured by theodolite, at p; and its orientation, and the necessary distances from p, can be found from map and plan. Its height is not really required, if the vertical angles have been measured at p. It gives a considerable confidence to find that the lines being drawn to construct an image from given data fall exactly on the image already present.

In some cases, there may be something to be said for putting the image of a proposed building, not on a single photograph only, but on to a panorama made up of two or three photographs taken from the one view-point and assembled together. The angle containing the field of view of even a single human eye is greater than the field of an ordinary camera. The best of photographs is a one-eyed view through a peep-hole, no matter how wide the camera's field-angle may be; and if it is extremely wide, the picture it takes is not an approximation of a human eye's view, but merely a mathematical curiosity; or rather, it is so if the picture is taken on a flat negative, and is printed on a plane.

Most people enjoy a field of view greater than that of one eye, which is cut off by the intervention of the nose. A panorama made by assembling three or so overlapping photographs is only an approximation of what even one single eye sees, let alone a pair; a panorama is an assembly into one plane, of two or three Positive Planes which in fact cut one another at considerable angles. The result is

not right, and it cannot be corrected, but it may give some sort of true impression of what a view itself will look like. It may happen that the image of the proposed building is to be more or less in the middle of one photograph, and that it is decided to extend the view both left and right. To do this, the camera should be kept quite level on its support and be rotated through an angle of, say, 20°, horizontally, to the left of the first position, for the taking of the second exposure, and then through a similar angle to the right of the first position, for the taking of the third. If the field-angle of the camera is, say, 30°, this will make an overall included angle of about 70°, which is about enough if some semblance to the fact is to be kept.

Assembling the prints is a skilled job, since it is impossible to make the images in the overlaps fit each other exactly. On the whole it is best to have the two wing prints made at exactly the same degree of enlargement as that of the central one on which the work of making the image has been carried out. The junction-line of a wing print with that of the central print should be, more or less, in the vertical line in which the two Positive Planes intersect. The junction need not be a straight line, but may be chosen, in steps or zig-zags, to avoid making apparent angles in the images of straight lines. The Horizon Line must be kept, apparently, straight across the prints. The wing prints should, in any case, be soaked and peeled off their paper backing, to make them thin; this makes them fragile, but it also makes it possible to squeeze-up parts of them, between parts that can be forced into matching on the fixed central print; once some parts have been stuck down—the best adhesive appears to be a rubber solution— any necessary squeezing-up of other parts can be done with the handle of a spoon. If it is not desired, or is found too difficult, to peel a whole print, at least the edge can be "feathered-off", to make the last inch or so much thinner than the rest. The people to do peeling, or feathering of edges, are those skilled in the making of photomosaics of air photographs. When the three prints are finally assembled, they can be trimmed into one tidy rectangle, and then the joins can be touched-up or touched-out somewhat with pencil, and the judicious use of black and white ink. Finally the whole thing is photographed, to make a print of reduced size. When this photography is being done, the negative of the camera must of course be parallel to the plane of the board to which the panorama is fastened. It may be necessary to add some touches to the final print. The result is not wholly a fraud. The image of the proposed building is right; the things in the vicinity of it are right; the extensions of the view, left to right, are really decorations, added to assist in forming a good idea of what the view will look like over a wide angle. Figure 51D is an example of the construction of an image on an assembly of two photographs.

Photographs taken for the purpose of showing something proposed in the way of alterations to an existing view are usually Horizontals. But to construct an image on an Air Oblique is not difficult. Assuming that the epP of an Oblique is known, and the place of P found, and some truly vertical lines to find P.P. or

Simple Photogrammetry

Fig. 51D. Image of the tower of Britannic House, London, at design stage (1963) constructed on a panorama. Reproduced by kind permission of the British Petroleum Company, Ltd.

some horizontal lines to find the Horizon Line are available, the Principal Vertical is drawn; given then ground points of known plan-position on the building-plan, and their heights above some datum, the Crone construction (Chapter 16, Section 2) can be used to find P.P.' on the plan and to draw P.V.'.

On the plan, from points of the proposed building's ground-plan, perpendiculars can be let fall to P.V.', and so, via the Principal Plane section in the Crone construction, the P.V.' points can be transferred to the Principal Vertical; from these, corresponding perpendiculars can be drawn across the photograph. PLA angles at P.P.' (Chapter 7) can be transformed to Pha angles at P.P., and so, rays to cut the perpendiculars can be drawn from P.P. Thus, the outline of the building's ground-plan is transferred to the photograph.

Summit-points can be plotted on the appropriate verticals rising from P.V.' on the Principal Plane section, and so, via the Trace of the Positive Plane on the section, can be transferred to the Principal Vertical; through the points so found, perpendiculars to the Principal Vertical cut the lines running from P.P. through the corresponding ground-points; thus, summit-points can be transferred to the photograph. As an exercise in this, it may be found interesting to investigate how an illustration in this book, for instance Fig. 42A, the photograph (p. 149) S., was in fact made by working in reverse from a plan, Fig. 42E, and a Principal Plane section, Fig. 42B, which drawings were made as a first step.

It is perfectly possible, although it does call for very exact work, to create images that can be viewed stereoscopically along with the real images. To do this, it is only necessary to work on each photograph of a stereoscopic pair, separately. At least the outline of a proposed block of building can be constructed for stereoscopic viewing. It is much more difficult to fill in detail that will "fuse" into realistic solid images, but the eyes are quite accommodating, and once persuaded that they are supposed to see something, they will often manage to see something of the kind.

Perhaps the great advantage of the showing of images of things-to-be on photographs of objects that exist, rather than on the most accurately constructed architectural drawings, is that the former carries conviction, at least in some respects, whereas the latter is regarded wholly as an expression of opinion. Particularly in the case of an argument about the effect on the sky-line of a city, a photographic construction is useful, since so far as dimensions go it is a statement of a fact that, being obtained by mechanical means and the use of simple arithmetic, it can be verified absolutely.

References

1. K. Schwidefsky: "An Outline of Photogrammetry", Sir Isaac Pitman and Sons Ltd., London, 1959.
2. Lyle G. Trorey: "Handbook of Aerial Mapping and Photogrammetry", Cambridge University Press, 1952.
3. Gomer T. McNeil: "Photographic Measurements, Problems and Solutions", Pitman Publishing Corporation, New York, Toronto, London, 1954.
4. M. Hotine: "Surveying from Air Photographs", Constable and Company Ltd., London, 1931.
5. "The Star Almanac for Land Surveyors", prepared annually by H.M. Nautical Almanac Office, Royal Greenwich Observatory. H.M. Stationery Office London.
6. James B. Friauf: "Nomograms for the Solution of Spherical Triangles", *J. Franklin Inst.* **232**, (1941). pp. 151-174.
7. Alexander Gleichen: "The Theory of Modern Optical Instruments". Published for the Department of Scientific and Industrial Research, H.M. Stationery Office, London, 1918.
8. A. Ivanoff and Paul Cherney: "Correcting Lenses for Underwater Use", *J. Soc. Motion Pict. Telev. Engrs,* **69**, (1960). pp. 264-266.

Other Publications consulted:

Professional Papers of the Air Survey Committee No. 3. "Simple Methods of Surveying from Air Photographs", M. Hotine, H.M. Stationery Office, London, 1927.

Professional Papers of the Air Survey Committee No. 8. "A Simple Method of Surveying from Air Photographs", J. S. A. Salt, H.M. Stationery Office, London, 1933.

"Graphical Methods of Plotting from Air Photographs", L. N. F. I. King, Issued by the War Office, H.M. Stationery Office, London, 1925.

"Textbook of Photogrammetry", M. Zeller, translated by E. A. Miskin and R. Powell, H. K. Lewis and Co. Ltd., London, 1952.

"Elementary Photogrammetry", D. R. Crone, E. Arnold, London, 1963.

Subject Index